VISIONING

OTHER WORKS BY DR. LUCIA CAPACCHIONE

Books

The Creative Journal: The Art of Finding Yourself

The Power of Your Other Hand

The Well Being Journal: Drawing upon Your Inner Power to Heal Yourself

The Creative Journal for Children:
A Guide for Parents, Teachers & Counselors

The Creative Journal for Teens

Lighten Up Your Body, Lighten Up Your Life
(with Johnson & Strohecker)

The Picture of Health: Healing Your Life with Art

Recovery of Your Inner Child

Putting Your Talent to Work (with Peggy Van Pelt)

The Creative Journal for Parents

Audiotapes

The Picture of Health (meditation and journal exercises)

The Wisdom of Your Other Hand (five tapes on creative journal and art therapy, inner family work, body/mind healing, relationships, career)

For information regarding materials, public presentations, consultations and Creative Journal Expressive Arts certification training, contact Lucia Capacchione at PO Box 1355, Cambria, CA 93428, (805) 546-1424, or visit her web site at: www.luciac.com

*Ten Steps to
Designing
the Life of
Your Dreams*

VISIONING

LUCIA CAPACCHIONE

Jeremy P. Tarcher/Putnam
a member of Penguin Putnam Inc.
New York

Most Tarcher/Putnam books are available at special quantity discounts for bulk purchases for sales promotions, premiums, fund-raising, and educational needs. Special books or book excerpts also can be created to fit specific needs. For details, write Putnam Special Markets, 375 Hudson Street, New York, NY 10014.

Jeremy P. Tarcher/Putnam
a member of
Penguin Putnam Inc.
375 Hudson Street
New York, NY 10014
www.penguinputnam.com

First trade paperback edition 2000
Copyright © 2000 by Lucia Capacchione

The illustration on page 1, "the door to the world is the heart" by Corita Kent, is reprinted with permission from the Corita Art Center Immaculate Heart Community.
 All quotations from Walt Disney and the Walt Disney Imagineers are reprinted from *Walt Disney Imagineering: A Behind the Dreams Look at Making the Magic Real* by The Imagineers. Copyright © 1996 Disney Enterprises, Inc. Published by Hyperion.

The Library of Congress has catalogued the hardcover edition as follows:

Capacchione, Lucia.
 Visioning : ten steps to designing the life of your dreams / Lucia Capacchione.
 p. cm.
 Includes bibliographical references.
 ISBN 1-58542-012-3
 1. Self-actualization (Psychology) 2. Self-actualization (Psychology) — Problems, exercises, etc. I. Title.

 BF637.S4 C353 2000 99-041035 CIP
 153.3 — dc21
ISBN 1-58542-087-5 (paperback edition)

Printed in the United States of America

This book is printed on acid-free paper. ♾

Book design by Mauna Eichner

Contributors

I am deeply grateful to the Visionaries
who shared their stories and artwork for this book.

Esther Denn

Carolyn Downey

Aleta Francis

Anna Marie Gabriel

Judith G. Hernandez

Christine Keebler

Gayle Laskosky

Steve and Catherine Loquet

Susan McElroy

Jan Meshkoff

Lisa Morrice

Jim Ogden

Mara Sanders

Tom and Beverly Staley

Gregory Wendt

Jane Wheeler

Thanks to my personal "dream team":

Marsha Gamel and Mara Sanders,
for their lasting friendship and support for this work over the years.

My agent, Liv Blumer, and personal editor, Marilyn Abraham,
for believing in me and helping to realize my dream.

Nanscy Neiman-Legette, for her enthusiastic support.

Joel Fotinos and David Groff, my editors at Tarcher/Putnam, for their
enthusiasm and creativity and being so much fun to work with.

The book designer, Mauna Eichner, and the jacket designer,
Andrew Newman, for presenting the material so beautifully.

And finally, Jeremy Tarcher, for creating the means to share my dream.

**This book is dedicated with love
to my design mentors:**

Corita Kent

Charles Eames

Maria Montessori

R. Buckminster Fuller

Walt Disney

and

the Walt Disney Imagineers

Contents

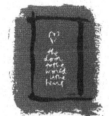

page 74

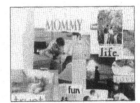

page 96

page 109

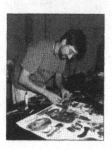

page 114

p a r t

SEEING RESULTS

Letting Your Mind See What Your Heart Already Knows

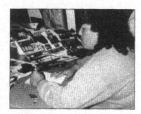

page 132

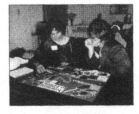

page 159

page 170

part **3**

VISIONING IN ACTION

Photo Album of Success Stories; Ideas and Suggestions

page 179

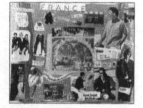

page 203

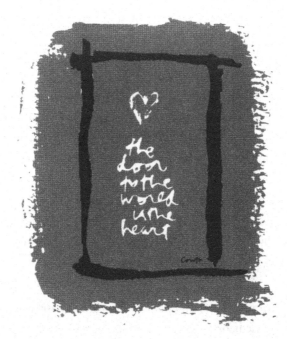

The door to the world
is the heart.
CORITA KENT,
Artist and educator

Introduction:
Life as Art, Art as Life

Since early childhood, I have had a fascination with cutting things up and putting the pieces together in new ways. My mother was an expert dressmaker and tailor who worked at home, so I grew up surrounded by pictures from fashion magazines, scissors, dress patterns, pins, sewing machines, and garments in progress. My father was also into cutting. A film editor at MGM, he worked on films such as *Meet Me in St. Louis*, starring Judy Garland, and *Ziegfeld Follies*, with Gene Kelly, Fred Astaire, and Frank Sinatra. I have vivid memories of the nondescript little rooms where he made magic by cutting up ribbons of film and gluing them together into movies. I always thought my

parents were engaged in the same process: they cut things up and put them together to create fabulous new things. As a child there was nothing more fun than making pictures and paper dolls.

Later, as a student in the highly unorthodox art department at Immaculate Heart College in Hollywood, I studied with two maverick nuns: the entrepreneurial department head, Sister Magdalen Mary, and Sister Mary Corita, the diminutive, quick-to-laugh resident artist. Corita (who later left the convent and became known as Corita Kent) was best known for her pop-art posters blending scripture, advertising art, and poetry. Her most famous piece was the United States postal stamp declaring "love," under a rainbow of brush strokes.

The art assignments that stand out in my memory involved cutting up *Life*, *Look*, and *National Geographic* magazines. We created handmade books, murals, and posters by gluing the photos and words together to illustrate inspirational quotes. Taking design clues from medieval illuminated manuscripts as well as modern artists such as Ben Shahn, we embellished the hand-lettered words with drawing, painting, and rubber-stamped decorations. Quotations from the Bible or from e. e. cummings and other poets were woven into splashes of color and texture to create a fantasy world on paper. It was more like kindergarten than college. School became fun again! However, the most important thing I learned at Immaculate Heart was *how to dream and how to turn a vision into reality*.

The process I call Visioning was born when I was a college freshman and saw the work of designer Charles Eames. Famed for his high-tech Eames chairs, fanciful films, and interactive exhibits, Charles was a renaissance man in the tradition of Leonardo da Vinci. Architect, designer, filmmaker, and lover of science, Charles was blazing trails in all areas of design and his office was a mecca for creative talent searching for a home. I was determined to work at the Eames office after graduation. Competition to work there was fierce, but my heart was set on it. The two Sisters lent their full support to my dream (which cynics would

Eames Office, ©1999
www.eamesoffice.com

have dubbed "a pipe dream"). They believed in the power of the heart and they taught me about magic.

I had another thing going for me: a vivid imagination. On student field trips we visited both the Eames house and the office in Venice, California, so I had powerful mental pictures to work with. I kept imagining myself working in the office—a cavernous old automotive-garage-turned-design-studio in a rundown neighborhood. I roamed around the magical interior, which had been transformed into a creative wonderland. Mentally, I walked through the fluid work cubicles made of partitions C-clamped to wooden beams, marveling at the scale models and design sketches in progress. I even paused to play with mechanical toys and other amusements from the Eames personal collection. My imagination also took me to the small studio at the famous Eames house, a bold glass and steel design set in an untamed meadow overlooking the Pacific Ocean. My daydreaming paid off! By my junior year I was working part-time in the studio of the Eames house. Upon graduation, a full-time staff position was waiting for me at the office. Many of the principles of design applied to life that you will learn in this book were inspired by my experiences working for Charles and his wife, Ray.

I learned that the designer

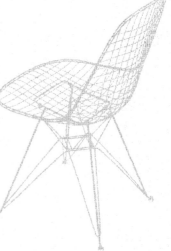

Eames Office, ©1999
www.eamesoffice.com

- gets a concept or idea or a problem

- feeds the idea with research and more input

- connects the research to his or her own concept, idea, or problem

- assembles the design elements

- mixes and matches in rough mock-up stage

- develops the design

- refines and finalizes the design

- starts the production process

- gets help with production

- gets and celebrates the final product

Later, you'll see how I have applied these ten steps of the design process for use in designing one's life.

My next mentor was inventor-philosopher-poet R. Buckminster Fuller, another renaissance man who called himself an "anticipatory design scientist." Bucky, as he was known, gifted the world with the geodesic dome, the self-contained dymaxion house, the "world map game" for getting resources where they were needed, and bringing McLuhan's term "global village" to life. We became friends during my post-Eames period when I had a second career as an early childhood education specialist. I was married to designer Peter Pearce, a fellow alumnus of the Eames office, who was editing Bucky's book on energetic-synergetic geometry. Bucky and I shared a love for the work of educator and designer Maria Montessori (whose method I had been trained in). While I was developing one of the first Head Start programs in Los Angeles and then began designing preschool toys for Mattel, Bucky extended his support and great wisdom. It was Bucky who taught me how to look deep beneath the surface of things and to find light in the darkest of times, as he had once done after the death of his first child. Bucky's example echoed in my heart after my divorce and subsequent career change to an art therapist and corporate consultant several years later. You will encounter some wisdom from Bucky Fuller later on and learn to apply it to your own life.

This journey through the roots of what I have come to call Visioning would not be complete without mention of Walt Disney. Although I never knew him personally, it was my privilege to be a consultant for ten years to the world-class team of talent that designs and builds the Disney theme parks, resorts, and retail stores. Some of the masters I

knew there had originally worked with Walt at the studio. They became my mentors. One of these was Herbert Ryman (or Herbie as he was known), who had been the art director on *Fantasia, Dumbo,* and *Pinocchio* before being recruited to work on the first Disneyland.

Some of the design principles used by the likes of Disney, Ryman, and my earlier design mentors form the foundation for what I call Visioning. This step-by-step approach enables you to learn and apply what every great designer knows. Now these secrets are yours to use in designing your own life. They rest on the fundamental belief that:

If you can dream it, you can do it.

VISIONING YOUR LIFE

Visioning is a process for creating the life you want. It is a method for finding the dream that lives in your heart and translating it into the world of three dimensions. Visioning can be described as practical dreaming. Walt Disney's vision of this complex process of designing and building a theme park became known as "imagineering." Blending whimsy, imagination, and art with the discipline and groundedness of engineering, Walt came up with a word that speaks volumes about how dreams become reality. Disney theme park designers are still called "imagineers." The story behind the creation of the first Disneyland is a wonderful example of wishes coming true. In this case, one man's dream eventually became the source of great pleasure to millions of people all over the world.

Walt was sitting around being bored while his children were playing in a kiddy carnival. I also suspect that he envied his children and wanted in on the fun. One day he started playing "what if" games in his head. "What if" there was a place where little kids and big kids and adults could go together and they could all have fun? What if there were

rides and amusements and other activities that the whole family could enjoy? For Walt Disney, "what if" always led to "why not?"

In the face of much criticism and pessimism, Walt persevered. He created a new form of entertainment that grew out of his own personal problem—boredom—and the theme park was born. He was also a master of feeling the pulse of the public. Long before the theme parks, his movies captured huge audiences of all ages with the simple message: "A dream is a wish your heart makes." Disneyland embodied that message in three dimensions. We all grew up on this philosophy. But it's more than corny kid stuff. More than a motto or slogan to sell entertainment. It's an ancient truth, the perennial wisdom. Isn't it time we started living it?

The Dream That You Wish Will Come True

Generations of children have been raised on a world view expressed in those early Disney classics: "the dream that you wish will come true." As youngsters we believed it. Then adulthood set in and we moved farther and farther away from everyday magic. The exceptions are artists and designers who keep the flame of dreams alive in their hearts and imaginations. What is more, they are willing to do whatever it takes to see those dreams come true. For it is the artists and designers who know a special secret: inner vision is just as real as the world we touch and smell and see with our five senses. They know how to travel between these two worlds. Through Visioning you will learn to do the same. Are you ready for the journey? Then join us in the time of your life.

Become a Visionary. Dare to find your true heart's desires and allow them to become a living reality. Apply the creative process in daily life by finding your inner vision, designing your own life, and letting it happen in the outer world. You'll do this through collage-making, journaling, and other activities for turning wishes into physical reality. No special talent or training in art is required. All you need is scissors and

glue (some paper, old magazines, and a journal) and the willingness to create the life you want.

Visioning is applied creativity. It offers a practical blueprint for using the creative process in daily life. Visioning follows the ten steps that any designer uses for turning desire into design and then into a final product. In this case, the "product" is your life, which, of course, is an ongoing process. Furthermore, Visioning takes into account the psychological stumbling blocks along the way and provides effective tools for working through them.

Yes, there will probably be some rough spots. When Walt Disney wanted to create the first Disneyland (and invent the "theme park") he was looked upon with suspicion by peers in the movie industry as well as finance. After all, they reasoned, he had already successfully pioneered the feature-length animated film. Why risk everything on some untested and possibly disastrous new enterprise? Why not just leave well enough alone? Those are the same kinds of voices (outside and inside your own head) that you'll have to contend with when venturing into the land of wishes and dreams. "Don't take risks. Who do you think you are? You're wasting your time on pipe dreams." Walt knew how to get past those obstacles and you will, too. You'll develop one of a designer's most important qualities: the ability to surmount the inevitable hurdles of fear, pessimism, self-doubt, and criticism. Visioning includes tools for surmounting such obstacles.

Getting Support

To counteract the internal as well as external critics, you'll also follow the principle of creating a support system. During the gestation of his theme park idea, Disney surrounded himself with a handpicked team of creative and supportive individuals from the film studio. They didn't have a clue what he was up to. One of the first on board was Herbie Ryman, master artist and art director from the Disney Studios. It was my

> "You're going to do it," said Walt Disney to Herbie Ryman when asked about his new amusement park idea. "No I'm not," Herbie said. "Will you do it if I stay here with you?" "Yes, I'll do it if you stay here."

privilege to have dined with Herbie and to have chatted with him on several occasions. Herbie applauded me for developing my technique of drawing and writing with the nondominant hand. So I consider him part of my own support system. But more on that later.

Over dinner one evening, Herbie told me about the time Walt called him in and shared some wild new idea about building an amusement park. Naturally, Herbie was curious and said he'd like to see it. There must be some drawings or models, he thought to himself. Walt's response was: "*You're* going to do it." Herbie refused. When Walt offered to stay with him in the room, Herbie agreed. "Would you believe it?" Herbie told me. "We did the first drawings of Disneyland in one weekend." These were the drawings that would be used to get financial support for Walt's dream.

I cannot overemphasize the importance of support, of surrounding yourself with your own personal cheering team. All the great designers I have known or worked with understood this principle. Although the Eames office has been enshrined in San Francisco's Museum of Modern Art with a life-size replica of Charles's conference room, it was not just the design esthetic of the place that made it so remarkable. The real secret was the cast of characters: the charismatic Charles and his wife and partner, Ray, and the highly creative and accomplished people that orbited around them. These two entrepreneurs had surrounded themselves with a dynamic team of designers, photographers, filmmakers, scientists, mathematicians, and researchers who had made names for themselves in their own areas of specialty: Talk about a support system! Not to mention the steady stream of supportive friends who visited the place on a regular basis: Bucky Fuller, Dr. Seuss, artist Saul Steinberg, director Billy Wilder, designer George Nelson, architect Eero Saarinen, and Tom Watson, Sr. of IBM, to name only a few. You'll learn to apply this same principle of support by rallying your own "dream team" as you proceed through the ten steps of Visioning.

Visioning shows you how to accept opportunity when it comes

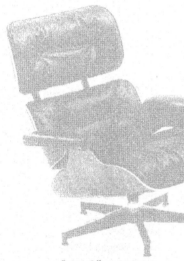

Eames Office, ©1999
www.eamesoffice.com

knocking and embrace results when they arrive. This requires courage (from *cor*, the Latin root for heart). I learned this from Corita and also from Eames, who lived by his motto: "Love what you are doing and never be afraid to follow where your next idea will lead." Charles followed his heart into a world of design opportunities that would have terrified a less courageous soul. His ideas spanned a universe of design applications: furniture and interiors, toys, photography, film, the first interactive exhibit, seven screen presentations, world's fair attractions, museum installations, and more.

Visioning applies these design principles by teaching you to follow your heart into the experiences that your imagination conjures. You can't know where it will take you in the long run. One thing leads to another. And the means for fulfilling one's dreams rarely follows a straight or predictable line. There will be fantastic surprises, twists, and turns that you couldn't have predicted in your wildest imaginings.

A good example of applied Visioning is the case of Greg, one of my students and dear friends. An enthusiastic young stockbroker, Greg wanted more abundance and travel in his life. Through collage and journaling he got in touch with the true significance of money: a tool for making dreams come true. He reconnected with a desire to visit India that dated back to his teenage years. By keeping his eyes on the prize (and on his Visioning collage), the means magically showed up. A friend who heard of his desire gave him a round-trip passage to India. He'd dreamed of India, but never dared to think he'd go for free. This was pure magic! At the same time Greg's business improved and he had the most profitable year of his career.

> The most important thing is that you love what you are doing, and the second that you are not afraid of where your next idea will lead.
>
> **CHARLES EAMES,**
> **Designer and filmmaker**

The Possession Of Wealth Does Not Exclude The Possession Of A Conscience.

Detail from Greg's collage
(story on page 234)

> I could never convince the financiers that Disneyland was feasible because dreams offer too little collateral. **WALT DISNEY**

Just because there are surprises ahead doesn't mean that you won't work at it. Working the Visioning process means cultivating the dream,

shaping and reshaping it until it's crystal clear, and staying with it to the end. All ten steps are necessary.

It wasn't enough for Walt to design Disneyland. His desire to expand storytelling into the 3-dimensional space of a theme park was only the first step. Clearly such an attraction was going to have a multimillion-dollar price tag. Disney had to bankroll it or his idea would never have been built. An ingenious financial solution had to be hatched simultaneously with the design. Moving away from the old bank financing system used by the film industry, Walt and his brother, Roy, who was the number cruncher of the dynamic duo, turned to the familiar television industry model of economic support: commercial sponsorship. They got big corporations to put up the money for restaurants, rides, and entertainment pavilions. Such creative solutions to mundane issues like money give life to the old sayings: "Where there's a will there's a way. Necessity is the mother of invention." You'll be putting these old maxims to the test when you embark on Visioning your own dreams.

Now you might be wondering: How does this all apply to me? I'm not an award-winning designer. I'm not a Walt Disney or a Charles Eames or anybody famous. I don't have any artistic talent. The fact is, you don't need a genius IQ or even an artist's eye to engage in Visioning and get great results. Scores of students and clients have contributed their success stories to this book. Each story demonstrates the principles outlined above. Each case study is the result of seemingly ordinary people achieving extraordinary things. Here are a few highlights.

Anna's dream ranch collage
(story on page 249)

A music teacher named Anna Visioned a wish she'd long held in her heart but had been too timid to embrace: living on a large ranch with houses, a barn, a tractor, and a truck. In a Visioning workshop she was encouraged to articulate her dream (which had been criticized by family members). Within weeks of beginning the Visioning process, Anna was living on her dream ranch.

Cathy and Steve, a married couple, both transformed their lives

through Visioning. Cathy found a job teaching in her ideal school and Steve changed careers entirely from management to design. What is more, Cathy's energy is recharged and Steve's health has improved dramatically since he left the old unsatisfying career that was literally killing him. You'll be reading more about them in chapter 11.

The couple and the collages
(story on page 202)

After her marriage ended, a heartbroken Lisa took the risk of finding love again. Through Visioning, in a few short months she had a wonderful new relationship with a man who resembled one she'd pictured in her collage. You can read more about how she did it in chapter 12.

Another woman, Susan, had struggled unsuccessfully for years with chronic health and weight problems. Through Visioning, she reshaped her self-image and the pounds melted away. Chronic physical conditions vanished and a new self-confidence emerged that spilled over into every area of her life. She began to believe in herself and embraced a life of dream-it-and-do-it. Her story appears in chapter 14.

Speaking from personal experience, I can say that Visioning works in all areas of life. I have:

- created the dream house I always wanted

- manifested travel to some of the most fabulous places in the world

- created loving relationships and professional support

- lost weight and reshaped my body

- healed from illness and returned to good health

- met career goals, like publishing this and many other books

- manifested creative projects, supportive clients, and students

- created greater prosperity

- designed the lifestyle of my dreams in the area I wanted to live

Visioning Takes You Where You Really Want to Go

In Visioning, the magic ingredient is the process. This is not merely a formula for accumulating *things*. We all know that happiness is not found in money or in stuff. If it were, all rich people would be happy. It's about life lived creatively, consciously designing the kinds of experiences you want. A commitment to Visioning leads to fulfilled wishes. And the best part is that the process itself is so much fun. Mark, an attorney, is Visioning a career change for himself. In sharing his process with me, he kept saying, "This is so much *fun*! Finding the photos and putting the collage together was a *blast*." He was already experiencing the bliss of his own creativity. What better way to prepare for dreams coming true than having fun on the way? For, after all, isn't joy and aliveness what we're really looking for? *Visioning can take you there.*

part

THE PROCESS

Following the

Pathways of the Heart

The Designer Within

1

THINKING WITH YOUR HEART

Visioning is purposeful daydreaming applied to everyday life. It is about thinking with your heart and allowing your true wishes to become reality. A Visionary's language is images and words from the heart. Deep within the heart we find the *creative self*. This creative self is home to the practical visionary within, our unlimited potential, our spiritual DNA, or life's purpose.

This creative self is our silent partner. It is always ready and willing to help us express our true desires in the world. The lover of books who spends hours browsing in bookstores, the amateur gardener who loses herself weeding and planting, the hiking enthusiast who can't seem to get enough of nature's beauty. These are ordinary people honoring the impulse of the creative self in daily life. For although it is our silent partner, it does have a voice. It speaks in images, in daydreams and night dreams. It sends messages through the body. Sometimes the creative self expresses through music, poetry, or art. It often comes through loud and clear in meditation and prayer.

> Everything in life responds to the song of the heart.
> **ERNEST HOLMES**

The *voice* of the creative self is our *creative conscience*. It keeps us on track when we:

- ignore or forget our heart's desires

- sell out to the demands of others

- shelve our dream in order to get someone's approval

- get stuck in a mindless and boring rut

Without the guidance of the creative conscience it's easy to get overworked, addicted, exhausted, or sick (or all of the above). When that happens you know your heart and soul are starving to death. Your creative conscience must resort to pain and discomfort to get your attention. The pain is there for a reason. You need to do something about it. Veer too far off the path of the heart and you get a pebble in your soul. Life hits you over the head with one of those *big* lessons: illness, an auto accident, bankruptcy, the relationship that ends painfully.

Some of life's catastrophes are preventable, some are not. Indulging in self-destructive behavior, like addictions or abusive relationships, can be reversed. But what about circumstances beyond your control? How can you predict that your company is going to downsize you out of a job? Or that an earthquake or flood will leave you homeless? Or that your spouse will die? Whether you are facing a crisis of your own making or one that was thrust upon you, Visioning works. Acquiring the habit of listening to your heart and giving voice to your creative conscience is a great survival strategy, enabling you to design and build the life you want with the pieces that life has given you.

WHAT IS DESIGN?

Visioning is rooted in the idea that *you can design your own life*, that it is within your power to:

- take charge of your own imagination

- become a purposeful dreamer

- design the life of your dreams

- Vision your dream into reality

Visioning begins by naming your heart's desire and translating it into pictures and words on paper. It is the same process designers, architects, and engineers use when they get an idea and create sketches, models, and blueprints. They know the alchemy of turning thoughts into things. There's nothing mysterious about it. It's the process known as design. And you can learn it, too, by designing from your heart's desires. In fact, in my dictionary, the word **desideratum** *immediately precedes* the words pertaining to design.

DESIDERATUM —something desired as essential or needed.

And the words *following* design are **desirable, desire,** and **desirous.**

Desire and **design.** Side by side in the dictionary. A perfect *verbal* road map for the adventure of designing your life. Knowing what you truly desire, you can create your life with intention and make it a work of art.

My favorite definitions for **design** from the dictionary are:

- to conceive and plan out in the mind
 in Visioning you'll do this through mental imagery

- to intend
 setting the intention is the first step in Visioning

(continued on next page)

(continued from previous page)

- to conceive and draw the plans for
 your collage is your plan or blueprint

- a particular purpose
 your heart's desire is your purpose

- an underlying scheme that governs functioning, developing, or unfolding
 that's Visioning

As a Visionary, you qualify as a **designer** according to the dictionary definition:

- one who creates plans for a project or structure
 the project is your life, the plan is your vision collage

Now let's explore the dictionary definitions of **desirable** and **desire** and see what they have to do with Visioning.

- a strong wish, longing
 Visioning helps you know and honor your wishes

- an expressed wish
 your collage and journaling are the expression of your strongest wish

- eagerly wishing
 the passion you feel will create a magnet for opportunity

The dictionary definitions of the word **vision** are also worth exploring.

- something seen otherwise than by ordinary sight
 this is the "wish your heart makes"

(continued on next page)

(continued from previous page)

- a vivid picture created by the imagination
 these are the mental images you'll portray in your collage

- the act or power of imagination
 you'll be developing this power through Visioning

- unusual wisdom in foreseeing what is going to happen
 collages have an uncanny way of showing you things before they happen, tapping into your innate intuition

THINKING IN PICTURES

Practical visionaries in any field often say that they think in pictures. Visual thinking is second nature for artists, designers, and architects who have developed this innate ability as part of their craft. Filmmakers and theme park designers create storyboards (cartoonlike panels telling the highlights of their story in captioned pictures). Successful executives, business entrepreneurs, scientists, writers, athletes, and just plain folks use mental imagery every day to "design in the mind" what they want to accomplish in the world. This has been true in the field of competitive sports for many years, in methods such as the inner game of tennis or golf.

Your Visioning collage will be a kind of storyboard or blueprint of the life you want to create. I say "kind of" because it won't be a linear, step-by-step representation of what's about to unfold. Rather it will serve as an intuitive impression, an all-at-a-glance preview of coming attractions coming from your intuitive creative self. And why is visual think-

ing and graphic representation through art so important for a Visionary? One reason is their suggestive power.

Visualization and other techniques for creating mental pictures are being used in the field of medicine. Patients of all ages and walks of life have been taught to use their imaginations for managing pain, dealing with life-threatening or chronic disease, and for losing weight. Carl and Stephanie Simonton blazed a trail many years ago in the field of healing by using mental imagery. Cancer patients are guided in mental Pac-Man games in which they visualize the cancer cells being gobbled up. Children are especially good at playing these imaginative healing games through visualizing battle scenes, Star Wars scenarios, cops and robbers chases, and so on. These techniques have been popularized by physicians like Martin Rossman and authors Shakti Gawain and Jean Achterberg. My Creative Journal, a method of visual diary-keeping, has been used in patient support groups with great success for many years.

What was once considered a highly esoteric pursuit—thinking things into reality—has now become quite common. The fact is, we all do it every day. You may think you don't know how to visualize, but stop and think for a minute. If I ask you to imagine a red apple, what do you do? By seeing with your mind's eye, you reproduce *a mental image* of a red apple, don't you? That's why we call it *imag*ination.

VISUAL IMAGERY: HOW IT WORKS

The human brain's right hemisphere contains the centers that govern visual-spatial perception and the ability to see in mental pictures. We use this ability every day, when we remember the route to work or visit a familiar restaurant or imagine a red apple (as you just did). Actually, we don't just see with our eyes. We see with our brains, too. In recent years a great deal of information has been gathered about the visual centers in

the brain through research in pathology and new imaging technology for scanning the brain. Observation of stroke victims and others who have suffered brain injury to the right hemisphere has contributed to our store of knowledge about how the human brain works. For instance, after suffering damage to the visual memory centers, patients cannot remember things and places they have seen many times before. This visual amnesia causes these patients to lose their way in previously familiar territory or impairs their ability to recognize people or objects they have known before.

For those who think they cannot visualize, who don't seem to see mental pictures or have a vivid imagination, here are some simple exercises you can do.

VISUALIZATION: THE MIND'S EYE

Visual Remembering

1. Sit quietly and relax for a few seconds. Then look around and find a simple object in your environment, something that is a basic geometric shape, like a circle, ball, or square. Perhaps it's a piece of fruit, a square table top, or a rectangular door or window frame. Look at the object for a couple of minutes, observing its shape, color, and texture. Then close your eyes and remember the object in your mind's eye. In your imagination see the shape, color, texture, and any other details you can recall.

2. Recall the last meal you had. Close your eyes and picture yourself there. Where were you? What did you eat? In your mind's eye picture the food on your plate: the colors, shapes, and textures.

3. Think of a favorite room in your home or office, one where you spend lots of time. Close your eyes and imagine that you are there. In your mind, look around. What colors, objects, and textures do you notice?

Creative Imagining

4. Now *imagine* a meal you'd *like* to eat. Just make it up. Where would you be and what would you eat? Picture the plate in your imagination. What food would be on that plate? See the shapes, colors, and textures of the items you've selected in your imagination.

5. Imagine a place you've never been before but have heard about or seen in pictures. Perhaps you take a mental trip to Hawaii or Italy or Japan or some other place you have never visited. Close your eyes and see what images come to mind when you think of that country or place.

6. Using your powers of visualization, invent a place in nature that you would like to be. Perhaps it's a country meadow, a lush tropical forest, a majestic mountaintop with a breathtaking view, or a beautiful beach at sunset. Use your imagination and picture it just the way you want it.

We don't often think of memory as imagination, but it is. Here's how the dictionary defines it.

IMAGINATION — the act or power of forming a mental image of something not present to the senses or not previously known or experienced.

If you can remember what was, you can imagine what could be. It's as simple as that. Your memory bank, chock full of visual images, enables you to invent or make up new realities. You have a giant research library right there in your own mind. From those images you can mix and match, creating anything your heart desires. What we usually think of as imagining is really *inventing*. Yet, when we remember anything, we are *imagining*, too. The difference is that with memory, there are no decisions to make. If you recall a blue vase you've seen, it is always going to be blue and it's always going to be the same shape. Nothing can change that fact. On the other hand, if you conjure a vase in your imagination — as an invention — you can make that vase any color, size, or shape

you wish. It's up to you to choose. In fact, you can make it anything you want.

Old joke that circulated around Walt Disney Imagineering:

How many Imagineers does it take to screw in a lightbulb?
Does it have to be a lightbulb?

> In Visioning, one goal is to *believe* that the life you imagine is possible, and that you can attract it to you in the material world.

DREAMING THE IMPOSSIBLE DREAM

> It's kind of fun to do the impossible. WALT DISNEY

What's been stopping you all these years from realizing your most outrageous and far-out dreams, the ones that gnaw away at your soul? Well, for one thing, your beliefs. If you believe that your dreams are impossible, then they will be. The movers and shakers who grab an idea and run with it believe in their vision. They also have the persistence to make it a reality, even when skeptics try to dis*courage* them from following the path of the heart.

Another thing that holds you back is inaction. Visionaries map out their dream, but they also swing into gear. Disney didn't just sit around talking about his idea of building an amusement park. He enlisted the aid of artist Herbie Ryman to translate it into drawings. Bucky Fuller felt that some action—any action—had to be taken right away. He created what I call Bucky's Law.

> What you actually do within twenty-four hours of having a creative idea will spell the difference between success and failure.
> **R. BUCKMINSTER FULLER,**
> **Inventor, designer, and philosopher**

CORITA'S IMPOSSIBLE ASSIGNMENTS

In the art classes at Immaculate Heart College, Corita was fond of giving us impossible drawing assignments. "Draw a hundred trees over the weekend," she'd say on Friday afternoon. That always elicited groans from the class. Many years after graduating I inquired as to why she asked the impossible. "To get you working," she answered with a sly smile. "If I'd said fifty, you would have done only twenty-five. As it was, students usually turned in thirty-five or so. But that was better than twenty-five. The more drawings you did, the better chance there was that maybe, just *maybe*, one or two of them would be pretty good."

Another important skill in the design process is brainstorming. This is the "sky's-the-limit" phase in the beginning when all things are possible and a critical frame of mind is a definite liability. Imagineers call this phase "blue sky." Anything goes, and there simply can be no mistakes or bad ideas. That's what used to happen in those hundred-trees-over-the-weekend assignments. You were drawing so fast and furiously you didn't have time to start picking things apart. You had to keep your eyes and your hand moving. You had to act! This freewheeling phase of the creative process is immensely liberating. In Visioning, looking for pictures and words and cutting them out is great fun.

BLOCK BUSTERS

Like anyone else engaged in the creative process, Visionaries face inner obstacles (such as self-doubt and procrastination) and outer deterrents (such as the criticism and skepticism of others). Fortunately, a Visionary's tool kit has powerful, time-tested techniques for dealing with both inner and outer barriers. There are steps aimed directly at creative blocks, which will be more likely to fall one by one, like dominoes.

An essential creative block buster is a strong support system. Vi-

sionaries seek encouragement from spouses, family, friends, or associ-
ates who believe in them. They also have an extended network of re-
sources, sponsors, and mentors. I learned this from my design mentors.
It was no accident that Charles and his wife, Ray, had a great team work-
ing with them and an extended group of supporters. Two of their dear
friends and mutual supporters were Bucky and Anne Fuller. Bucky did
the same thing Charles did: collected people all over the world who
shared his vision of a global village. He started right at home. His wife,
Anne, was one of the most supportive people I've ever known, and in
gratitude Bucky told me he named his Montreal dome "Anne's Taj Ma-
hal." Bucky's daughter and son-in-law, Bob and Allegra Snyder, pro-
vided immense support during the years when many thought he was a
madman. The first time I heard him speak to an audience of architects,
most of them walked out before his slide and film presentation was com-
pleted. They were shaking their heads and mumbling things like "crazy"
and "nuts." His family and us die-hard fans stuck it out, though. The
world eventually beat a path to his door and put him on the cover of
Time magazine. Later on, you'll read more about how to create and use
your own support system.

THOUGHTS BECOMING THINGS

One thing that all Visionaries have in common is that they practice
making "thoughts become things." They cultivate their creative ideas
like loving gardeners. And they have faith. They don't have to keep dig-
ging the seed up every five minutes to find out if the plant is growing.
They germinate ideas and trust the creative process.

In addition, Visionaries are committed to taking all the steps neces-
sary for giving birth to their creations. Their attitude is: whatever it takes.
Like Disney and Fuller, they face doubts, fears, rejection, disappoint-
ment, delays, and other obstacles that everyone faces in life. Yet, they

hold true to the creative idea, knowing that sooner or later it will take form in the physical world. Some gestation periods are longer than others. One idea may take twenty years to hatch, another may take twenty days. The creative thought is the thing. Nurture it, charge it with energy and enthusiasm, and the world will be drawn to it as to a magnet.

How Ideas Take Shape in the Physical World

We see thoughts taking shape in the world every minute. For example, I am sitting at my computer entering my ideas through a keyboard. Thoughts appear as words on the screen, and get printed out on paper. This is a common occurrence. In fact, as simple an act as drinking from a glass of water (as I just did between sentences) is nothing more than my thoughts taking shape in the physical world. I had a *desire* based on a body signal: thirst. I took an *action*: drinking from the glass. I changed my body (by satisfying my thirst) and changed the outside world (there's less water in the glass now). When I take a sip of water, I need the intention and the action.

Granted, writing a book is a more complex act than drinking a few sips of water, yet both acts come from the same place. We have an inner desire or wish and we act on it. Sound familiar? Sounds like the blended definitions of *desire* and *design* to me. In writing this book, I start with a design in the form of a table of contents. This serves as the foundation upon which I build the chapters. It is the container into which I feed my ideas.

As dissimilar as they may seem, both acts—drinking water and writing a book—have a common thread. My physical thirst is satisfied when I drink water. My creative thirst—a need to explore and communicate ideas and experiences—is met when I type words into my computer. I know what I want to achieve and I take the action to achieve it. The writer's creative thirst was probably best described by Henry Miller, who said: "I write to find out what I am writing about."

Here's an exercise you can do to explore the power of your own mental images.

VISUALIZATION: PICTURE THIS

Recall the last time you bought something. What was it? What motivated you to purchase the item? What need were you attempting to satisfy? How did you know what it was that you were looking for? Did you picture it in your mind? Write it down on a shopping list? Did you satisfy your need? If not, why? If you did, recall the moment when you knew you'd found the right item. How did you know? How did you feel?

Shopping is a very common, perhaps even mundane, activity. Everyone does it. Usually you start with an idea in your memory or imagination and then you shop around until you find an item that matches the picture in your mind. For instance, if you want clothes for a formal gathering you probably have ideas about size, color, fabric, and price. Those are your design specifications. You may have conjured something in your mind or seen a particular outfit in a magazine or catalog, in a store window, or on another person. When you shop you are practicing your ability to turn thoughts into things. Never mind that you didn't design or manufacture the product. You had a thought and, after the purchase, you have the thing.

WE'RE ALL DESIGNERS

From the last exercise it should be clear that we use design skills every day of our lives. When we have a strong desire and act on it, we are practicing the first steps of the design process. We all have dreams, wishes, and desires. The question for you to ask is: Do I take my dreams seriously? Do I take *myself* seriously as a person who dreams and deserves to have my dreams come true? And I don't just mean the little tiny

dreams—like finding the right apparel for a particular occasion. I'm talking *big* dreams here, like finding your dream house, discovering the right career, feeling better about your body, recharging your relationship, finding a partner or mate, creating more abundance in your life, and so on. I'm talking about finding your life purpose and staying on track. Why are you here on the planet? What unique gifts are you here to contribute? You know, the *big* stuff.

Everyone Has Designs in Mind

Let's face it, we're all designers. Any time we have a goal, we're working from a mental design. Let's go back to ordinary reality for a second and check out your own creativity quotient. Look at the activities you engage in most frequently. In order to cook a meal, put an outfit together, decorate a room, send an E-mail, solve a problem, or take a snapshot you have to have a goal. That's your designing mind at work.

VISUALIZATION: REFLECTING ON PAST SUCCESSES

When was the last time you created something original or solved a problem? Picture it in your mind. Was it a special meal? An important memo? A ceramic pot? An article of clothing? A garden? A proposal? A party? An original way to fix something that was broken? How did you get the idea to make what you created? What need were you trying to satisfy or problem were you attempting to solve? Did you accomplish what you set out to do? If not, why?

THE FEAR OF ART

Speaking of creating something, let's talk about one of the barriers that could come up as you embark upon the process of Visioning your life. It's the fear of art. When you take the risk and make something that can

be seen and touched (in this case a photo collage), fear usually comes up. Or more precisely, *the fear of making a mistake.* Why? Well, you tell me. Everyone has their own reasons for not wanting to make a mistake. We each had our own critics as we were growing up: Mom or Dad, Aunt Harriet, the third grade teacher, or whoever it was that put you down and managed to stick a pin in the balloon of your childhood wishes and ambitions.

As we get older, those outer voices become our own internalized put-downs. Negative self-talk becomes so pervasive and so treacherous that we don't even know it has a hold on us. We can tell by the symptoms, though: frustration, depression, boredom, hopelessness, resignation, and so on. It may even show up in physical conditions like low energy, chronic illness, accident proneness, or addictions. The creative self does not want to be denied. It takes a great deal of energy and effort to keep it underground. And it's the critical voice within our own heads that shoots down the healthy impulses from the creative self, from the heart. If the critic within is stronger, the creative conscience will have difficulty getting through. And, remember, the Visioning process is all about listening to your creative conscience.

The critical self usually wants to keep control over our lives and it does this by throwing all kinds of smoke screens up. It says things like:

- You don't have any artistic talent.

- Whatever you make will be ugly.

- Don't waste paper and glue on making stupid-looking art.

- Collage-making is frivolous; you've got more important things to do.

- You'll get your hands all dirty and make a mess.

- How can making pictures and journaling change your life? How dumb!

Sounds like a prissy schoolteacher or critical parent, doesn't it? Well, guess where we heard all that stuff that plays on in the back of our minds like Muzak? It's all learned. More accurately, it's a hypnotic trance and we need to break the spell. For fear of art is fear of life. It is fear of the unknown, of mystery, of magic. It is fear of our own God-given creative power and limitless potential. Fear of art is fear of our creative self that is made in the image and likeness of God. So you folks who are on a spiritual path, bite your tongue when you hear yourself saying, "I have no talent. I'm not creative." That's blasphemy.

Art-Making, Your Natural Birthright

The fact is that art-making in any medium (be it song, dance, photography, or any other form of expression) is a natural ability that all humans are born with. Humans have known from time immemorial that the arts speak for the heart better than any language. Whether one becomes a professional in the arts or not is another matter entirely. We simply need to use the arts for accessing the creative self.

> Life is a work of art, designed by the one who lives it.
> Message found in a Dove candy wrapper

With the exception of artists, anthropologists, art historians, and art therapists, most people are not taught visual or artistic literacy. Neither do they fully understand the language of symbols or the power in images (except for media specialists who use it to manipulate and influence). Most adults feel incapable of being "artistic." In working with more than 30,000 clients and students and corresponding with hundreds of readers, I have observed that most adults are terrified of making art of any kind. The most common phrases I hear are "I don't have any artistic talent," "I can't draw a straight line," or "I'll make something ugly."

One of the other great Imagineers and a cherished mentor of mine has been Marty Sklar. Originally a writer, Marty rose to become the leader and nurturer of creative talent in his division. I have rarely known anyone who understands and cares for creativity the way Marty does.

And few people have as much respect for people engaged in the creative process. Marty shepherded his team through the company's most tumultuous days and through its greatest growth. This humble yet highly creative executive knows well that fear is only one way of approaching art-making and design. The other way is possibility thinking.

Anxiety in the face of a blank paper is usually fear of making mistakes. It is also fear of our unlimited potential. What if we are more than we thought we were? What then? How would our lives change?

Yet that fear usually melts in the face of photo collage-making. The great advantage of this medium is that anyone can do it. People are not afraid of this activity because they are not being asked to draw, be artistic, or make Art. Selecting from ready-made images that are chosen for personal meaning is far from intimidating. It's more like shopping than making art. Since it takes no special talent, training, or skill in the arts to cut and paste, the collage medium bypasses people's resistance and fear of making a mistake or creating something that will look dumb or ugly.

> There are two ways to look at a blank sheet of paper. You can look at it as the most frightening thing in the world or as the greatest opportunity in the world, because nobody's put anything on it. That's the way we look at it around here. You can dream, create new things, let your imagination go.
>
> **MARTY SKLAR,**
> **President, Walt Disney**
> **Imagineering**

There can be no mistakes, because artistic technique is not the goal. Personal Visioning is.

Everyone has dreams that have come true, no matter how small or grand they may seem. In this journal activity, you can explore the dreams you've had that actually became a reality.

VISUALIZATION: DREAMS THAT CAME TRUE

Think back to a time in your life when you had a strong wish or dream that actually came true. What was your wish? Picture it in your mind. What need were you attempting to satisfy? What did you do to make your dream come true? What obsta-

cles did you face? What strengths or skills did you develop? How do you feel about
it now?

VISIONING: HOW IT WORKS

Visioning is applied creativity. It offers a practical blueprint for using the
creative process in daily life. Visioning follows the ten steps that any de-
signer uses (as discussed in the introduction) for turning desire into de-
sign and then into a final product. I call these the Principles of Design
and have linked them to the ten steps of Visioning.

TEN PRINCIPLES OF DESIGN

- Get an idea

- Feed your idea with research

- Connect the research to your own idea

- Assemble the design elements

- Mix and match in rough mock-up stage

- Develop the design

- Refine and finalize the design

- Start the production process

- Get help with production

- Complete and celebrate the final product

In this case the "product" is your life, which, of course, is an on-
going process. Design is an inner and outer process.

THE TEN STEPS OF VISIONING

Step 1: *Make a Wish*

The Visionary begins by deciding to explore new possibilities in some area of life, choosing a theme on which to focus. This is like the designer's first step of getting an idea. This first step of Visioning poses the question: What do I want? What is my true heart's desire? It might be: "A new career direction," or "Finding a place to live," or "Finding a mate," or "Making more money," or "Getting healthier," or "Making a film." Some Visionaries choose a broader playing field, such as, "A projection of the year ahead, " or "What areas of my life need attention?" or "What does a balance between professional and personal life look like?" Other Visionaries want to resolve a specific problem or situation and do a "before" and "after" collage titled "How it looks now" and "How I'd like it to look."

Step 2: *Search for Images and Words*

This is the designer's research phase. The task here is to gather pictures, captions, and phrases from magazines, newspapers, catalogs, or other visual sources. One's personal collection of snapshots, postcards, or greeting cards can also be used. In this phase, the Visionary is tearing and cutting, amassing a heart's-desire image bank. The emphasis is on what experience she wants to create in her life rather than simply picturing stuff to be acquired. It is a way of exploring quality of life, living by choice instead of default. The only rule during the research phase is to collect photos and phrases that depict one's deepest wishes. *The mantra is: Grab what grabs you.* Dreaming is in, practicality is out. This is about going for it, the sky's the limit. This is a time to be inclusive and expand one's horizons, keeping an open mind while gathering as many relevant images and words as possible. If other great pictures surface that are unrelated to the theme, they are set aside in a separate file to be used in other collages.

Step 3: *Focus on the Vision*

In the design process, this is when research is connected more specifically to the designer's idea or problem to be solved. Here the Visionary sorts through the mass of torn or cut-out raw material that has been gathered. The question is asked of each image, word, or phrase: Does this express my innermost wishes, my fondest dreams? If it relates to the theme, it's in. If not, it's out or put in the "save" file for possible use in the future. This phase is about discrimination, selectivity, choice-making, but always from the heart.

Step 4: *Compose the Design*

Visioning collage-making is a new language, a language of symbols and images, of color and words blended together to form a unique montage of creative possibilities. Like any designer assembling the elements of a design, the Visionary starts building the visible expression of her dream by putting the pieces together, almost as if assembling a jigsaw puzzle. Laying the pictures out on the art paper, she tentatively arranges them in relationships to each other. Mixing and matching, she tries ideas out for size and placement, using a sixth sense about how to accurately portray the dream. There is no right way to do it, only the particular Visionary's way. This is the time to be completely authentic and original, true to oneself and one's vision. It is at this point that a great deal of inner doubt often arises, leading us to the next step.

Step 5: *Explore and Find Order in Creative Chaos*

Chaos is a natural part of any creative or design process. If it doesn't happen, it usually means that nothing new is being learned, nothing original is being created. This step isn't one that is done consciously or by choice. Something within the Visionary just starts questioning the

whole enterprise. For designers, this often occurs during the mix-and-match phase when mock-ups are being created. For the Visionary, it's getting closer to the time when pictures will be glued down, a commitment will be made, the collage will be made permanent. The self-talk usually starts with questions like, "Why am I doing this?" Or statements like, "I don't know how to do this" (as if there were a set way such collages should look, which there isn't). Perhaps an inner art critic starts in: "This is ugly and stupid. People will really laugh when they see this stuff." Worse yet is the voice that says the entire activity is a waste of time. "This wish will never come true. This is all just pie-in-the-sky dreaming. You're doomed to disappointment." This phase holds the biggest challenge but also the greatest learning. It is where the leap forward takes place and where the Visionary is tested for faith in the dream and courage to express it. This is the time for perseverance in the face of self-doubt. The warring factions in the mind are dealt with through journal work.

Step 6: *Create the Collage*

After the mock-up stage, a designer must develop his design with an eye toward the end product. In Visioning, this is the step of integration, of putting all the pieces together on the paper to create a Vision collage. Gradually, the images and words that speak for the dream are being committed to paper and glued down for good. It is an experience of surrender to some inner knowing, to the creative self (which has a vision) and to the creative conscience (which speaks from the heart). By combining photos and phrases in new ways, new connections are made and personal meaning is revealed.

Step 7: *Articulate the Vision*

As visual as the design process is, eventually the designer must translate his design and communicate it in words to others. Drawings, blueprints,

diagrams must be explained to production specialists, manufacturers, and builders. In Visioning, it isn't quite enough to simply make a collage. It is also important to reflect upon it in words. This is not so much analysis as it is the act of gaining deeper insight. Looking at these picture/word collages after they are completed is like reading poetry or deciphering symbols. We see all kinds of things we didn't notice while we were in the heat of creative chaos. The first part of articulation is to quietly sit and contemplate the collage. What does it say? What surprises does it hold? What is the resistance, if any, to taking this Vision collage seriously and believing that it will come true? One question to be avoided is, "How am I going to make this dream happen?" Visionaries are asked to relax and surrender to a higher order of creativity and *allow* the dream to materialize rather than to force it. Anxiety and fear only block energy. Following this guided contemplation, journal-writing activities are used for more deeply exploring meaning in the pictures and phrases. As the visual right brain has its say (in art) and the verbal left brain gets to talk (through the written word), both hemispheres of the brain are activated and integrated.

Step 8: *Reinforce the Dream*

It is now time for the production process. Since it is the creative self who works the magic and makes the dream a reality, the Visionary's task is to turn the design over to this higher power within. The artwork that results from collage-making is a visual affirmation. As with verbal affirmations, which are positive self-talk messages, the Vision collage establishes and reinforces a desired goal or experience. The Visionary exercises her visual right brain (which sees in pictures) by using the visual affirmations on a daily basis. By looking at the collage repeatedly, the images are reinforced in the imagination and memory. Practicing the art and science of building wishes and dreams in the world of physical reality develops "practical imagination."

The clearer the collage image, the more receptive we can be when it shows up in real life. The very concreteness of the photo collage makes it the perfect vehicle for reinforcing—through the eyes—the inner vision of the heart. We take it out of the realm of imagination and bring it down to earth. Before long, as if by magic, the Visionary's dream appears in three dimensions. There may still be some final hurdles, however, and that's where we enter the next step.

Step 9: *Embrace the Reality*

In order to make their designs a reality, designers get help. After sharpening their own skills, they enlist the support and expertise of others. Step 9 is both an internal process of enhanced perception and an external one of working with others. First, it involves the ability to recognize the embodiment of one's desire when it comes along. Fortunately, the specific and realistic nature of the photo collage makes this easy. The guesswork has been removed. The collage and the physical reality look and feel the same. There may even be captions that are specific. However, it is not unusual for resistance to arise at this point. We start questioning: "Can I afford it ? Do I have time for it? Does my life situation permit me to have this? Do I deserve it? Will it really happen? Will I get it and then lose it? Will I be disappointed in the long run?" More journal work, the gathering of a support system, experts, or mentors who can provide coaching are all encouraged. Once we say, "Yes, this is it, and I'm going for it!" the decision to embrace the reality is made. We reach out to others for help, and then simply live out the actions that take us to our destination: the dream come true.

Step 10: *Celebrate the Dream Come True*

Architects, designers, artists, authors, theater companies, filmmakers, and so on announce the unveiling of their dream-come-true with re-

ceptions, grand openings, book signings, and other kinds of festivities. Celebrations are just as important for the Visionary. This step may seem obvious, but it can't be overemphasized. Acknowledging ourselves for a job well done builds self-confidence. When we celebrate we also express gratitude to others, starting with a prayer or other ritual of thanksgiving to God, the creative self, or whatever higher power the Visionary recognizes. It is also a time to thank all the members of one's personal support team as well. The process has been brought to completion, the traveler has reached her destination. It's time to party!

TECHNIQUES USED IN VISIONING

The practice of Visioning includes several techniques. They are all designed to get you into the creative areas of your right brain and to integrate both hemispheres. This is how you carry your inner vision out into the everyday world of schedules, deadlines, contracts, and communication with others. These techniques include meditation, focus, visual research, collage-making, visualization, poetic wordplay, and journaling.

MEDITATION—Assists you in listening to the creative self. Sitting quietly in a relaxed state invites the heart to speak its truth.

FOCUS—Helps you get clear about your intention and your dream. It is a form of purposeful contemplation on certain questions or themes.

VISUAL RESEARCH—Starts you thinking visually as you browse through magazines and picture collections for images of your heart's desire.

(continued on next page)

(continued from previous page)

COLLAGE-MAKING — Helps you create a wish map in the form of a poster, book, mural, etc., puts the dream into a tangible form, and provides the visual affirmation for reinforcing it.

VISUALIZATION — Fosters your ability to think in pictures, develop your imagination, and reinforce your dream.

POETIC WORDPLAY — Introduces a right brain approach to language, develops strong intuitive powers and thinking "outside the box."

CREATIVE JOURNALING — Brings the dream all together in words and pictures, enabling you to work through obstacles, give voice to your vision, and celebrate its fulfillment.

The techniques used in the Creative Journal method include drawing as well as writing, using both the dominant and nondominant hand. Since you may not be familiar with these techniques and how they work, let me explain them briefly here.

Two Brains, Two Hands

One of the most powerful methods for listening to the words of the creative conscience is writing with the nondominant hand. Since discovering this technique many years ago, I've taught it to thousands of people worldwide. Invariably the response is the same, whether it's a middle-aged European woman, an American teenager, an Asian banker, or an Aboriginal artist. Through the nondominant hand, the crystal-clear voice of truth speaks. Sometimes it sounds like a playful or emotional child. At other

(continued on next page)

(continued from previous page)

times it is an artist brimming with creative ideas. Or it speaks words of ancient wisdom that sound like holy scripture. There is a sacredness and profound liveliness in these words from the uneducated and previously illiterate hand that has never been allowed to write. It is truly awesome and adds a dimension to Visioning that can hardly be fathomed. For more about my research and applications of this technique, you can read my earlier book, *The Power of Your Other Hand.*

Doodling with Both Hands

As mentioned in the introduction, Herbie Ryman had (unbeknownst to me) already discovered the power of the nondominant hand for opening up artistic freedom in the drawing and painting classes he taught at Disney. In his role as mentor to many young artists, Herbie experienced great success with this technique. Herbie knew what Corita, Eames, Fuller, and Disney knew. The wellspring of creativity is the spirit of the child.

Just as dancers warm up at the barre and musicians tune their instruments, I suggest that Visionaries get in the creative groove by drawing and writing with both hands. Here's a little limbering-up activity to exercise both sides of your brain. *It's also a wonderful way to allow the child in you to play.*

The truly great artist has the eyes of a child and the vision of a sage.
PABLO CASALS

JOURNAL:

WARMING UP—DANCING ON PAPER

Find a piece of paper and two pens or pencils. Try scribbling with your dominant hand for a while. Just get into being a kid and having fun with colors

(continued on next page)

(continued from previous page)

and line and movement on the page. That's right. Plunge right in and be messy on the paper. If your inner critic starts bugging you, just ask him (or her) to take a coffee break.

Now, change hands. Let your "other hand" scribble for awhile. When you start drawing with your "other hand" you'll probably feel like a little kid again. Great! That's the whole idea.

Now take your pens or pencils and draw with both hands at the same time. Scribble and doodle to your heart's content. See what happens. Do your hands want to draw the same lines, or a mirror image, or are they doing totally different things on the page? Relax, have fun.

If you want to really enjoy this, try putting on your favorite music and drawing to the rhythms. In my workshops, I often use the audio tapes of movement teacher Gabrielle Roth, author of *Sweat Your Prayers*. Whatever music you use, have fun with this. That's why I call it *dancing on paper*.

WHY VISIONING WORKS

We know from the work of C. G. Jung, Joseph Campbell, and countless others that the unconscious mind, feelings, intuitions, wishes, and dreams speak most truthfully in the language of images and symbols. This is the domain of the right brain, which specializes in visual-spatial perception, metaphoric thinking, emotional expression, and intuitive knowing. It is the realm of dreams and the arts. By first approaching our deepest feelings and wishes through right-brain visual imagery in pictures, we gain direct access to the unvarnished truth of our heart's true desires. Then we verbalize our insights and our creative process.

Designers know that to move from the realm of imagination into the material world, an idea must first be explored in tangible form:

thumbnail sketch, diagram, mock-up, or blueprint. In Visioning, making a collage is the first action taken in the material world, where life is lived and where dreams come true. Dreams are translated into visible, tangible form. Looking at the collages repeatedly after they are completed burns the image into the brain and the memory.

PICTURES AND WORDS

Visioning is a whole-brain approach. It uses both hemispheres of the brain: the visual, nonverbal right side (through collage-making) and the verbal left side (through captions and phrases, as well as journal-writing). Writing with the nondominant hand integrates both hemispheres because it uses words (from the language centers of the left brain), but draws its content and tone from the emotional and intuitive right brain. The nondominant hand writes from the heart, from wholeness, from the creative conscience. The verbal component of Visioning is important since it is the bridge to telling others about your dream.

As a Visionary *you are a person with dreams and desires*. In manifesting your dreams, inevitably you will have to relate to other people. And most of your relating happens through words, whether by E-mail, fax, snail mail, or in face-to-face conversations. Words are the currency of your communication. You need to use them well. Speaking from the heart—in your collages and journals—is great practice for speaking to others about your dream.

Are you ready to find your dream and turn it into reality? Come on, let's go for it!

> The future belongs to those who believe in the beauty of their dreams.
> **ELEANOR ROOSEVELT**

The Field of Dreams

PREPARING THE INNER
AND OUTER SPACE

All artists—regardless of their medium—engage in preparation rituals for entering the door of creativity. Musicians tune up their instruments, dancers warm up their bodies, painters get their materials ready. Preparation rituals not only get the artist ready physically; they also declare her intention to do the work. The same is true for Visionaries. In this chapter you'll prepare by making time in your life for Visioning, gathering the materials, and finding and setting up the physical space. I call this *creating the field of dreams.*

> At the still point, in the center of the circle, one can see the infinite in all things. **CHUANG TZU**

In addition to setting the stage for Visioning, you'll also learn about the psychological preparation for your creative work. Taking your inner being into account, you'll learn how to quiet your body and mind, focus your attention, and heighten your sensory awareness. This encourages your creative self to emerge. Inner preparation is just as necessary to the creative process as organizing your physical work space. This chapter is about both: the outer place and inner space conducive to creating. We'll start with the externals.

Make the Time

In order to get the benefits from Visioning, you'll need a chunk of time that is free from interruptions. Without time for yourself, all the supplies and best intentions in the world will add up to nothing. This is *your* time, so honor it and your creative self. The amount of time you devote depends on what aspect of Visioning you are working on. For instance, to do your Vision collage, you'll need at least a couple of hours, although some people become so engrossed that they spend three, four, or more hours at this task. Journaling usually takes a half hour or more.

To assure that you reserve time, I recommend putting the word Visioning on your calendar. Make an appointment with yourself, just the way you do with others. Then make sure you keep your commitment. Jan, a Visionary friend of mine, said that just carving out a day each month to engage in this work was one of the greatest benefits. She said, "My schedule is always loaded with 'doing for others.' Valuing *myself* enough to devote extended periods of time *just for me* was amazing. Best of all, I realized that I deserve it. And I am getting incredible results."

If you have young children or other family members around who may distract you, consider doing this work at night when they're asleep or when they are out of the house. Annie, the mother of two toddlers, arranged a baby-sitting trade with another young mom in the neighborhood. On her "free day," while her neighbor cared for the children, Annie created a work space in her kitchen and engaged in Visioning for several hours at a time. She said she always felt recharged after these Visioning sessions and had more energy to be with her kids.

If the needs of others are going to interfere with concentrating on your Visioning project, it will be an uphill battle. You may have to negotiate with others, rearrange your schedule or your space. It will be worth it. Karl, the father of three teenage sons, found that when the boys and their friends were around the house he had difficulty focusing on

his Visioning work. He turned a little-used guest room over the garage into his personal studio and put a "do not disturb sign" on the door. It worked. Karl Visioned his way into a new company of his own after being downsized by his employer of fifteen years.

You can do Visioning at home on your own, or join or form a group that meets for this purpose on a regular basis. One group I know uses the rec room in one member's condo. Another group rented a room in their local parks and recreation center. And a third group met in their church hall.

Gather the Tools

Before you begin the Visioning process, you'll need some basic materials. As time goes on, you'll amass a delightful collection of resources, but for now a starter kit is all you need. You probably have most of this already lying around the house.

SUPPLIES

- scissors

- glue (choose one from suggestions below)

 - white liquid glue, such as Borden's or Lepage's

 - glue stick

 - roll-on liquid glue

 - Liquitex acrylic matte medium or matte varnish (satin finish), and bristle brush for applying it

(continued on next page)

(continued from previous page)

- any adhesive of your choice for gluing paper down (avoid rubber cement, which peels off after time and discolors pictures)

- (optional) photo mount squares for pictures you do not wish to glue down permanently (available in camera and stationery stores)

- **art paper or poster board (18 x 24 inches or larger)**

 White drawing paper, inexpensive watercolor paper, or poster board in any color. Pads of drawing and watercolor paper are also available in art supply stores in these large sizes.

- **magazines with lots of pictures in them**

 In addition to your own collection, check with your neighbors and your doctor's or dentist's office for old magazines about to be discarded.

 Life, National Geographic, Smithsonian, fashion mags, travel and sports magazines are especially good sources of photo materials, as are illustrated magazines that specialize in topics you are particularly interested in.

 You can also use brochures or other promotional literature containing good photos to cut up. Check your wastebasket; use that junk mail! Some of it has great photos and captions. Start a collection of greeting cards, postcards, and other picture materials suitable for collages, including snapshots or other photos from your personal collection; make photocopies if you don't want to glue the originals down.

(continued on next page)

(continued from previous page)

- **notebook to be used as a Creative Journal (8 x 12 inches or larger)**

 This can be a hard-bound blank book with unlined white pages, a spiral-bound artist's sketch pad, or a three-ring folder with unlined white paper

- **set of felt-tip pens, 12 or more colors (points suitable for writing or drawing)**

Setting Up Your "Creativity Gym"

Your "creativity gym" can be any work space that you choose for doing Visioning. It's a place to exercise your imagination and vision. Think of this as a studio for heart yoga or soul aerobics. You don't need a room or even a corner that's used exclusively for this purpose. Of course, if you want to dedicate a particular area to Visioning, great! However, that's not always possible or practical. The fact is that almost all the Visionaries I know adapt a space that is already used for other things: their den, workshop, home office, garage, kitchen, or dining room.

My first "studio" was the kitchen of our small two bedroom bungalow. When we moved to bigger quarters and had a second child, I set up a desk and work space at one end of our family room. In our next home, my designer husband and I turned our third bedroom into a shared studio. Later, when I needed a quiet place to write, an alcove in our large master bedroom became my mini-office. Our fourth home already had a beautiful separate studio space.

I'm telling you this story because I don't want you to use the excuse, "I have no room to do this work." If you've got a table in your kitchen (dining room, den, family room, or wherever), you've got the makings of

a portable studio or, what I call a "creativity gym." You can also use folding tables and chairs to create a work space where none existed before. This work isn't so messy that you can't use living spaces to do it in. If you feel you need to protect your work surface, a house painter's plastic drop cloth will do just fine. So when you're ready to take the plunge, here's what to do.

Prepare the Space

Once you've gathered up all your materials and decided upon a physical location for your Visioning work, you are ready to set up your portable studio. But don't rush into it. You're going to start by consulting with yourself about what is right for you. In this way, you'll be practicing the art of inner listening. Take your time and feel your way into your field of dreams. Here's what you'll need:

> **a big table surface:** A comfortable work surface is about twice the size of your art paper. It's okay if yours is larger than that, but any smaller and it can get cluttered and feel cramped. So if you're using 18 x 24 inch paper, your table might be approximately 24 x 36 inches (or larger, if possible). The space surrounding your paper or board must accommodate your supplies: magazines, glue, scissors, and a space to pile the clippings. If you don't have a table large enough, consider finding another one, such as a collapsible card table or TV tray for your art supplies and magazines. One woman has her kitchen table close enough to the counter, which serves as her supply area when she's doing collages.

> **a trash basket for scraps**

> optional: a plastic tarp to cover your work surface, if needed.

As you start laying out your paper and supplies, ask yourself:

- Where do I want to sit or stand in relation to the light source?

- Where do I want my art supplies? My magazines and photos?

- Where will I place my art paper and actually create my collage?

- Do I have a trash basket or bag handy for throwing out clippings?

This is a very intuitive process. There are no objective standards of placement. Each room is different, each person is different, and each day is different. Interior designers, architects, exhibition planners, and theme park designers have developed this ability, but we all have it. I have observed that people have an innate instinct about how to place themselves in space and in relation to other things. We simply don't get any practice in doing this consciously or with awareness.

Interestingly, the subject of spatial use is gaining popularity through the ancient Chinese art and science of Feng Shui (which addresses placement and energy movement in space). Yet you don't need to know Feng Shui or become an architect or interior designer in order to develop spatial awareness. You can practice it in your everyday life.

Next time you're in a restaurant or engaged in a particular activity at work or at home take the time to ask: Where do I feel most comfortable in this particular space? Is this the right place for me to stand or sit given the purpose of my activity? Would I feel more comfortable with a different arrangement? It's just another way to practice listening to your heart.

Examine the spaces in your own home or office. Do you have places in your home that feel right for reading, but not writing? Meditating but not negotiating a business contract? Dining, but not talking on the phone? Sleeping but not reading business mail? Remember the old phrase "He got up on the wrong side of the bed this morning?"

There's a lot of truth in that. We can learn to feel our way into a place, just as we feel our way into a relationship or a job. In doing so, we listen to our creative self and exercise our creative conscience. Preparing the space for Visioning is really about making a temple to the spirit of creativity, even if you only inhabit this space for a couple of hours. Approaching your creative self is a sacred undertaking; do it with respect and love.

Find the sacred in the ordinary; make what is common holy.

Talismans, Totems, and Good Luck Charms

If the spiritual aspect of this journey to your creative self attracts you, it might be worthwhile including some kind of power object in your work space: a statue that has personal significance for you, something from nature, a favorite object, a picture of a loved one. Talismans have been used for consecration and initiation into sacred mysteries for eons. Today we'd call them good luck charms. Some Visionaries use a photo of themselves from early childhood when their creativity and sense of wonder and joy were still intact.

Totems are another form of power symbols, which have been used traditionally for protection and to declare family or tribal identity. Today we have corporate identity logos. You could create or find an object that signifies your creative self. Here are some examples of talismans and totems that have been used by Visionaries.

- A rose (symbol of unfolding, of love, and of the soul)

- A chambered nautilus shell with the words from the poem by the same name ("Build thee statelier mansions, O my soul"). The organism that inhabits these shells creates increasingly larger chambers as it grows, until it finally leaves the last chamber.

- A photo of the self as a cherubic two-year-old (emblem of the inner self)

- A photo of a favorite artist or designer

- A statue of the Indian goddess Lakshmi, goddess of divine abundance, or Saraswati, goddess of culture, the arts, wisdom

- A postcard of a favorite place in nature (signifying divine creativity)

- An Indian ceramic pot filled with cornmeal (symbol of abundance)

Preparation: Setting the Stage, Creating a Studio

Set up your studio by first establishing the actual area on your table or work surface. This is the clear space where you will do your collage, where the cutting and pasting will eventually happen. Arrange your art supplies, magazines, and other picture materials nearby so that they are conveniently located but don't clutter up your work area. Have a waste-basket handy. Check your supplies. Do you have:

- paper on which to create your collage

- scissors

- glue

- magazines and collection of photos and picture materials

- journal

- colored felt pens

- trash basket

- talisman or totem

- any other optional materials, like drawing or painting supplies, other collage materials, such as items from nature, colored paper, stickers, rubber stamps, etc.

- optional: CDs or tapes of your favorite music if you have a sound system available in your space; be sure some of it is soothing and relaxing music

Don't rush this procedure. Make sure you feel comfortable with the setup. Start practicing your ability to turn thoughts into things, to wish and have it be so. This space is yours. Make it the way you want it.

Prepare Your Inner Space

Reaching a place of inner silence that naturally leads into purposeful activity is an important preparation for Visioning. As my movement teacher says: "Find the stillness within movement, and the movement within stillness." It is easier to do this when you are working alone. However, alone or with others, there will be your own chattering mind, the extraneous and irrelevant thoughts that distract you from truly experiencing with your senses. Here is an exercise for centering in the present moment and "being here now."

FOCUS: CREATING THE CONTAINER

Sit quietly in your studio space. Seated at your work area, look at your arrangement of materials and supplies. How do you feel being here? How does it feel to be setting out on this inner journey to find and realize your dreams? Spend a moment reflecting on your physical sensations. Do you feel anxious or tense? If so, allow yourself to breath the anxiety out of your body. On the exhale, simply let it go. Remember that there is no way you can possibly make any mistakes in Visioning. There is no right or wrong way to do any of this work.

Check out your work area. Are you completely satisfied with where it is and

how you set things up? If not, take the necessary time to adjust things the way you want them. You don't need any rational explanation for this. Just follow your instincts and intuition.

Now focus your attention on the work area or playing field. This is the magic circle of creativity where you will actually be making your Visioning collage. Place your hands in the space. Run the palms of your hands over the paper, tracing the outline of your paper with your fingertips. Contemplate the Australian Aboriginal practice of each artist painting her own "dreaming" or element of nature and thereby co-creating that element. Be willing to co-create, in partnership with your creative self, the life that your heart truly desires.

Close your eyes and focus your attention within. As you sit in silence and stillness, allow yourself to become aware of your creative self, that fount of limitless potential that lives inside of you. See that you are becoming the *conscious* container of your creative self. Ask your creative self to be your silent partner, flowing through you. Ask it to show its face as you portray your heart's desires in your Vision collage. Open up to your own innate wisdom pouring out through images and words.

As you get a deeper sense of partnering with your creative self, it is helpful to allow an image to appear. This is a highly intuitive process and, again, there is no right or wrong way to do it. The next exercise is intended to help you allow your creative self to transmit an image to your mind, one that is relevant for you today. Each time you do this exercise, a different image is likely to appear. The creative self has many messages to send us, depending on what we need at any given time.

IMAGERY: SYMBOL FOR YOUR CREATIVE SELF

Purpose:

To find a symbol for your creative self; to find an image that will serve as the center point in your collage.

Materials:

- Scissors

- Index card or note card

- Your collection of picture materials, magazines, etc.

Procedure:

1. Sort through your materials and find an image that expresses your true self, your real essence. It can be a symbol, such as a rose, a sunset, a smiling baby. Or it can be a more literal portrayal, such as a photo portrait or a snapshot of you showing your creative self shining through. Perhaps it was a time when you were joyful, serene, or feeling very good about yourself. When you find this creative self image, set it aside where you can see it.

The creative self shown as a radiant, expansive woman.

2. On an index card or note paper, write down the following affirmation from my friend, author Giorgio Cerquetti:

I have all the good qualities and resources within me to fulfill my desires. Place the card next to your creative self symbol.

3. Close your eyes and repeat the affirmation to yourself. Repeat these words each day to reinforce your belief in your dream and your ability to manifest it. It's best to say them while looking at your collage or picturing it in your mind. Some Visionaries who are in the habit of meditating do this as part of their daily meditation.

UNFOLDING FROM THE CREATIVE SELF

This creative self symbol is extremely important. It puts us in touch with the spiritual dimension of Visioning. It reminds us that what we *do* and what we *have* are simply the means for arriving at a state of *being*, not doing. What we really seek is an *inner experience*, not an external acquisition. The creative self symbol keeps us focused on our soul needs. For if we get off the track, we're likely to be headed for disappointment. We may get what we want, but feel empty when we finally possess it. That's because we were going for the *thing* and not the experience. People who do this end up asking the question, "Is that all there is? I achieved my goals, but I'm still unhappy. I'm depressed all the time (or tired or sick or my relationships don't work). What happened?" Contemplating the creative self logo at the center of your collage reconnects you with your own heart and with the source of all abundance and fulfillment.

MOVING FROM THE CREATIVE SELF

Creativity flows more naturally when we are relaxed. Although we see with our eyes and mind, we also see with our hearts and our bodies. Natural, spontaneous movement that is free of formal instruction or externally imposed form or restriction can be a powerful way to relax and let go. It beckons the creative spirit to flow through us physically and to revitalize our bodies and minds.

MOVEMENT MEDITATION: INNER LISTENING

With your eyes open, spend a moment allowing your body to move spontaneously. You can do this standing or seated. Ask your creative self to lead the movement from

within. Start out by allowing your hands to dance with each other in preparation for working on your collage. This is your own intuitive movement and there are no formulas for this. It is *your* dance. No one else's. If you feel inhibited about moving in this way, try putting some music on if you have included it in your work environment. If the movement takes you into a whole-body dance, feel free to follow the impulse. Make your dance a prayer, an invocation to the spirit of creativity that dwells within you.

THE SILENT PARTNER

The final step of preparation will be a conversation with your silent partner, your creative conscience. This will be the first of many written dialogues you'll have with the voice of wisdom and guidance that lives in your heart.

JOURNAL:
MEET YOUR CREATIVE CONSCIENCE

Purpose:

To invite your creative self to speak to you in words, to listen to the voice of your creative conscience

Materials:

- journal and pens

- your creative self symbol

Procedure:

1. Place your creative self symbol in the center of your work space where you can look at it. Writing with your dominant hand, ask your creative conscience to speak to you in words.

2. Date the first page of this entry. (That will be true for all journal entries.)

3. With a contrasting color, write with your nondominant hand. Allow your creative conscience to speak to you. Let it say anything it wishes to tell you at this time.

Greg's journal message from his creative conscience.

4. If you have a particular concern, try directing questions to your creative conscience. Write the question with your dominant hand. The creative conscience always responds with the nondominant hand.

This is an exercise you can do frequently. When things are troubling you, ask your creative conscience for advice. It is quietly waiting to give you its gift of guidance and wisdom.

3 Get a Dream, Get a Life

First Design Principle:
Get an Idea

Design starts with an idea, an inspiration, a flash of insight. We are moved to act by the magical spark of our creative self. When the designer follows where the next creative idea leads, it is as if she says to the creative self, "Your wish is my command."

VISIONING STEP 1:
MAKE A WISH

Getting results with Visioning depends on clarity and commitment. You'll need to commit to your dream, really wanting it to come true. But you can't commit to your dream unless you know what it is. You do that by finding your true heart's desire. It will speak through your creative conscience in a few simple words. This chapter will help you find your dream and make a wish. Your wish is your design idea.

The Courage to Dream

The root of the word "courage"—Latin *cor*—is found in all the Romance languages: *coeur* in French, *corazón* in Spanish, *cuore* in Italian all mean "heart." We speak of "having a heart" (compassion), of "having the heart for" some undertaking (courage), of "heartless" people (uncaring), of speaking "from the bottom of my heart" (deepest feelings). Following the pathways of the heart takes courage, for it means listening to the core (also from the same root as heart) of our being. On the heart path we listen to the sound of a "different drummer," not the one most others are marching to.

Early on in life we learn to deny the promptings of our creative self. We choose the spouse our parents approve of or the career that will bring us power and money (or whatever else we think we're "supposed to" want). However, it's not good for our hearts and souls (or our bodies, either). As a therapist I have had to help my clients mop up the messes in their lives that resulted from denying the creative self and their real needs. The good news is that it's never too late to put heart back into one's life.

The fact is that our true dreams don't disappear, they go underground. Deep within we still carry our secretly held wishes, both literally and figuratively, no matter how old we are. They may actually be lodged in our anatomical heart. If you look at the growing body of cardiology research, you'll see evidence that our desires are actually registered in this organ. Heart transplant patients tell about their surprising and sudden desire for foods that they either disliked or were neutral about before the surgery. In checking with the donor's family, it has been discovered that he had a passion for this particular food. Sometimes the recipient discovers an attraction to music or activities he had no interest in previous to the operation, but that were favorites of the heart's donor. Could it be that the heart is a filing cabinet of wishes and passions? Are you ready to look through yours?

Another reason that it takes courage to follow the pathways of the heart is that once you have heard your creative conscience, you must take

action. How wonderful! And how terrifying. As Ralph Waldo Emerson said: "Be careful what you set your heart on, for it will surely be yours."

Ask yourself these questions:

Am I ready to look into my heart?

Am I ready to partner with my creative self?

Am I ready to listen to my creative conscience?

Am I ready to have my deepest dreams come true?

If the answer is *yes*, then you have given yourself permission to follow your heart and to act from that place of inner truth. This takes courage and is very different from wanting what everyone else wants or trying to acquire the most "stuff." It's diametrically opposed to the bumper sticker that reads "The one who dies with the most toys wins." Later in this book, you'll find some dramatic stories about people who decided to let their heart do the talking for a change, and who found whole new lives as a result.

JOURNAL: PERMISSION TO ACT

If you answered any of the four questions above with a negative response or with ambivalence, then I would suggest writing about it in your Creative Journal. Start by writing the questions down with your dominant hand. Then with your nondominant hand, list your fears related to each question. Lastly, write whatever comes to mind, using your dominant hand. Which are your biggest fears? Are you willing to work through them? Are you willing to *feel* the fear and engage in the Visioning process anyway? What would happen if your dreams did come true? What would you lose? What would you gain?

By now, it should be clear that Visioning is not just another "success program" to feed acquistiveness and ego. It is a spiritual path that puts

you in touch with your soul's DNA, your destiny or life's *inner* purpose. The media you will be using and the way in which you will be applying them are intended to take you to a far deeper place than just material gain. Visioning is about spiritual action in daily life. It is about wedding spirit and matter, heaven and earth, the invisible and the visible, imagination and action.

Having your dreams come true brings a new kind of freedom and fulfillment. It also brings new responsibilities. There will be surprises when you realize your true desires. From each risk you take, you become stronger and learn more about yourself. From every encounter with your creative conscience, you learn more about who you *could* be. If you dare to dream and act on your dreams, you have everything to gain: your true creative self.

Finding a Focus

As a therapist, I've learned that there are several predictable barriers to bringing your heart's desire to fruition. You may be facing one or more of them. They are:

- Knowing what you want but not knowing how to get it
 Lack of positive examples or experiences with success

- Knowing what you want but being afraid to ask for it
 Fear of failure or rejection, fear of disappointment

- Knowing what you want but being afraid to *have* it
 Fear of the unknown, fear of responsibility, inability to redefine yourself, fear of the envy or disapproval of others

- Thinking you know what you want, but finding it doesn't match with what your creative conscience says
 Inner split between material and spiritual values, between other people's agendas and your real heart's desire

- Not knowing what you want, and then not getting it because you don't know what *it* is

 Feeling you don't deserve fulfillment, lack of focus

The road that leads through these barriers is commitment. And one common trait of committed individuals—whether it's to a project, a career, a relationship, a spiritual path, or a hobby—is focus. To be committed you have to focus on where your loyalties lie and what your priorities are. Visioning starts with focus, continues with focus, and ends with focus. As the saying goes, "Keep your eyes on the prize."

Crafting a Focus Phase

In Visioning there are many exercises for practicing the art of staying focused. The first one is to find words that clearly and succinctly state your heart's desire. I call this clear statement of one's true desire a *focus phrase*. When your mind starts chasing all over the place, the focus phrase is the still point you return to. You let extraneous, distracting, and disruptive thoughts go their own way. Instead of allowing your mind to roam about and take control, *you* take charge of it. You decide where you want your thoughts to go and where to put your energy.

Your focus phrase will serve several purposes:

- a title for your Vision collage

- a theme for journal writing after you've done your collage

- a verbal affirmation to go with the visual affirmation of your collage

- a theme for journaling in the weeks after you have made your collage

As you do more Visioning, you will inevitably find that your themes or issues change. One month it might be finances, another time you

might want to explore relationships or family. As circumstances change your dreams will, too.

Someone who is in the exploratory phase and doesn't know what they really want might use a question as a focus phrase:

- What's in the year ahead? (a good birthday or New Year's theme)

- What kind of home do I want?

- What would a new career look like?

- What would a fulfilling relationship look and feel like?

- What would life be like if I made a lot more money?

For those who are clear about their heart's desire, a focus phrase would probably be a more direct statement of intent:

- my new image in a healthier, lighter body

- the apartment I'm looking for

- my trip to Europe

- my ideal job

Some people are very clear about their desires in one area of their lives and are totally lost in others. You might have well-defined goals in career, business, or travel, and yet draw a blank when it come to creating a satisfying home environment or a healthy love relationship or a healthy body. As long as you are vague or ambivalent about what you truly want, the material world cannot respond. If you're going to place an order at a restaurant, you need to state it clearly. Visioning works in exactly the same way. When your heart is allowed to speak, it does so with laser-beam directness.

In order to find this inner direction you'll be using your focus

phrase like a mantra. In many meditation practices a mantra (from the Sanskrit) is a word or phrase that is repeated over and over. The mantra can be said out loud or repeated silently in the mind. In some traditions, the mantra has a spiritual meaning: "I honor the Divine spirit within me." Or it can be a prayer that is repeated, as with the Catholic rosary or Eastern mala beads. In other methods of meditation, the mantra is a series of syllables that has no meaning at all. It is simply used as a focal point for one's attention when it wanders.

In the collage-making phase of Visioning, the focus phrase is the core, the theme, the hook upon which you hang your selections. The pictures and words either support your dream or they don't. It's quite simple. If they don't, they get tossed. If they do, they get included. Your focus phrase acts as a compass, helping to guide your choices and decisions. This will be especially helpful when you start finding photographs that do not tie into your theme. There's nothing wrong with being drawn to beautiful pictures, but if they don't match the theme of your focus phrase, you'll need to set them aside and save them for another time.

Learning to use your focus phrase carries over into everyday life, too. It will become easier to make decisions and use discrimination in your daily choices if the focus phrase that came from your heart has become emblazoned in your mind. When you learn the power of focus, realizing your dreams becomes easier and easier; life becomes a meditation. You'll be able to move more easily toward what you love and away from the things and situations that distract you from what you really want and drain your creative energy. Cleaning out the clutter in your life will become a natural by-product of working with a focus phrase.

In finding the appropriate focus phrase, here are some questions and themes to consider. These are intended to assist you in surveying the personal issues you are dealing with and the areas where you are less than satisfied. Problems, challenges, or painful areas usually indicate that some dream or wish is being blocked. Your creative self is not flowing and your creative conscience has been muffled.

Focus Phrases: A Menu of Possible Themes

The themes and focus phrases listed below are meant to spark your own creativity. Please don't think you have to copy one of them. If you already have a pretty clear idea of your fondest dream, then it will speak for itself in the exercise below. If you're not at all sure what your heart's desire is, these suggestions may help.

WORK AND CAREER

- Am I working in the field where I truly belong? What does my heart want?

- My dream job or ideal career.

- What a job or career change looks like.

- Work that works for me: a healthy work situation.

- What needs to change in my current work situation?

- How I'd like things to be at work.

- Recharging my work life.

- Being more creative in my work.

- Balancing work and personal life.

FINANCES AND ABUNDANCE

- What money does for me.

- What I'm willing and able to do for money.

(continued on next page)

(continued from previous page)

- What financial security looks like.

- What I'd do with lots of money.

- A picture of my financial goals.

- How can I invest in myself?

- Money and me.

- An abundant life.

RELATIONSHIPS

Family

- What family looks like.

- My place in the family.

- Where the conflicts are. What solutions look like. (two-part collage)

- What unconditional love looks like.

- Creating more joy.

- Family matters.

Friends and Others

- The gift of friendship: my true friends.

- Me and my support system.

(continued on next page)

(continued from previous page)

- What mutual acceptance looks like.

- Relationships that are problematic. What the solution looks like. (two-part collage)

- Recharging a relationship.

- The important people in my life.

- Who is missing from my life?

Love and Marriage

- What a satisfying partnership looks like.

- Being myself and still committing to someone else.

- What trust looks and feels like.

- Deepening our relationship.

- What romance looks and feels like.

- Giving and receiving love.

- Through the eyes of love: seeing what is lovable in another.

Health and Self-Image

- How a healthy body looks and feels.

- What I need in order to be healthy.

- A healthy lifestyle for me. The habits I want to cultivate.

- Nurturing body and soul.

(continued on next page)

(continued from previous page)

- Changes I need to make (work, home, relationships, etc.).

- My body, myself: body image and self-image.

- The image of myself I want to create.

- What I wear and how I feel.

Home and Residence

- Creating my nest.

- Redecorating or renovating my present place: what would it look like?

- Where do I want to live?

- What would life be like in a new place, town, or country?

- My dream house, inside and outside.

- What kind of place do I want to build?

Happiness and Fulfillment

- What makes me happy?

- Nourishment for my soul.

- Signposts in my daydreams and night dreams.

- Creating more joy in my life: people, places, things, and activities.

- Portrait of happiness in the future.

(continued on next page)

(continued from previous page)

Creativity and Growth

- My spiritual life: How can I nourish my soul more?

- Where do I go in my daydreams? What parts of me are longing to be experienced?

- What talents do I want to develop?

- How can I express myself creatively?

- Having fun and expressing myself in daily life: clothing, furnishings, entertaining.

- My talents: hobbies, passions, and more.

Creating My Future

- My vision of the year ahead.

- Five years into the future.

- What am I doing with the rest of my life?

- Who do I want to be? Where do I want to go?

- Childhood dreams revealed.

- My resources and support system for the future.

- Experiences I'd like to have.

- Where I'd like to travel to.

- What secret life dreams do I feel ready to reveal?

- Who can help me make my dreams comes true?

JOURNAL: FINDING MY FOCUS PHRASE

Sit quietly and review the themes you've read in the menu above. Allow your heart to tell you your focus phrase. Write it down on a card or small piece of paper with your nondominant hand. It is important to write this with your nondominant hand so that the words come from that deeper place of truth in you (which is more readily accessible from the right brain). It doesn't matter whether you are right- or left-handed when it comes to writing, just use the hand you don't normally write with.

Sometimes our focus phrase is found in our daily problems. By facing these challenges visually through the collage process, we can excavate dreams buried under everyday life issues. Visioning turns crisis into opportunity. Being willing to look at *what is* (even if we don't like what we see) can lead to picturing *what could be.*

JOURNAL: WHAT'S THE PROBLEM?

If you want to use a current problem as the hook for your focus phrase, start by writing about it in your journal. Using your nondominant hand, write down what the problem is. Then write out your feelings about it. Don't hold back. Let the feelings flow out onto the page. Scribble your feelings out first if you're having a hard time finding words for them. What is troubling you?

Sit quietly and ask your creative conscience to give you a focus phrase for the solution to your problem. It may be as simple as:

- how I'd like things to be

- resolution

- the solution

- solving the problem

- meeting the challenge

- the lesson learned

- victory

The Problem.
(see page 178)

This technique can apply to any challenge you are facing in your life. Think of it as a picture of "before and after." Look honestly at how it is, but also how you want it to be. In later chapters there are examples of how this method has been used for creative problem solving. It is a wonderful way to turn junk into gold.

In chapter 11, you'll read about how Marissa Visioned a problem on the job into a victory.

Peaceful Resolution.
(see page 180)

Reinforcing Your Focus Phrase

Remember the flash cards they used for drilling math and language in school? The principle was that if you kept reinforcing the information over and over, it would eventually sink in. You can do the same with your focus phrase. Your heart is sending the information, and your conscious mind needs to get the message.

FOCUS: FLASH CARDS

Write your focus phrase on a file card or page from your memo pad. This is your portable "flash card" for display in the environment. Use this during your collage-making and journaling time. In your everyday life, display your focus phrase on the dashboard of your car, your desk, next to your computer, on the night stand next to your bed or any other place where you spend time each day. Some Visionaries carry their focus phrase in their purses, wallets, or briefcases. Make more than one focus phrase flash card and put them in different places.

In the hectic pace of daily life, it's easy to forget your heart's desire. Keep your focus phrase before your eyes. Throughout the day, remind yourself of your dream.

PEACE AND
WELL-BEING

MY DREAM JOB

A LOVING
RELATIONSHIP

MY HEALTHY
AND
ACTIVE BODY

THE IDEAL
APARTMENT

LOVE AND
ABUNDANCE

EXPRESSING
MY TALENT

Sorting and Sifting 4

Second Design Principle: Feed Your Idea with Research

In order to charge your dreams and wishes with magnetic power, you need more than a phrase. You need to flesh your dreams out, translate them into the material world. If dreams are going to come true in physical form they can't be vague. There's nothing ephemeral about the material world. It has laws and is very tangible. You can taste it, touch it, see it, smell it, and hear it.

> Whatever you can do, or dream you can, begin it: Boldness has genius, power and magic in it.
>
> GOETHE

Whether you are aware of it or not, you have pictures in your mind. Now you'll begin to externalize them. The key here is to be receptive, let yourself get excited, be inspired. Think of window-shopping or trying clothes on just to see if they fit or test-driving a car to find out if you like the feel of it. The difference here is that you get to have the *picture* of what you like and it doesn't cost a cent.

VISIONING STEP 2: SEARCH FOR IMAGES AND WORDS

A focus phrase—"Letting Go"—
posted on the wall.

The task here is to gather photos and images, captions and phrases expressing your dream. This is a game of seek and find. It's like window-shopping. You don't have to commit to anything yet. You can just pick out what you want. Don't second-guess yourself or edit your choices in any way. Look for those images and words that literally speak for your heart.

Your focus phrase exerts great power in your selection of pictures and words. As the clear statement of your heart's desire, it also functions as a working title for your collage. The focus phrase drives your choice of pictures and words and it acts like a magnet. Think of how magnets work. They just sit there and pull toward them any bit of metal that happens to be in the neighborhood. They can't help themselves: the magnet or the things that get magnetized. A magnet lives out its purpose in life in a way that seems effortless. Your heart is a magnet.

Explore the Treasures in Your Research Bank: The Art of Gathering

Searching from the heart for
images and words.

The very practice of being selective and choosing pictures or symbols of your focus phrase is the way to start making your dream a reality. Seeing your imaginary wishes in tangible form—in photos and pictures—lets you believe in your dream. You're sitting on a gold mine of potentially powerful images. Eventually you'll put them to-

gether like the pieces of a puzzle. For now, all you have to do is follow your heart to the pictures that sing to you, that make you happy, that evoke the response: "Yes, I want that in my life!"

Sounds like fun, doesn't it? So you're probably anxious to get started. However, there are some mind fields (yes, I mean *mind*, not mine) to contend with. I want to warn you about them so you can be prepared.

Warning: Beware of the Cluttered Mind and the Inner Critic

As we move toward our dream, old well-worn thoughts and beliefs are likely to come floating to the surface of the mind like so much debris. As you find wonderful images of your heart's desire, a little voice may come in and start editing. It usually says things like:

- "You can't afford that."

- "This is totally impossible."

- "Who do you think you are wishing for something that outrageous?"

- "That's completely impractical. It'll never happen."

- "Don't choose that picture. You'll just be disappointed when it doesn't materialize."

I speak from experience, for I've heard this voice a million times during my own personal Visioning sessions. Never mind that most of my dreams have actually come true. Forget about the fact that whatever I set my heart on usually becomes mine. That inner party pooper just never knows when to quit. It cares nothing about facts (so don't try to reason with it). It just wants to butt in with its "buts" every time.

- "But you don't have time for that."

- "But you're too old for that."

- "But you don't have enough money."

- "But you have too much work to do."

- "But you're not smart enough."

On and on it goes. The inner critic. The voice of doom and gloom, it is the antagonist of the creative self and the creative conscience. The inner critic has been programmed by the values of society, your parents, and others who want you to do it *their* way. If your dream is to work for yourself or start your own business, the inner critic will start telling you you're crazy. Before you've even had a chance to research the possibilities, get some training, find a mentor or a support system, the inner critic will try to shut you down. Then you notice that your energy is gone, your inspiration has vanished, and you can't even remember what your heart's desire was. When the inner critic's negative self-talk comes up, as it inevitably will, there is something you can do.

Image-Finding as Meditation

One of the great benefits of meditation is the process of watching how your mind works. Many people think that meditation is clearing the mind. Maybe it is for some, but as a long-experienced meditator, I'm here to tell you that trying to get my mind to shut up is like trying to stop breathing. Instead of battling with it, I've learned to just watch and become aware of it. Then I let the thoughts go. These thoughts are anything that take you out of the present moment. In meditation it is typical for the mind to mull over past mistakes, invent new worries about the future, rehearse what to say or do when a certain situation recurs, etc. Anything but being here now.

When the inner critic strikes, be aware of it, but don't let it stop you

from sorting and sifting through your photos. If you do stop, if you do get depressed, if your energy suddenly dries up or you start feeling despondent, just know that the inner critic has gotten the upper hand. Stop. Become aware of that fact. Tell it to step outside until you finish what you are doing. The inner critic will never go away for good, but you can refuse to let it distract you. Stay focused on your dream. Look at your flash card. Say your focus phrase out loud. And keep your resolve.

It's time to take the plunge into action now. Let your fingers do the walking. Let your eyes have a field day searching for what your heart desires.

RESEARCH: GRAB WHAT GRABS YOU

Purpose:

To collect images and words that express a specific dream, wish, or desire from which to later create a collage

Materials:

- scissors

- art paper or poster board, 18 x 24 inches or larger

- sources of pictures and words (magazines that contain good photos in color and black and white and that contain good words, captions, or phrases; personal snapshots and photo portraits in photocopy form; other materials, such as greeting cards, brochures, catalogs, advertisements, posters, etc.)

Procedure:

1. Place your art paper in front of you on your work surface. Think of this paper as the open space, the field of dreams that contains all possibilities. It will be the container for your fondest wishes.

2. Take your focus phrase and display it in a place where you can see it while you work on your collage. Some Visionaries actually write it on the bottom of their art paper as a title for their collage. Others put it on a piece of paper or 3 x 5 index card and place it nearby. Do what feels right for you.

3. Repeat your focus phrase to yourself a few times. Speak your dream in your own words.

4. Start paging through your collection of photos or printed materials. Cut or tear out images and words that express your theme. Place them in two separate piles—one of pictures, the other words—on your art paper. Select pictures and words that speak to your heart about your true desire, that leap off the page at you. The key phrase here is to "grab what grabs you." Do not think too much about your choices or analyze them. Just focus on your theme and go with your intuition and feelings. What do you like? It doesn't matter how crazy or impractical or unattainable the content of any picture or phrase appears to be. If it grabs you, grab it. Just remember to stay focused on your theme as you collect images and words.

 Do not edit your choices yet. That process is reserved for later. All you need to do now is keep your mind open, exercise your imagination, and go for your dream in pictures and words. If you start thinking of obstacles to having your dream come true, let go of them. Stay in your imagination where anything is possible.

 You may find some pictures or words that don't relate to your theme, but which really grab you. Cut them out anyway, but set them aside in a separate pile for possible use later in another collage.

5. When you have gathered enough pictures and words for your collage, put the magazines and other sources aside. You're now ready to start exploring words.

Ad Art as Poetry in the Marketplace

Once you start doing Visioning, you'll never look at magazine ads or junk mail in the same way again. In looking for pithy phrases and right-on words in print media and brochures, remember what passes for dross may really be gold. How delightful for those of us deluged with junk mail. I used to just toss it in the nearest trash receptacle. Now I'm a little more selective, and I've learned how to recycle it in my Visioning collages.

The following is an example of how I recycled so-called junk mail into a powerful and prophetic pair of New Year's collages entitled "The kind of life I want to create in the coming year." Each panel represented a different aspect of my life: work, abundance, and health.

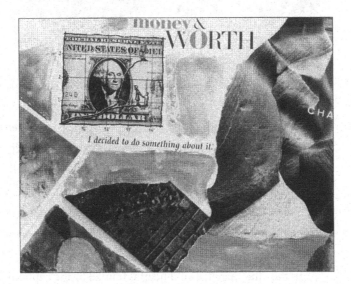

Detail from New Year's collage.

The first panel, devoted to abundance in the coming year, shows a picture of money accompanied by the words "Money and worth . . . I decided to do something about it." From this I realized that true

abundance has to do with how I value myself, my work, and my time. "Do something about it" to me refers to setting priorities and acting on them.

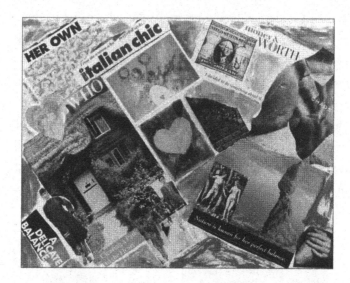

Full panel of my New Year's collage.

Another picture section on the left shows a charming English cottage right out of Dr. Doolittle with a path leading to the door and the words "Clearing a Path to the Heart." The cottage reminded me of my own house set in a beautiful forest. I took this to mean that my writing (which I do at home in the place I love most) would be coming more from the heart than ever before. This also seemed related to a phrase that appears next to the path, "A delicate balance." (I needed quiet time at home writing, in contrast to the recent traveling and work with groups I'd been doing.)

In the other panel, a gold heart is framed by the captions "Soul and earth are one. . . . The path to perfect health. . . . Come find yourself." This refers to coming back home to my country house and garden (after being on tour most of the fall). Echoing the message in the other panel, it appeared to be saying that by returning home I would reconnect with my creative self once again.

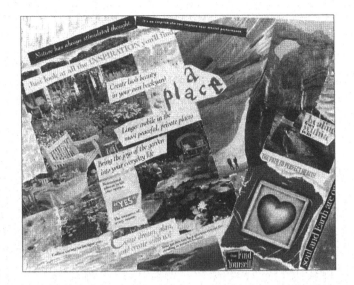

Second panel of my
New Year's collage.

The rest of this panel has to do with food for the soul, with a garden montage and the caption "Nature has always stimulated thought. It's no wonder she can improve your mental performance. Just look at all the Inspiration you'll find." My studio has French doors and a balcony that look out directly over my English country garden filled with lavender, sage, rosemary, and calla lilies. What better place to be inspired? I also included the phrase, "Create lush beauty in your own backyard. Linger awhile in the most peaceful, private places." Gardening is very nurturing and relaxing for me, but I hadn't done it for a long time. These words told me that my creative self wanted me to slow down, to hang out in the garden, meditate, dig, plant, and play in the earth.

At the time I made them, I interpreted the collages as saying I would find abundance and better health from following my heart and creating balance in my life. And it all came true. I followed my creative conscience as expressed in these pictures and words and that year my income increased dramatically, I lost weight, and my health improved. In addition, my creative output doubled. I wrote two books that year.

Most of the images and phrases came from ad copy and commercial

brochures. In other words, junk mail. I share this experience to show you how words we take for granted can be pulled out of context and recycled into some personally significant captions and picture-poems. Over time, these words may prove to be highly prophetic and even literally accurate. All you have to do is *follow the wisdom being expressed.*

Serendipity: The Gift of Finding Valuable Things Not Sought For

In the next activity, you'll browse through your collection of materials and start exploring the captions and phrases related to your theme. You're not composing your collage or gluing anything down yet. Rather you're finding gems of meaning in the most unlikely places: ads and promotional literature. As you sort through words, captions, phrases, and even paragraphs found at random, some lovely connections are likely to reveal themselves. Weaving these words together, you'll find that you are giving voice to your innermost yearnings.

POEM-MAKING: WORDPLAY

Purpose:

To put words into your own context and create personal meaning; to explore words in a right-brain, poetic style

Materials:

- journal and felt pens

- scissors

- words and phrases that have been cut or torn out of magazines and other sources

Procedure:

1. Place your collection of photos and words to the side of your art paper. Sort through this pile and select the pages that have words and phrases related to your theme. Cut the words out and lay them on your art paper so that you can see them all.

2. Now scan the words looking for connections. Is there a particular word or theme that keeps repeating itself? If so, group them together on one area of your paper.

3. Try making a phrase or sentence out of the isolated words. How does it relate to your theme?

4. Take three or four phrases that seem thematically related or that are re- peated (as in my captions about *nature, garden, backyard, balance, health,* and *heart*) and group them on your paper. Does one caption paraphrase another? Try combining them. Move the words around, grouping them in new ways. Do you see any new levels of meaning?

5. Do you have a lot of individual words? Use them to create new sentences and meanings by juxtaposing them in a variety of ways. How do these sentences relate to your focus phrase?

6. If you came across some word combinations that really spoke to you, put them to the side for possible use in your collage. You might want to write them out in your journal as a "found word poem." Try reading these po- ems out loud and tape-record them.

7. Remove the rest of your words from the art paper and set them to one side of your work surface in a separate pile.

This wordplay is a warm-up for the later step of captioning the pic- tures in your collage. It is also a good way to learn how to see differently,

to create new meaning out of the everyday stuff of print media. Later on you'll have a chance to weave the cut-out words and pictures together in ways that interpret and illuminate the images. But before that, you'll need to make a final selection of the images that portray your heart's inner vision.

Third Design Principle: Connect the Research to Your Own Idea

It is said that Michelangelo described sculpting as "getting rid of everything that wasn't the sculpture." That's what you are about to do. Step 3 emphasizes the next phase in the creative process: discrimination, elimination, editing, refinement, exclusion.

VISIONING STEP 3: FOCUS ON THE VISION

Now it's time to make decisions and make more refined choices. You only have so much room on your art paper (unless you want more than one sheet). Sooner or later there is a finite amount of space you can use for your playing field, for your creative container. And there are a finite number of pieces it can hold. This phase is about creativity within the limits and confinements of the material world. It's something that all designers must face: how to bring the imaginary down to earth.

THE BALANCE BETWEEN FREEDOM AND STRUCTURE

In the realm of pure imagination and ideas, there are no limits. Anything goes. In the material world we are bound by things like gravity, time, space, and so on. And it is into this finite cup called "physical reality" that we must pour the limitless ocean that is the creative spirit. How can we pour the infinite into the finite? By making one little decision at a time, putting one foot in front of the other. One leads to another and to another and still another. Before you know it, you've woven a tapestry of preferences and choices. Just as you do in life. And you become the sum of all your choices. Your character is shaped, your life is formed just as creatively as any work of art.

This may sound tedious and restrictive, all these decisions and choices, but it is at the heart of the creative process. Nothing gets into the material world unless we can say *yes* to this and *no* to that. Decisions, decisions, decisions.

Cleaning Out the Closets of Your Mind

In making your final selections, home in once again on your focus phrase. Repeat it, say it to yourself out loud. Remember, you are looking for the pictures and words that truly express your heart's desire and your focus.

Your heart may show you things your mind is not ready to grasp. Keep your eyes open for new possibilities. If you knew everything there is to know about yourself, you wouldn't be weaving a new dream or following your heart's desire. Your creative self is leading you into new territory. Will you travel there?

In discarding images, it is important to keep an open mind and open heart. Do your best to drop as many of your old preconceptions as you can regarding what is possible. You may be tempted to throw an image out because you think it is beyond your reach. Let your dreams be as outrageous as your imagination can make them. Dreams cost nothing. Don't limit your heart's desire because you think you may not be entitled to it. The only real basis for evaluating any of your pictures is: Does this image express my truest wish?

Making Room for the Imagination: Surrendering to the Inner Dreamer

This is where imagination can be allowed its full freedom. I'm reminded of the old song "Smoke Gets in Your Eyes." *Something deep inside could not be denied.* If you keep clear on your dream or inner vision and continue referring your choices back to that, you may have some extraordinary surprises in store. Trust the Visioning process. Keep on cutting and pasting. Follow the dictates of your intuition and imagination. If you do, the portrait of your vision that evolves will be compelling, and it will feel unmistakably right. When that happens, you know it is your creative conscience speaking and you are coming home to your true self.

Following Your Heart

Let's complete the process of selecting images and words with two final activities. Here's your chance to really let your creative conscience be your guide. Listen carefully to your heart song as you sift and sort through your pictures. This is the best way I know to practice following the pathways of the heart in the most practical and tangible way.

FOCUS: WHAT'S HOT AND WHAT'S NOT?

Purpose:

To make final selections of pictures for use in your collage

Materials:

- scissors

- materials that were collected in Visioning step 2

Procedure:

1. Begin with the images. Sort through your pile of pictures and select the ones you wish to include in this collage. As you do this, keep remembering your focus phrase. Base your decisions on whether this picture relates to your theme. If there are some pictures that you like, but that you want to eliminate at this time, put them in a separate pile away from your work area. You may change your mind later and retrieve one of these, but for now separate the piles.

2. Place your final selections in a pile on your art paper.

What's in a Word?

This is one of the most revealing phases of Visioning: examining and deciphering your own personal meaning in the words you have collected. If you do this thoughtfully, the insights you're likely to gain are immense. The interpretations of your visual images will begin happening as you mix and match pictures and words. So select carefully and always ask: Do these words really say it? Do they speak about my theme? Do they illuminate my focus phrase? You'll start seeing connections. This phrase really goes with that picture. The words in this picture really mean something when that other picture is added to it. All kinds of combinations and permutations will appear.

Magazines as Chinese Fortune Cookies

As you sort through your words and phrases, pay close attention to the nuances of the words. They take on an entirely new meaning when put into your own personal context. Ask yourself as you go:

- How does this relate to my life now?

- How could it relate in the future?

- How does it speak for my theme?

You'll be saving these collages and have many opportunities to look back on them in the rearview mirror of time. You are likely to find (as I and so many of my clients and students have) that these cut-out words were more prophetic than you could ever have dreamed. One student said to me: "Why pay to go to a psychic when you can do it yourself with a Visioning collage? When I look back at my collages, they always are accurate and even quite specific." You'll see this in some of the case studies presented later in the book.

You'll complete step 3 by doing the same thing with your collection of words and phrases that you did with your pictures.

POEM-MAKING: MORE WORDPLAY

Purpose:

To make final word selections for your collage

Materials:

- scissors

- words, phrases, sentences, or paragraphs collected from printed materials

Procedure:

1. As you did with the picture materials in the previous activity, look through all the words you have collected and decide which ones you want to use. By now you have a lot of images in mind as you evaluate which words are expressive of your dream and which are not. Sometimes, you're not certain why you chose a particular picture until you find a phrase that gives it meaning. Sometimes it's the reverse: the picture illuminates the words. Imagine putting a jigsaw puzzle together. The question you're asking here is: Of all the stuff in this pile of words, which pieces fit together with the pile of pictures?

2. Place your final word choices in a pile next to the pictures.

Congratulations! You are now ready for the big leap into the land of creative commitment: cutting and pasting. You've graduated to kindergarten.

5

A Picture Is Worth a Thousand Words

Go confidently in the
direction of your dreams.
Live the life you've
imagined.
HENRY DAVID THOREAU

You have collected pictures and words that speak of possibilities, of paths untraveled, of your innermost wishes waiting to come to life. The elements are all there, but the whole remains unclear because you're looking inward through the eyes of your imagination. Soon the dream will become tangible. The invisible will become visible. Your inner vision will gradually take shape externally. This next phase is a step that theme park and film designers use in developing ideas for environmental designs. They put together something called a *storyboard* (a cartoon strip of the story line made on large poster-like sheets of paper). Environmental designers create styleboards. Usually made on poster board, these combine photos, sketches, collages, fabric swatches, etc., to depict the *feel* and the *look* of the desired result.

VISIONING STEP 4:
COMPOSE THE DESIGN

In putting your Vision collage together, you'll let your creative conscience lead the way. You'll mix and match individual elements, fitting pictures with words to find meaning. Like Alice in Wonderland, things will mean what *you* want them to mean. The significance you assign to the pictures will be personal and specific to your heart's desire. When you have the right match, your heart will say, *yes*. When the pieces of your dream find each other, you'll feel it in your body.

Design by Intuition

INTUITION—the power of knowing things without conscious reasoning.

Intuition speaks to us in dreams, mental images, symbols, feelings, extrasensory perception, and artistic expression. Actually, intuition is the prompting from our creative self, speaking through the voice of creative conscience. Our innate intuitive wisdom points toward what is going to unfold in the future. Visionaries have reported that their collages were uncannily precise. After their dream came true, pictures and phrases that appeared irrational or impossible when they made their collage turned out to have great validity. Composing your Vision collage is a great technique for strengthening your intuition, an ability that we all have, but often disregard.

Anna's collage showing the
card symbolizing good credit.
(story on page 249)

Anna manifested her dream ranch even though she was pessimistic about it when she made her collage. She didn't think she could afford to buy her dream. In her collage, she had placed a picture of a credit card taken from a magazine ad for a bank she'd never heard of. "This is my symbol for credit, " she told the workshop participants in our sharing circle. After finding the *real* ranch a few weeks later, Anna told the realtor about her need for a loan to buy the property. The next day she was contacted by the very same bank whose credit card ad she had used in her collage. They offered to finance her purchase of the property. She thought someone was playing a prank, but it was for real. Unbeknownst to Anna, the realtor (who knew nothing about her collage) happened to contact that particular bank to help her get a loan. Her story appears in chapter 14.

There are many stories of coincidences, synchronicity, and serendipity that can be traced back to images and words placed in Vision collages. The Visionary often thinks it's a metaphor at the time, but it may turn out to be a literal depiction of things to come. Keep your collages even after your heart's desire comes true. In looking back over them, you may observe for yourself the predictive nature of Visioning.

Lay Out the Elements

Your guiding light will be the focus phrase. It helps you determine which pictures make a "visual sentence" (when combined with each other) and which words best illuminate certain pictures. Think of your focus phrase as the title of your Vision collage and your heart's desire as the subject.

Begin by putting your creative self symbol in the center of your pa-

per or board; it's the key to your collage. Sometimes Visionaries who have forgotten this step end up manifesting a dream for someone close to them instead of themselves. Toby did a dream house collage but neglected to include herself in the picture. She found a lovely home much like the one she had portrayed, but it was too big and in the wrong location. It was perfect for her sister, however, who had children and needed a larger place. The sister ended up getting the first "dream house." When Toby created a new collage with an image of herself at the center, she manifested a beautiful cottage that was ideally suited for her in every way.

FOCUS AND CONTEMPLATION: YOUR SYMBOL HERE

Purpose:

To put your creative self symbol as the centerpiece of your collage; to connect with the source of abundance and true fulfillment

Materials:

- scissors

- art paper or poster board

- your pictures and words selected in Visioning steps 2 and 3

Procedure:

1. Contemplate your creative self symbol, which you found in chapter 2. After doing your research in Visioning steps 2 and 3, does this image still feel appropriate as a creative self symbol? If not, sort through your picture materials for an image that truly represents your creative self.

2. Place this image in the center of your paper. Don't glue it down yet. Simply put it there as a focal point, as the hub of a wheel around which you

will start positioning your other images and words. If you found a word that expresses your symbol, then place it in relation to the image.

3. Look at your personal symbol in the center of the page. Imagine yourself right inside that picture and repeat the affirmation: *I have all the good qualities and resources within me to fulfill my desires.* Then close your eyes and repeat these words to yourself.

Random Acts of Beauty: Seeing Relationships, Making Connections

Your collage design will literally unfold from your creative self. This keeps you focused on the true goal. Placing your personal symbol at the center of the Vision collage is an important reminder of where you're coming from: the creative self.

In designing your vision collage, start by inventorying the elements you have collected. Clear your art paper or board and lay your pictures and words on the area surrounding it. If there isn't enough room, you may need an adjacent surface for your collection. Just be sure the pictures and words are close at hand.

Begin by placing some elements together in groups on your art paper to see how they work in combination. There are two things to keep in mind. First is the clustering of images to create meaning in what I call "visual sentences." Second is arranging groupings so they fit visually and spatially on the page. There are no rules, formulas, or right or wrong ways to do this.

In paring things down to what is most relevant to your focus phrase, go for quality, not quantity. You may end up discarding or simply not having room for all the pictures and words you selected. It's better to use images and phrases that *really say it* than to have your collage cluttered with distracting, irrelevant, or redundant elements. If you find yourself feeling confused by the sheer volume of images and words, it's probably

best to remove some. Your collage will appear too busy and won't be as much fun to look at. You can also cut sections out of larger photos, saving only the part that speaks to you. This is called "cropping" and is done by photographers and designers all the time.

Karl was doing a collage called "Travel in the Year Ahead." He had gathered photos of many different foreign lands. After a while, he found himself feeling very confused. In stepping back and surveying the layout, Karl realized that there were far too many places for him to visit in his annual month's vacation. Referring back to his focus phrase, he asked himself, "But where do I want to go *in the coming year?*" Refining his choices, Karl zeroed in on Indonesia. He transferred the other travel photos into a file folder for future use. He later made a five-year travel projection collage and has since visited all the places he pictured, taking them one at a time. Karl reported that he'd wanted to see the rest of the world for a very long time but had procrastinated until he started Visioning. The clarity and excitement he experienced in this process motivated him into action.

Finding Your Own Style

Every person's style is different. Some Visionaries have a more austere less-is-more zen approach with a few pictures and words floating on lots of white or colored background.

Others prefer a more baroque or even rococo style with a myriad of images and phrases dancing around among decorative elements and colors.

Left: Simple, more formal composition style. **Right:** Another fairly formal style of composition.

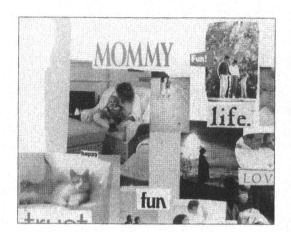

Left: A more complex, decorative, free-flowing composition. **Right:** Another free-flowing composition but simpler style.

We'll talk more about style in a later chapter when we discuss the details of collage design and decoration.

Sometimes *all* your images are great. You need them, but there isn't room on one piece of paper. In order to fully express what's in your heart, you simply may need more space. If necessary, you can expand to more than one panel.

Lay your pictures out so you can see as many as possible. As you sort through the images, certain connections will become obvious. One picture seems to expand upon the theme in another picture so you superimpose them or cluster them. You'll naturally start grouping images according to subtopics.

You'll be using a sixth sense in combining elements to make thematic sections of your collage. This may seem quite random. You put the pictures out on your art paper or poster board just to see what you have and presto! Two of them find each other. Images naturally start coming together like metal to a magnet. At this point you don't have to worry about the overall design or how the whole collage is going to look. Simply start grouping things here, matching elements there, and playing with possibilities.

While starting to compose their collages, some Visionaries get nervous. When confronted with a big blank piece of paper they feel at a loss. They say things like, "I don't know anything about design or esthetics. I don't understand symbolism. How do I interpret this stuff? How do I know where to put what? Aren't there any rules or guidelines for composition? Where do I begin?" I always tell them the following: "You already began when you placed your creative self symbol in the center of your page." As they build out from there, they make an incredible discovery. *The ability to compose a picture that says what your heart wants to say is something we're all born with.*

That includes you. Yes, you may surprise yourself with how well put together your Vision collage looks in the end. Through some magic our

rational minds will never fully understand, these collages express the inner vision. Don't worry about how it happens. Trust that it does.

FOCUS: PLAYING IN THE LAND OF MAKE-BELIEVE

Purpose:

To select and combine images; to block out your Vision collage by arranging the elements on the page

Materials:

- scissors

- art paper or poster board

- your collection of pictures selected in Visioning steps 2 and 3

Procedure:

1. Keeping your focus phrase in mind, lay some pictures out on the page around your creative self symbol. Experiment with combinations by laying the pictures side by side or superimposing a smaller one on a larger one. Try not to analyze the specific combinations that take shape in front of you. Follow your feelings, intuition, and gut instincts.

2. Continue placing your pictures, making final choices for what you want to include and which ones you might eliminate. As you place your selections in your composition, keep your focus phrase in mind. Stay true to your heart's desire. For now, arrange only the visual images, seeing how they relate to each other and to your focus phrase. Don't be concerned about the words yet. We'll get to those next. And remember, nothing is set in concrete here. You haven't glued anything down yet, so you can always change the placement of your pictures.

Don't rush this process. It's okay to feel tentative, to move things around. Do some adjusting here and there. You may notice that something's missing but aren't sure what it is. Consult with your creative conscience, revisit your focus phrase. At other times, you may need to edit out certain images because they really don't say what you want to say.

If your inner critic jumps out and starts analyzing or judging your merits as "an artist" or the feasibility of your dream, simply ask it to take a coffee break, and return to what you are doing. Do the same thing with your chattering mind if it starts talking about other matters, like the memo you forgot to write at work, bills that need paying, or the laundry that didn't get done. Don't let your busy brain distract you from listening to your heart.

Matching Words and Pictures

Words are an integral part of Vision collages. They add another dimension of meaning to your pictures. Of course we're using words in a different way than we normally do. This is a right-brain approach: spontaneous, improvisational, whimsical, and highly invigorating. You prepared for this nonlinear use of words in the last chapter when you engaged in wordplay.

In exploring the relationship of words to pictures, you'll be using the same intuitive process you did in clustering your images. A particular phrase might work perfectly as a caption for a whole group of photos. Sometimes a photo already has a great caption, but you find another phrase that amplifies its meaning in the context of your focus phrase. Or suddenly you notice that a paragraph you really love finds its illustration in a picture you almost tossed in the trash. Separately they weren't very powerful, but together they speak volumes.

Words and pictures that match.

WORD JAZZ: RANSOM NOTES FROM THE SOUL

Purpose:

To connect words with pictures; to play with new meanings and interpretations of pictures; to reinforce your heart's desire with words

Materials:

- scissors

- art paper or poster board

- your collection of pictures and words selected in Visioning steps 2 and 3

Procedure:

1. Switching your attention to the pile of words in your collection, begin laying them out next to your art paper. Trim them down if necessary, eliminating any extraneous background or text. Just go for the words that speak your dream.

2. Allow the words to find their place among the images that lie before you by playing and exploring. Let the words fall together in new ways, illuminating the meaning you have given to the picture. The idea here is to have fun, be inventive, and try out all the possibilities. Everything's up for grabs and nothing is glued down.

3. Using a picture image as a springboard, try stringing some individual words, phrases, or sentences together to create poems. It's like those kits of magnetic words for use on the refrigerator door. The words don't have to make sense grammatically. You have "poetic license" and can say anything you wish with these verbal nuggets.

 Lay these word ribbons out wherever you like. Some Visionaries prefer starting this wordplay on the table next to their collage paper. When they've created some they like, they reassemble them on or near pictures in their layout. Your intuition will guide you.

4. When you feel finished, sit quietly and reread the phrases and captions, sentences, and paragraphs that you have placed. Take your time and enjoy the nuances, double entendres, plays on words.

 Note: You can tape-record your favorite poems or write them down in your journal.

Here is a "found object" poem created from phrases and sentences cut from magazines. It was displayed as a flash card next to the Visionary's computer and she felt that it contributed to her doubling her income that year.

she doesn't have to work hard at all.

Leaving more time for happy

how to have it all

Who says you can't own the future?

Creating your own freedom

for your dreams

Wordplay

Poems woven together from found phrases and captions come from deep in the unconscious. These wordplay and poem-making escapades rattle the cage of your old ways of thinking and using language. Word jazz has a liberating effect.

You've just completed a major leap forward in Visioning. Enjoy your collage-in-progress. See what new discoveries you make about yourself and about your dream. Who you *thought* you were and what you *thought* you were doing with your life may not be the true story at all. Trust the images, trust the words from your creative conscience. They will never steer you wrong. And they will guide you in the next steps of completing your Vision collage.

Fly free on clouds of words
that float and fly and swoop
back down into your heart.

Your inner poet is just waiting
to be set free.

Get ready
for flying high
when your dreams start coming true.
Enjoy the ride!

Order Out of Chaos

*Fifth Design Principle:
Mix and Match in
Rough Mock-up Stage*

The first activities in Visioning were designed to help you build confidence in yourself and in your dream, to develop intuition and fluency in the language of the heart. However, like life, Visioning is a creative process that takes you through the whole spectrum of experiences: lightness and dark, order and chaos. And the most important ingredient is chaos.

> We get in there and toss ideas around. And we throw them in and put all the minds together and come up with something and say a little prayer and open it and hope it will go.
>
> **WALT DISNEY**

Chaos and Creativity

Chaos is that *essential* element of the creative process that makes the gears turn and breathes life into what you do. Without it, you're just going through the motions. The chaos component makes it clear that you can't sanitize or pasteurize the creative process. Like a seed hidden under the ground, new form takes shape in the dark, in silence, in an unseen and mysterious place that can only be hinted at. Call it the

unconscious, the subconscious, or whatever you like. It is as unexplainable as where *physical* life comes from.

When we descend into that dark place of gestation—the primordial ooze of the psyche, the *prima materia* from which all new forms arise— we inevitably encounter chaos. A fancy way of saying this is that we are going through a "paradigm shift," we're emerging into a new order. In fact, scientists have defined this in "chaos theory." It's that limbo state in which the old form has broken apart and the new one can't be seen yet.

When we encounter chaos in the creative process, everything feels topsy-turvy. We're the Hanged Man card in the tarot deck, suspended by our feet. Our linear left brains are helpless when we face the mystery of creative chaos head-on. Of course artists understand this subterranean world where new life takes shape. So do pregnant women, gardeners, shamans, and all those who have dared to participate in birthing something new. Innovators and explorers who venture off the straight and narrow path, who shun the predictable, the acceptable, and the approved live in this zone. Creative chaos is its name and change is its game.

The challenge is that change is difficult. It's so much easier to retreat into the safety of the known and familiar. What may be most difficult is learning to live with the *possibilities* that change presents. When we change we redefine ourselves.

> Machiavelli said, "There are people who know everything, but that's all they know." That's very good, because when I learn everything, I'm missing something.
> **ROBERTO BENIGNI,**
> **Actor and filmmaker**

VISIONING STEP 5: EXPLORE AND FIND ORDER IN CREATIVE CHAOS

Creative chaos is the experience of not knowing. It is a time of shape-shifting. In Visioning we are reshaping the images in our heads to catch up with the vision in our hearts. The heart leads, or more accurately, it *allows*. It allows our creative self to emerge. The heart trusts in divine

unfolding. And so we must trust the heart. And that's tough for the head to accept. It wants control. It *thinks* it knows who we are and what we should do. But the heart knows the *real* truth. The heart cares not a whit about control. It wants us to *experience* the creative self: its ecstatic highs, unfathomable depths, and everything in between.

During chaos we must learn to deal with the voice in our head: the inner critic. The farther we venture into the unknown, the more frenetic it gets. It's very cerebral, extremely talkative, and can be a real headache, both literally and figuratively. "What are you doing?" it shouts. "Where are you going? Why are you doing this?" When that voice takes over, we get intimidated and fall into the confusion of creative chaos.

As we swim around in that fluid place where the new form has not emerged yet, the inner critic can get painfully overbearing. Intolerant of ambiguity, it insists on sharp definitions, clear-cut answers, and results. "What's the bottom line?" it demands. A creature of sunlight with no shadows, a foreigner to intuition and feeling, it champions the status quo, the safe and secure. "Do what has always worked," it admonishes. "Avoid taking risks. It's too unpredictable. I'm only saying this for your own good."

There's nothing wrong with having an inner compass reminding you to drive on the right side of the road, pay your bills, and abide by the laws of the land. There's a place for practicality, but not at the beginning of the creative process. If it enters prematurely, it can easily abort your attempts to fully engage in the Visioning process. What you need to beware of is the inner voice that indulges in character assassination, that says things like "You'll never make it. Forget about this pipe dream. Even if you get it, which is highly improbable, it will be taken away from you." That's the killer inner critic who will shoot your dreams down if it can. But remember what Langston Hughes said: "if dreams die/ Life is a broken-winged bird that cannot fly."

RECOGNIZING THE INNER CRITIC

The inner critic is no stranger. We all have one. It's factory equipment, right along with our innate creativity. We often feel the inner critic in our bodies as chronic pain, headaches, low energy, and lack of motivation. If the inner critic really gets the upper hand, we may feel depressed and hopeless, plagued with vague discontent and a defeatist attitude. Typical thoughts that buzz through the mind when the inner critic has reared its head are:

- Is this really practical? You're living in fantasyland. Grow up!

- Are you capable of pulling this off? Better quit before you fail.

- Aren't you being grandiose here? Who do you think you're kidding?

- This is a pipe dream, childish and escapist nonsense. Be responsible.

- This will never happen. You'll be disappointed.

- I don't want you to get hurt. I'm saying this for your own good.

If that isn't enough to stop you in your tracks, the critic then goes in for the kill.

- And anyway, you're no artist. You can't make a picture that's worth anything.

- Cutting up magazines? What a colossal waste of time.

- Don't you have more important things to do? What about the bills, laundry, housecleaning, taxes, etc.?

Sound like anybody you know? Many Visionaries recognize the voice of their parents or other family members in this inner critic. Or it may be

a teacher or other authoritarian adult that influenced them when they were growing up. The voice got recorded in their own brain and plays on and on and on.

Although I call it *step 5*, the experience of creative chaos is like the trickster in mythology and fairy tales. It can pop up wherever it damn well pleases. It doesn't know anything about the ten steps of Visioning, nor does it care. I deal with the inner critic here because this is the point where creative chaos often strikes and strikes hard. This is when some Visionaries fall into the abyss of questioning themselves and the process. They get cold feet and want to retreat. Why? Because it's time to make a commitment. In step 6 you're going to glue things down and finalize your collage.

So far you have been romancing your dream. No glue, no commitments. Now you're getting engaged, making a formal announcement. When those pictures and words get glued down, you speak your dream out loud on paper. There's no taking it back (unless—God forbid—your critic takes over, you destroy your collage, and you abandon your dream).

How can you extricate yourself from the quicksand of negative self-talk, or what one student called "Self-Doubt Bog and Swamp"? Here's an exercise to use whenever the inner critic grabs you by the neck and causes you to doubt your dream, question what you're doing, and lose self-confidence. It's a way to handle the strong emotions and physical symptoms that often result from an inner critic running roughshod over your heart's desire.

JOURNAL: THE INNER CRITIC

Purpose:

To identify creative blocks; to become aware of negative self-talk; to disidentify from the inner critic and assert yourself against the tyranny of self-criticism and judgment

Materials:

- journal
- two different colored felt pens

Procedure:

1. Using your nondominant hand, write down any thoughts or feelings that are coming up.

 - Are you aware of any particularly strong emotions?

 - Do you feel any discomfort or pain in your body?
 Write about it.

2. Try scribbling the emotions or physical sensations out in your journal using your nondominant hand.

 - What color best expresses your feelings?

 - What colors express the sensations in your body?

3. On a new page, using a contrasting color, write with your dominant hand. This time record all the things your inner critic is saying to you about your heart's desire and your dream. Write this quickly without thinking or premeditating what it says. The inner critic speaks in the second person as if it were another person talking to you. This enables you to disidentify from it.

4. Switch back to your nondominant hand and the original color (used in #2 above). On a new page, allow your creative child self to answer back to what the critic has said. Pull out all the stops. You can say whatever you feel. Don't worry about grammar or spelling or penmanship. Forget about being polite. Four letter words are okay. Assert yourself and declare your right to your dreams. Have fun breaking the old rules about not talking back to elders.

DIALOGUE WITH THE INNER CRITIC

Dominant Hand

This whole thing is stupid. You know that a week from now you're going to be back where you started. What makes you think you can change your attitude. You have always been negative. You can't even say that you love yourself. How are you *ever* going to turn your attitude to positive? Let's get started on this creativity thing. Why in the world do you think you're creative? Didn't you learn your lesson in the art classes you took? You knew you were out of place. The only reason Greg was nice to you was because he felt sorry for you. You'll never succeed as an artist. You better have another plan for making money. If you had to rely on being creative to earn your living, you'd be in sad shape. *Give it up.*

Nondominant Hand

You SHUT UP!! You don't know what you're talking about. I am C-R-E-A-T-I-V-E!! I am an artist. I do love myself. It just took me a while to figure it out. I am so sick of your constant NAGGING. You make me SICK!

> You are the one that holds me back. I wish you would get out of my life!! I want good things for myself and I am going to get them despite you. You can just sit back and watch me!! It's time for you to respect me. I am here and I am strong. Did you hear me? I said STRONG.

> Get out of my head. I could move mountains if you would just shut up.

> I am here and I'm NOT going to be quiet anymore. Deal with that huh!

A Visionary answers back to her inner critic, with her nondominant hand.

After doing this exercise, repeat the affirmation that you received in chapter 5. Say it out loud. Say it with feeling.

I have all the good qualities and resources within me to fulfill my desires.

The Mistakes Myth

Another reason to explore negative self-talk is that when you go to finish your collage, the inner art critic is likely to emerge. And you need to be prepared. "You're going to make a mistake," it usually warns. "You'll make something ugly and look foolish. You'll end up wasting all this time and material."

Nonartists think this is only a problem for them, but let me assure you this is not the case. Professionals who attend my workshops often have a killer art critic in their minds. If they're used to exhibiting their art, entering competitions, or earning a living through the visual arts, they can get all hung up on esthetics: how the collage looks instead of what it means to their heart. They may end up with something that's pleasing to the eye, but sterile and lacking the fire and spirit that comes from one's true heart's desire.

Whether you consider yourself an artist or not, if the inner art critic jumps out while you're completing your collage, go back to the journal process above and tell it off. Don't try to reason with it. Better to descend to the *feelings* in your guts and dump them out on the paper. This *feeling* self is your inner child, that spontaneous, playful, creative part of you that just wants to mess around and have fun on paper.

When it comes to making your Vision collage, let me remind you that the whole idea of mistakes (which the inner critic loves to throw in your face) is a myth. There's no such thing. You can't really do it wrong.

There are no grades and no one is criticizing you except you, or more accurately, the schoolmarm or judge that sits in your own mind.

JOURNAL:
GUIDANCE FROM THE CREATIVE SELF

Purpose:

To contact the nurturing voice of the creative self; to become aware of positive self-talk; to identify with your innate creative ability and wisdom

Materials:

- journal
- two different colored felt pens

Procedure:

1. Using your nondominant hand, let your creative self write messages of encouragement and guidance.

2. Try scribbling the emotions or physical sensations out in your journal using your nondominant hand.

> Message from your Creative Self:
> When you feel lost and doubt your dream and your ability to live it, come to me for help. You think you have to do everything yourself.
> You are not alone. I am here inspiring you, moving you toward the light. So when things seem dark or chaotic stop and ask me for help. Remember I carry the dream in your heart and I will draw its manifestation toward you. Let me do my work. Your job is to trust, allow and embrace the dream with your whole heart.

Message from the creative self written with the nondominant hand.

The pathways of the heart lead through dark and light, through chaos and clarity. There will be challenges and obstacles. You can count on it. Just know that you have the inner resources and the tools to face inner criticism and self-doubt. You have what it takes to make your Vision collage, to enter the magic garden of creativity. Once inside you may never want to leave.

7
The Design of Your Life

If one advances confidently
in the direction of his
dreams and endeavors to
live the life which he has
imagined, he will meet
success unexpected in
common hours.

If you have built castles in
the air, your work need not
be lost; now put the
foundations under them.

**HENRY DAVID
THOREAU**

The goal now is to complete a collage that you will enjoy looking at every day. Let go of judgment, preconceived ideas, and the need to please others. Portray *what your heart wants*. This is the phase of Visioning where you really go for the gusto in the land of no mistakes.

Creating this collage can be positively liberating. This newfound freedom is likely to spill over into everything else you do. You've heard about getting a new lease on life. Making this collage gives you a new *lens* on life. The prescription of your inner glasses changes and everything starts to look different.

The Pieces Coming Together

In this phase you'll make a commitment to your dream by first gluing down your images, then your words. After that, you may also be weaving

in some embellishments that your inner artist and creative child want to add. This can include using colored and textured papers, paint, crayons, felt pens, rubber stamps, and more. Collage is a perfect vehicle for mixed media. Combine pens with crayons, oil pastels with water colors or poster paints. You can also use rubber stamp words, available in kits where memory album supplies are sold. The key here is to create a Vision collage that pleases you.

VISIONING STEP 6:
CREATE THE COLLAGE

I always think of this step as letting the images settle into place. Up to now, you've been feeling your way around, experimenting with what goes where. Now the final placements and combinations of elements are made. As you do this, avoid trying to predict what the finished collage will look like. That line of thinking will take you into your head and out of your heart. It can lead to self-consciousness and open the floodgates to your inner art critic. You're not getting a grade, a critique, or job review, so relax and enjoy. Instead of evaluating yourself or your work, concentrate on portraying your heart's desire. Stay with the *process*, with the inner vision.

Visionaries tell me that when they finally let go, they love the spontaneity of watching the final design take shape. They fall into an improvisational, free-wheeling state. Swept into the creative process as if into a gently flowing river, they start floating on an energy that carries them to places they've never been before. Rational thought stops, time seems to stand still, and all striving ceases. It's as if the pictures and words themselves are dictating where they want to go in relation to each other and to the whole. The collage seems to create itself.

Artists describe this as the time "when the dance dances the dancer"

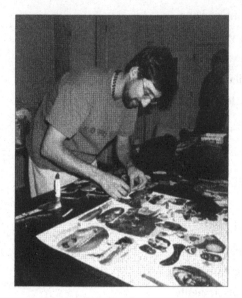

Greg works on his collage.

or "the music plays the pianist." We become instruments of a higher creative power. We aren't *doing* so much as we are *being*. In this experience of being we become the hollow flute through which the creative self plays its song. Surrendering to "not knowing" from the rational side of the brain, you enter "zen mind, beginner's mind." This is the doorway to expressing your truth, to becoming fluent in the language of the heart.

It's fun, but it's serious as well. When you glue your collage elements down you make a *commitment* to your dream. But don't get so serious that you lose the joy. If that happens it's probably because the inner art critic has come jumping out and is trying to spoil everything. Not to worry. You can always go back and use the tools you learned in chapter 6.

"Where should I start?" is a question many people ask when confronted with the task of designing a page. You already began when you placed your creative self symbol in the center of the page. Using your personal symbol as the central focal point for your design counteracts indecisiveness. As you build your collage, piece by piece, you'll find that working around this symbol is a valuable meditation. It helps you stay centered in your creative self and in your heart. In the same way, you can use your focus phrase as a constant reminder in guiding your final choices. So have your focus phrase flash card displayed where you can refer back to it from time to time.

COLLAGE:
PUTTING THE PUZZLE PIECES TOGETHER

Purpose:

To place the visual elements where you want them in your finished collage; to finalize the composition of your Vision poster

Materials:

- scissors

- glue

- art paper or poster board

- pictures and words you've selected and grouped for use in your collage

- scratch paper for laying out elements while you apply glue

- paper towels

Procedure:

1. Look at the way you laid out your picture elements and subgroupings in step 4. Allow yourself plenty of time.

- Did you build out from your creative self symbol?

- Does this arrangement express your heart's desire?

2. Look at your use of space. This is like arranging furniture in a room.

- Does it seem a little too crowded here, a little too bare over there?

- What about that empty space in the corner? Does something want to go in there? Maybe a caption or short paragraph?

- Do you prefer some open places to frame your pictures.

- Add or subtract elements as you wish.

 You may need to trim the pictures and words down or crop sections out to fit them in exactly where you want them. You can trim your pictures to any shape you like: square, rectangle, circle, oval, etc.

 With regard to angles and positions on the page, there are no rules. Pictures can be placed straight up (perpendicular to the bottom of your

paper or board) or placed diagonally at an angle, as shown in many examples in this book.

3. In combining pictures that work together for meaning, try different styles: side by side, overlapped, or superimposed on each other. There are many examples of Vision collages throughout this book. If you need some inspiration, browse around and see if anything sparks your creative spirit. Please don't imitate them, however. Just use them as springboards into your own style. This is *your* dream, and *your* collage.

4. Now arrange things on the page the way you want them in your final design.

5. Once the pictures and words are in place glue them down, beginning with your creative self symbol.

Gluing suggestions:

If you're using a liquid brush-on glue, like Liquitex medium varnish, be sure to use scratch paper for laying it out while you apply glue to the back of your pictures. The same is true if you are using white glue in a dispenser. In that case, place your picture upside down on your scratch paper and apply a very thin stream of glue around the inside edge. You don't need much. If the picture is large, make a cross with the glue from edge to edge through the center so that it will adhere to your art paper or board without buckling or wrinkling up in the middle.

If you're using a glue stick, be sure to distribute your dots of glue on the edges and the center of your picture as well. Inadequate coverage often leads to elements dropping off when the collage is displayed on a wall.

Regardless of what type of glue or adhesive you use, when you place each picture use a piece of scratch paper on top to gently press it down. This way you won't get your hands all covered with a residue of printer's ink from the photos. If the glue oozes out around the edges, just wipe it off with a small piece of paper towel.

Turning Words on Their Heads

The final placement of words usually comes after the images are glued down. You are doing the reverse of decorating words the way they did in medieval manuscripts. Rather you are using words to *illuminate* the personal meaning you have assigned to the images. By juxtaposing your own combinations of phrases, captions, and even sentences and paragraphs, you are reinterpreting and shedding new light on the pictorial elements in your collage.

You've played with words in earlier chapters, but now you really need to pay attention to them in the context of your pictures. As you shift things around and combine an image over here with some words over there, a whole new dimension of your dream will emerge. Newly blended words reveal an interpretation you hadn't thought of before. For example, Clare was completing a Vision collage and noticed a big empty space under a photo of a bespectacled photographer looking out from behind the lens of his camera. Clare had interpreted the photo as symbolizing her need to focus on her dream. Suddenly her eye glanced over to a discarded ad in her reject word pile. A caption and paragraph jumped out at her and spoke to a far deeper meaning in the picture. It read:

> Visionary
> Our eyes are capable of seeing many things in life:
> what is common and familiar, or what is rare and extra-
> ordinary.

Clare took this to mean that she needed to look at *everything* in life with new awareness and attentiveness. A camera lens is a mundane and quite literal illustration for the idea of focus. On the other hand, the word "visionary" and its accompanying text allude to another, deeper level of perception.

Zen and the Art of Cut and Paste

In these last stages of gluing the pieces down, some surprising connections between words and pictures are often revealed. Insights and messages from one's creative conscience pop up all over the place. For this reason, this phase of Visioning has many things in common with traditional meditation. In fact, you have been engaging in a form of *active* meditation. It's different from sitting perfectly still with eyes closed, yet the goal is similar and the results are often the same: contact with your creative self.

In active meditation through Visioning you:

- focus your attention (using your focus phrase as a mantra)

- surrender to a higher power or the creative self

- attune to intuition and nonrational ways of knowing

- open yourself to insights and guidance from inner wisdom

Stay in the stream of creative consciousness and remain clear about your goal: *to declare your heart's desire in a collage poster you will enjoy looking at every day.*

COLLAGE: WORD WEAVING

Purpose:

To make final selections of words; to glue words down in the context of the pictures in your collage poster

Materials:

- scissors

- glue

- art paper or poster board with pictures glued on it

- your collection of cut-out words, captions, phrases, paragraphs, etc.

- scratch paper for laying out elements while you apply glue

- paper towels

- optional: rubber stamp words (available in kits from the memory album section of the stationery or art supply store—see resource list for suggestions)

Procedure:

1. Make final word selections and position them in relation to the pictures. Ask yourself:

 - Do these words express my dream?

 - Do they expand or deepen the meaning of the pictures?

2. Glue your words onto your collage. Use them as captions to express the meaning you have assigned to the pictures. Consider a variety of ways to position your words. You can place ribbons of cut-out words vertically next to pictures, almost as sidebars. Or they can serve as footnotes here and there under pictures. Strips of combined words can also be used to literally frame a picture. Be sure it adds meaning to the image. Beware of overdoing it. Excess in the decorative use of words can lead to clutter that distracts rather than illuminates.

3. Optional: In adding words to your collage, you may want to consider using rubber stamp word kits. You will use them the same way you would the "found words" from your magazines or other printed material. There are a limited number of word stamps in these kits, but they can be a nice addition to your cut-out word collection.

God Is in the Details

In the final stages of refining your collage, your own flair and sense of color and style can really shine. For this reason you may want to dig

deeper into your own personal collection of art supplies. Some Visionaries stop at this point and reserve another work session for painting, drawing, and generally embellishing their collages. It isn't necessary but it can be great fun. Dozens of Visionaries have told me that in creating their collage they discovered buried talent for design, crafts, poetry, or other artistic pursuits. Many of them have gone on to take painting and drawing classes, creative writing and poetry seminars, and even music and improvisation workshops. Who knows where Visioning will lead you?

MIXED MEDIA: CONNECT THE DOTS

Purpose:

To complete your Vision collage; to play with colors, embellishments, and decorative elements that enhance the expression of your heart's desire

Materials:

(Any or all of the items listed below. There really is no limit)

- colored construction paper, origami paper, colored tissue paper, wallpaper samples, gift wrap

- tempera paint, water colors, poster paint, and brushes

- felt markers, crayons, oil pastels

- ribbons, stickers, seals, buttons, wrappers, labels

- rubber stamps with pictures and symbols

- leaves, twigs, small shells, and other items from nature

Procedure:

1. Sit with your collage for a while and ask yourself if it needs anything more.

 • Do you want to add color?

 • Do the colors have any particular meaning to you?

2. Is a photo or section of your collage calling out for a frame or border to emphasize it? A background color or texture perhaps?

3. Are there any words missing from your collage? Do you want to print, rubber stamp, or collage them into the appropriate areas?

Explore, experiment, and innovate with your own unique mix of materials. Be aware of coincidental placements or serendipitous combinations. That's often how messages from the creative self are delivered.

Be careful not to do too much. There's a fine art to knowing when to stop. It means listening to that inner voice that has guided you this far. It will tell you when your collage is finished. It often comes as a feeling that says "That's enough."

Have fun completing your Vision collage. Stay clear about your goal: to create a collage that speaks to your heart every day until the dream becomes a physical reality.

> DISPLAY YOUR COMPLETED COLLAGE IN A PLACE
> WHERE YOU CAN SEE IT DAILY. THIS IS CRUCIAL,
> AS YOU WILL SEE IN THE NEXT PHASE.

In steps 8 and 9 you'll be using your collage for writing and visualization activities. This is how you'll reinforce the images and words that spoke from your heart. You'll also develop a deeper awareness and strengthen your commitment to your dream. This is when the magic starts.

Other Formats for Visioning

After you've experienced the basic collage poster format, in future Visioning sessions you may want to explore some other applications. They include such media as murals, books, postcards, and 3-dimensional assemblages. I'm presenting them here for future reference. The full range of media that veteran Visionaries have explored opens up many possibilities in terms of size, portability, and practicality. They include the following:

- poster (that's what you were just guided in creating)

- mural

- book or album

- postcard

- 3-dimensional model or assemblage

Collage poster.

POSTER — The poster format is the Vision collage on art paper or poster board. I call it a poster because it is for wall display and is approximately the size of a typical poster (18 x 24 inches or larger). It can be made vertically or horizontally. Of course you can make more than one panel, if you choose. These sometimes become mini-murals. You can display it any way you like. One Visionary, who didn't have enough wall space in his office, put his collage under a piece of glass on his desk top and used it in place of a desk blotter.

MURAL — Some Visionaries who have lots of wall space graduate to murals made on butcher paper, brown wrap (used for shipping), or photog-

raphers' no-seam backdrop paper. (See materials in resource guide for suggestions). Murals can also be made by putting several pieces of drawing paper or poster board together. The only size limitation is the available wall space for displaying your mural. Remember you'll be using it as a visual affirmation in your daily life so it needs to be in a place where you can easily see it. Your display wall may be in a different location than the work area where you actually make the mural.

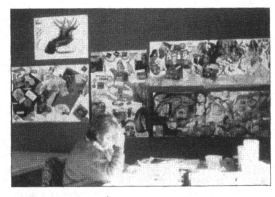

Collage murals on display.

Murals are less portable, yet some Visionaries thrive on size and prefer this format to all others. A mural can provide a powerful visual affirmation by sheer virtue of its size. Some mural papers are quite substantial and can accommodate paint, pastels, and crayons as well as collage. For this reason, the mural format lends itself to mixed media.

BOOK OR ALBUM—Some Visionaries have enjoyed using a book format. This can include a photo album, large spiral drawing pad, or hardbound sketcher's diary. I have also seen Vision books made by folding wide strips of art paper (about 12 inches high and 24 inches wide), and taping them together like an accordion-pleated scroll. There are Japanese books that use this format. They open out into a mini-mural, but close back down into a book.

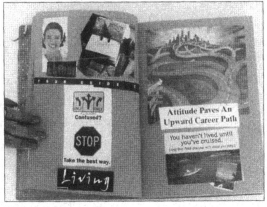

Collage journal.

The advantage of a book is that it can be carried with you. Many people who travel a lot prefer this format. They tell me that they get into the practice of leafing through their Visioning book on a regular basis to reinforce the images, especially while waiting for planes or trains. Some Visionaries who are also active in the popular memory album movement find that this is a natural extension of what

they've already been doing. They consider this a photo album of the future rather than the past.

The disadvantage of a book is that you don't have the whole collage at a glance to use as a visual affirmation. However the next format can solve that problem, especially for those who travel frequently.

POSTCARDS — Collage postcards make handy flash cards for display. I call these "postcards from the cutting edge." They are made just like the larger-format poster collages except that they're more portable and take

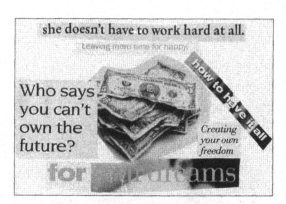

Collage postcard.

less space. You can use little photos and smaller captions and phrases. Ready-made packages of plain postcards are available in art supply stores and some stationers, but you can make your own by cutting up art paper into the appropriate sizes. Displayed on the dashboard of your car, on the bathroom mirror, or next to your computer, these mini-collages serve as great visual affirmations. Some Visionaries display their postcards on the refrigerator door, on their desks at work, or by the telephone. It's best to put them up in places where you're likely to see them often. You can even carry them in a handbag, purse, or pocket. How about scanning them into your computer and displaying them on the screen whenever you wish?

On the backside of the postcard, I recommend writing yourself a message from the future. Write it "as if" your dream had already come true. These are really back-to-the-future messages in which you project yourself to a time *after you have achieved your heart's desire.* Write messages to yourself like: "It feels so great to be in my new home"; "This is definitely my dream job. I love going to work every day"; or "It feels so wonderful to be healthy again and I'm really enjoying taking dance classes."

I also send "postcards from the cutting edge" to my work associates

regarding shared goals we are projecting for the future. I imagine our desired results, do a collage postcard as if it had already happened, date it in the future, and send it. My postcard then becomes a reinforcement for our common dream.

As with books, postcards from the future are a perfect medium for travelers who are doing their Visioning work on the road. Postcards are the most portable medium, yet they can be displayed for visual reinforcement just as a poster can. This handy format complements a Visioning notebook or journal.

3-DIMENSIONAL MODELS OR ASSEMBLAGES—Working 3-dimensionally is also great fun. You may have a kinesthetic style and prefer the added enjoyment of constructing your dream in more complex shapes and forms. Easily accessible found objects can be used as a base structure, such as cardboard boxes, ice cream cartons, and other recyclable materials you already have around the house. You can add paper towel, toilet paper rolls, and other objects for more elaborate forms. This format really lends itself to mixed media: photo collage, painted surfaces, objects from nature, found objects, etc. You just need to be sure to use strong enough adhesives, like glue guns and hobby glue.

In exploring these formats, the idea is to find a form that works best for you. Visioning is about embodying your heart's desire in material form and then contemplating it. If the process is fun, the product is more likely to express your fondest dream. So follow the pathways of the heart until your dream becomes a reality.

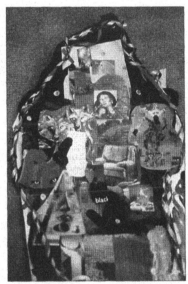

Collage assemblage.

part 2

SEEING RESULTS

Letting Your
Mind See What
Your Heart
Already Knows

Talking Pictures

Seventh Design Principle:
Refine and Finalize the Design

Since Vision collages come from the heart they contain many levels of meaning. This may not be apparent while you're in the flow of finding and arranging the pieces, cutting, pasting, and adding embellishments. Only upon further contemplation do the layers of meaning reveal themselves. The next phase of Visioning delves into the many messages from the creative self that are contained in your collage. It's about insight, about seeing with your heart, and more fully embracing your dream.

> Love lights up the world . . .
> with its generous flames.
> **RALPH WALDO**
> **EMERSON**

VISIONING STEP 7:
ARTICULATE THE VISION

Interpreting the meaning in your collage through journal-writing is a significant part of the Visioning process. Translating pictures into words

bridges intuitive and rational thought, nonverbal and verbal ways of knowing, right and left sides of the brain, and yields invaluable insight into the creative unconscious. It's a lot like interpreting dreams. Anyone who's ever deciphered the seemingly strange juxtapositions of images and scenarios that visit us in the sleep state knows the power of this non-rational world. It may not make linear sense, but it's packed full of meaning. So packed full, in fact, that it often requires some practice, skill, and time to "get the message." Included here are some very simple techniques for understanding imagery that don't require training or experience in symbolic interpretation. These techniques grew out of my art therapy practice.

Art therapy and dream work have many parallels. Both work with material that comes from a different state than ordinary waking reality. As you've probably noticed by now, immersion in art-making puts you in a different state of mind. You lose all sense of time and the rest of the world fades away. Both dreams and art-making use images from the unconscious. As in dream work, the art therapist invites the client to explore spontaneous images (in this case from artwork). These images are the vehicle for free association and insight. An advantage of art therapy is that there's no struggle to remember dreams, for "the dream" is right out there in front of the client's eyes in a piece of artwork. It's the same process as making your Vision collage: you're dreaming on paper. To understand your personal symbols more fully, all you have to do is contemplate the images, engage them in dialogue, and arrive at your own insights. It's really quite simple.

In the collage-making process of Visioning, we enter *an altered state of creative consciousness, which bypasses the rational mind* just the way we do in our sleep. Although we are awake and aware while creating the collage, we plunge into that deeper storehouse of information and guidance that is usually not accessible in the waking state. Yet picturing that hidden world is not enough. We have a verbal side of the

brain that needs to comprehend through language. This is done through journaling, beginning with what I call "image writing."

Image writing is a technique that allows words to flow directly from the images in the collage. The pictures and captions are the raw material for verbal metaphors. Through image writing, the creative self spotlights the elements in one medium (art) and illuminates their deeper meaning in another (poetry). It's true that a picture is worth a thousand words, but some things that can be said in words can't be said with pictures. Each medium takes us to a different place in the psyche, its own area of expression and insight.

Image writing connects the subjects portrayed in the collage, interpreting and illuminating your personal symbols. You are doing with the written word the same thing you did with pictures when you made your collage: taking a bunch of isolated images and putting them together to create new meaning. It's a lot like the free-association technique used in therapy and dream interpretation where you take an image or word and start spinning out its personal significance off the top of your head. Image writing encourages the same kind of spontaneity, and takes you to deeper levels of understanding.

You can do image writing immediately after you've finished your collage or in another Visioning session later on. I recommend doing it as soon after your collage-making session as possible. This journal work tends to hasten results in your everyday life, so don't procrastinate on this one. The sooner the better if results are what you want.

JOURNAL: IMAGE WRITING

Purpose:

To contemplate your finished Vision collage; to tap deeper layers of meaning in the collage images

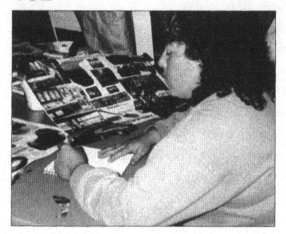

Writing in the journal.

Materials:

- journal and pens

- completed Vision collage

Procedure:

1. Look at your completed collage and observe what's there. Take plenty of time to do this.

2. Using your nondominant hand, write from the images in your collage. Use the pictures and words to suggest metaphors or themes in your written piece. Create a poem, paragraph, or short piece. It doesn't have to rhyme or follow any rules. Don't worry about grammar or spelling. When it's finished, give your poem or piece a title.

Here's an example of some image writing I did just before my sixtieth birthday. The focus phrase for my collage was: "Preview of the coming year." It had the following magazine photos in it:

- autumn trees and ground covered with golden leaves

- abstract textures and bright colors from magazine photos

- roses in bloom

- a seated Buddha

- fireworks in the sky

- a huge sunflower (a creative self symbol)

The list evokes a string of visual images in your mind. However, they don't signify anything yet. Watch what happened, though, when I moved into image writing and came up with the following poem:

What Sixty Looks Like

Autumn leaves dipped in pure gold
Richly woven textures of life moments
Roses unfolding in a blaze
* before winter creeps in*
A Buddha sitting quietly in the heart
* waiting patiently for enlightenment*
While a perennial kid anticipates the next fireworks display
* and party celebrating another decade*
Sixty looks like a giant sunflower,
* standing tall, head held high*
* emanating its own radiance*

There's a big difference between the poem and the list of images. One has meaning, the other doesn't. We make lists with our left brain, poems with both sides of the brain. I could have just written a description of my collage, but that would never have yielded such insights as "a Buddha sitting quietly in the heart waiting patiently for enlightenment." By the way, none of these metaphors were in my mind when I made the collage.

If Pictures Could Talk

Beneath the surface of your collage lies a story. Each image is a character in a play with its own message to deliver. The pieces of your collage puzzle represent parts of yourself, roles you play (or want to play): the inner artist, business person, traveler, contemplative, dancer, athlete, lover, spouse, parent, and so on. As you come to understand what these parts of you need and want, you'll be able to nurture them and give them room to grow in your life. By manifesting your dreams you become your full, whole self, expressing all the beauty you carry within.

The ancient sages tell us "As within, so without." As long as you are in conflict with any part of yourself that is trying to emerge through your dream, it will be a struggle to manifest your heart's desire. Do you want to start your own business? Have a baby? Travel the world? Are you having trouble embracing the business executive in yourself? The parent role? The risk-taker and adventurer within? If so, you'll hold back, resist, and generally throw up barriers to opportunity. The next journal activity invites you to dialogue with the key elements in your collage, to find their deeper meaning, and to embrace them as parts of the whole.

JOURNAL: WRITING BY HEART

Purpose:

To discover the significance behind key elements in your Vision collage; to uncover any conflict with parts of yourself represented by these elements

Materials:

- journal and pens

- completed Vision collage

Procedure:

1. Look carefully at your collage. With your dominant hand, write a list of the key elements or images in your collage.

 - What scenes do you see?

 - Are there people there? What kinds of people?

 - Are there any animals in your collage? Any elements of nature?

 - What about objects? Buildings or other manmade structures?

 - Are there any abstract shapes or textures that seem significant?

2. With your nondominant hand, let each key element or image write about itself in the first person.

- What is its name?

- What are its characteristics or qualities?

- What part of yourself or your life does it express?

- What does this element want from you?

- What gift does it have to give you by way of guidance or advice?

3. With your dominant hand, write down your reactions to what you discovered in step 2.

- Can you apply the insights you received from #2 in your daily life?

- How can you use these insights as practical guidance?

The Story Inside the Collage

As the designer of your collage, you have created the poster of coming attractions for the next episode in your life. In order to flesh the story out and ground it in your body, there are some basic storytelling techniques you can use. By putting your future into the present tense, you can describe in detail the scenes you portrayed. Your collage is providing the visual scenario for a written tale about your dream, just like the storyboards that animators and screenwriters use for developing their plot lines. Use your collage as an all-at-a-glance storyboard or blueprint for what is about to unfold. What does your heart's desire look like, smell like, sound like? How do you feel living the life of your dreams? Do some time traveling. Project yourself into the future. Be there now and write about it. Enter your time machine and play Let's Pretend.

JOURNAL: TELLING MY STORY

Purpose:

To discover the story contained in your heart's desire; to use your imagination to flesh out the details of your dream

Materials:

- journal and pens

- completed Vision collage

Procedure:

1. Looking carefully at your collage, imagine that you are already living the life you have pictured there. Open up all your senses.

 - What sights do you see?

 - What sounds do you hear?

 - What about fragrances or odors? Tastes? Touch and textures?

 - How do you feel physically? Emotionally? Mentally? Spiritually?

 Write about it in your journal using your nondominant hand. Be sure to write in the first person, present tense, for example: "I see a forest with the ocean beyond it and a bright blue sky. I smell the scent of pine trees, feel fresh sea breezes, hear the sound of the surf. I feel energized, creative, relaxed, and at peace."

2. Focusing on one or more of the images in your collage, do some time traveling. Project yourself into a typical day in the future after your dream has come true. Write about it in the present tense using your nondominant hand. Be specific and fill in the details.

 - Where are you?

 - Who are you with?

- What are you doing?

- What's happening?

- How do you feel?

3. Continue to stay in the future and go on writing. This time use your dominant hand. Answer the following questions:

 - How has your *life* changed since your dream became a reality?

 - How have *you* changed? What does the change feel like?

 Write in the first person, present tense, as if you already existed in this future time. For example: "I am finally living a life of abundance. I've healed my fear about being wealthy and feel comfortable with investments, money management, and the responsibility of having money. Money is coming to me easily and without struggle. I'm able to freely give money to worthy causes and this new generosity feels liberating and heartwarming."

4. With your dominant hand, write the story of your inner journey. Write it as a letter to someone you know. Date the letter in the future, after your dream has come true.

 - Describe the heart's desire that you manifested.

 - What did you overcome in order for your dream to come true?

 - How did you face your challenges?

 - What did you learn from taking this journey of the heart?

Notice that in step 1, you were writing positive affirmations. It was in the context of a game of Let's Pretend. For that reason, the critic is less likely to jump out and yell, "Liar! Liar!" After all, you're only playing make-believe. When your dream becomes reality, your positive statements will be real in the physical world.

Eighth Design Principle:
Start the Production Process

An essential part of manifesting your heart's desire is contemplation and visualization (or what I call purposeful daydreaming). You do this by letting your images and words speak to you visually on a daily basis. This phase is where things start to really happen in the outer world. It is the stage of design in which the idea gets translated into final form: the chair design is taken to the production phase, the blueprints are prepared for the building contractor, the clothing design is translated into patterns to be used in production. You're now turning your life design over to the creative self within, which will put your dream into production in the outer world. Yes, it's magic. And it works.

VISIONING STEP 8:
REINFORCE THE DREAM

This phase of Visioning invites you to simply contemplate your collage. You do this by looking at it as well as picturing it in your mind's eye. This is how you reprogram your mind to believe in the reality of what you truly want. You are undoing the programming we've all received that says: believe only in what you see, feel, hear, taste, and touch in the present moment or what you experienced in the past.

What is in your imagination is every bit as real, though. It's just another level of reality. After all, the past isn't "here and now" any more than the future is. Yet we believe in the past. Why? Because we perceived it with our senses. In step 8, you render your desired future believable by taking it in through your senses and burning it into your imagination. Your collage is a projection of things to come.

Architects, designers, artists, and all visionaries believe in imagination. For them the future is very real, the realm of potentiality exists, the veil between the imaginary and physical world is very thin. They move back and forth across that line with relative ease. Their formula: *Picture it in your imagination, represent it on paper or in a model, make it in three dimensions, and build it.* It's no big deal to them. Yet, it seems mysterious to most people. Even for professionals, the whole process inspires a sense of wonderment, no matter how many times we do it. The same is true with Visioning. It is truly awesome to participate in this creative process.

How do you learn to cross the line between imagination and physical reality? By reinforcing the image each day. This is done through looking at your collage and by practicing mental imagery or visualization. When you look at your collage on a regular basis, you cultivate its reality in your mind. Your collage becomes a visual affirmation.

You may be familiar with verbal affirmations: positive statements in the present tense about what you want to manifest. Spoken or written and read back frequently, such mantras are used to reprogram the mind for positive outcomes. For instance, a chronically ill person might use the affirmation, "I am healthy and full of energy." Someone with money worries might affirm, "I experience abundance and well-being." Although verbal affirmations have been quite effective for some, they often bring up resistance in the form of inner chatter. The critic immediately shoots down the verbal affirmation with a remark like, "That's not true and you know it. Your back is killing you (or you are going bankrupt), so who do you think you're kidding?"

Although there are techniques to counteract this, visual affirmations seem to circumvent this battle altogether. Looking at your collage tends to keep you in your nonverbal right brain so you're less likely to hear the critic. You just take in the collage with your eyes and reinforce it in heart and mind. You keep your eyes on the prize. The same is true

when you visualize by picturing the collage in your mind's eye. Let the images speak to your visual and emotional right brain. Reprogram yourself by drilling your mind in what the new reality looks like.

The other reason visual affirmations are so effective is that your pictures are more like physical reality than words will ever be. Believe me, designers and architects don't sit around repeating verbal affirmations about what they want to create. They're too busy sketching, creating models and prototypes. This gives a whole new meaning to the old saying "seeing is believing." It's true. The more you see your dream, the more you'll believe it. And the more real it will become.

VISUAL AFFIRMATION AND VISUALIZATION: WHAT YOU SEE IS WHAT YOU GET

Purpose:

To use your Vision collage as a visual affirmation; to reinforce to your mind and body the reality you are creating from your heart; to practice purposeful daydreaming

Materials:

• completed Vision collage displayed where you can see it daily

Procedure:

1. Reserve a few minutes three times a day to sit quietly and look at your Vision collage. Good times to do this are early in the morning, middle of the day or early evening, and just before retiring for the night. Be sure you are not distracted or interrupted while contemplating your collage.

2. With your mind, put yourself in the picture.

 • Walk through the scenes you have portrayed in your collage.

- Enjoy the atmosphere, the feeling of living in your dream.

- Get up and actually walk around the room or space the way you did in your imaginary stroll through your collage.

- How does your body feel? Do you notice any change?

3. During the day, spend some time visualizing your dream in your mind's eye. Do this with intention for a focused period of time (about two to five minutes).

If you are in the habit of meditating, #3 above can be done before or afterward. Visualization is a great way to "kill time" (or should I say, use time well) while waiting in doctors' offices or on the phone. Get into the habit of practicing this kind of purposeful daydreaming.

Dealing with Resistance

You were already introduced to the inner critic in chapter 6. That voice in your head is likely to appear during this phase of Visioning. It will test you and try to wear down your resolve. Be alert for self-sabotage because that's usually the inner critic at work. By self-sabotage, I mean those golden opportunities you don't follow up on, the phone calls you neglect to return, the invitations you turn down that could move you closer to your heart's desire. Those opportunities are all gifts from your creative self. Don't neglect them.

My favorite self-sabotage fable is about a man who is caught in a flood. As the water rises, a fireman comes by in a big truck and offers him a ride. "No," he says. "I have faith in God. He will save me." Meanwhile the ground floor of the man's house is flooded, forcing him up to the second story. Some neighbors come by in a boat, urging him to climb out the window and jump in. "No, I have faith in God," he tells them. Soon the man is on his rooftop surrounded by water, at which

point a helicopter circles overhead. A rope is dropped and the rescue team implores him to grab on. "No, God will save me," he shouts. A short while later, the house is destroyed by the flood and the man drowns.

In heaven, the man stands at the pearly gates in shock. How could God let him ("a true believer") down? A voice is heard thundering from above. "First I sent you a truck, then a boat, then a helicopter. What more did you want, man?"

Opportunities to live from the creative self are being handed to us every day. But the inner critic will keep us stuck in old ways of thinking and believing. It will cause us to compartmentalize, preconceive, and stay in a safe rut. At this stage of Visioning, the blinders of the inner critic (who doesn't like change and is never satisfied) can pose a huge obstacle.

One thing it may do is induce you to share your dream with people who are critical and echo its negative sentiments. "You see," it shouts gleefully. "Your father thinks this is a stupid goal, too." Or it might say, "Your neighbor's right, this dream of yours will never happen." The result is criticism in stereophonic sound: inside your own head and outside from someone else. It can be quite debilitating.

Protect Your Dream

The solution to this problem is to protect your dream. *Do not share it with people who tend to criticize you.* Don't show them your collage. Don't even discuss the Visioning process if you anticipate they'll shoot your dream down. Avoid setting yourself up for other people's target practice. In chapter 9 we'll talk more about creating a support system for your dream, but in the meantime set clear limits on boundaries for yourself. And remember, those who are not living their dream will be the first naysayers. You know who they are, so don't even go there.

Throughout the Visioning process, the biggest opponent you'll have to face is your own inner critic. If you deal with that one effectively, you'll be able to take on others who try to discourage you. So be on the alert. You may need to go back to chapter 6 and do some journal dialogues. If you've done that and your faith starts to flag again, try dialoguing with your inner wisdom about the collage.

JOURNAL: KEEPING THE FAITH

Purpose:

To rekindle enthusiasm for your dream; to reinforce your heart's desire; to tap into the strength of your creative self

Materials:

- journal and pens

- completed Vision collage

Procedure:

1. Write a dialogue with the creative self symbol in the center of your collage. Ask questions with your dominant hand, answer them with your non-dominant hand. Ask your creative self to help you through any obstacles that stand between you and the fulfillment of your dream. What words of wisdom does it have for you?

2. With your dominant hand, write a letter to your creative self.

 - Turn your dream over to its care.

 - Thank it for guiding your life.

 - Express gratitude for the resources you've been given.

If you really want to hear God laugh, tell Him or Her your plans. **ANONYMOUS**

A Wish Your Heart Makes

This may be the most difficult aspect of reinforcing the dream. It's the part where you relax and let go.

let go of attachment to the outcome

let go of masterminding the means to your goal

let go of rational planning

let go of worry

let go of negative beliefs

Let your creative self take care of things in its own mysterious way. Have faith that the creative process is at work. To help you along, here are some words a friend shared with me that I have displayed next to my computer.

Good morning [your name here],

This is God speaking.
I will be handling all of your problems today
and your help will not be needed.

Have a nice day.

Keeping the faith means trusting in your creative self, the source of your wishes and the magnet for drawing opportunity to you. Your job is to welcome the blessings that will befall you. Open your heart to magic and miracles. Keep your eyes open for signs and messages that are pointing you toward your dream come true. The way will be shown, but you need to follow. Say yes to your creative self. It's the best invest-

ment in your future that you will ever make. Remember to say your mantra:

> I have all the good qualities and resources within me to fulfill my desires.

And to show good faith, say "Thank you" now. Your creative self will always bless a grateful heart.

9 Seeing Is Believing

"Come to the edge,"
he said.
They said:
"We are afraid."
"Come to the edge,"
he said.
They came.
He pushed them . . .
and they flew.
GUILLAUME
APOLLINAIRE

You came into the world bearing a precious gift: your own individual destiny. No one can live it for you and you cannot live anyone else's. By destiny I do not mean to imply a preordained script written in stone over which you have no control. Rather it is your soul's DNA, the seed of your true potential, which you are charged with cultivating. Your creative self carries that seed, your creative conscience speaks for it. When you lose heart, enthusiasm, vitality it may be that you have neglected the daily whisperings from your creative conscience. Its inner compass is pointing you in the right direction, but you aren't bothering to stop and look at it.

If entered fully, the next phase of Visioning can reconnect you with that sacred trust that is your destiny, revitalizing all areas of your life. It can restore your childlike sense of magic while at the same time opening up an innate, ancient wisdom. The next step takes you across the threshold into true alchemy: turning the ordinary events of daily life into the gold of your heart's desire.

VISIONING STEP 9:
EMBRACE THE REALITY

Allowing your Vision collage to bear fruit requires that you embrace both your dream and your present life with awareness. If you pay close attention, you'll find that each day brings messages and opportunities. Each experience invites you to see beyond the visible and ordinary, just as when you looked beneath the surface of your collage images. Interpreting the deeper meanings in your collage was practice for this kind of heightened awareness. Understanding the language of symbols and images enables you to recognize your dream as it unfolds before your eyes.

Don't Just Do Something, Sit There

At this point, our culturally conditioned tendency is to break into a run: strategize, plan, and try to control outcomes. I often hear new Visionaries ask, "Okay I finished my collage. What do I do now? What's the game plan? What action do I take to make this happen?" Our society worships at the shrine of quick results and fast profits. Visioning doesn't work that way. It follows the pathways of the heart, which are neither linear, rational, nor predictable. Rather, they meander through the field of dreams and turn up the most wonderful surprises. In this case, the shortest distance and most effortless path between two points is not a straight line. It's more like water flowing around rocks in the riverbed. Your heart's desire has its own momentum, rhythm, and impulse. Your job is to stay true to the dream, be alert, and open the door when opportunity knocks.

Although planning and structured activity have their place and time, they need to be subservient to the dream. I know this sounds like heresy, especially to those who work in results-oriented organizations and corporations obsessed with product and procedures instead of

process. However, it's still the truth. Dreams that are full of heart take on form in the physical world in ways that cannot be predicted, controlled, or forced into neat little bottom-line formulas.

Yours is not to ask *how*, but to declare *what*. What you desire is your business, how it will come about is up to the creative self from which the desire sprung in the first place. You're simply the open channel through which the creative process is flowing.

This is the way of breakthroughs. And that means a new way of seeing. When you look at the world with the eyes of your heart, opportunities you would have missed before will loom up in neon lights. You won't be able to miss them. Hunches you used to shrug off as silly or irrational will speak to you now with an urgency you cannot ignore. For example, the day I found my dream house, I was merely taking a break from writing, enjoying a longtime hobby: looking around at architecture and property just for the fun of it. For me it's sort of like going window shopping. I'd looked at many homes during the years I'd been visiting the area. What was different this time was that the pictures from my recent collage were in the back of my mind. Having been reinforced daily for several months, those images were waiting on my radar screen for the perfect match to present itself. And so it did.

Miraculous is the key word here, for that's how these events seemed. The place where I was staying when I found my home is called Serendipity, which means *the gift of finding valuable things not sought for*. Although I had stayed there many times, I had never noticed my future home right down the hill on the next street even though it is visible from every room. My heart's desire had been literally under my nose for a couple of years waiting to be discovered.

Applying the principles of Visioning, I had let go of *how* my dream would come about and had turned it over to my creative self. It couldn't have happened any other way. My schedule was so full I had neither the time, energy, nor inclination to go house hunting or plan a relocation.

As the saying advises, I had to *Let go and let God.* My home wasn't brought to me until I was ready for it. I say "brought" because I didn't discover it myself. A realtor took me there after I told her how much I loved the particular part of the forest where I was staying. You'll find the complete story in chapter 14.

What's Behind the Dream

One way to let go of preoccupations with *how* your dream will manifest is to make room for the new *you* that is emerging. To fully accept that your dream will come true, you have to see yourself playing the role in your new visual scenario. What part of you wants to emerge? The artist, the homebody, the business entrepreneur? Of course, the role is not who you *are*, it's a way of experiencing. The role allows you to stretch and grow and become a fuller human being. That's why children role-play and enjoy let's-pretend games. They instinctively want to try on different selves, different ways of being in the world. You were already practicing that mind-shift when you took imaginary walks through your collage in chapter 8. It's a practice that bears cultivating in the days and weeks after you have finished your Vision collage.

It should be clear by now that each step of Visioning builds on the one before. If you've reinforced your dream through contemplation and journaling, by the time opportunity knocks you'll have your hand on the door ready to welcome it. When you open that door in your heart and see your dream standing there, you'll know you have entered what David Whyte calls "the moment the soul enters the gravity field of its own destiny." You'll see that you have drawn your heart's desire to you through the magic of magnetism. It will seem like nothing less than miraculous. Why miraculous? Because you didn't take the old linear, logical road. Instead, you followed the pathways of the heart, *allowing* rather than manipulating things into shape.

It's About Time

It's easy to talk about allowing things to unfold, but doing it is something else. To counteract the tendency to push instead of unfold, you can practice observing the daily events of your life and witnessing what's going on around you. At the same time, you need to understand that there are no guarantees. I can't predict and neither can you how or when the opportunities will come. That's not your job anyway. It's up to the creative self which is guiding this process. And believe me, letting the creative self work its magic is much more fun than trying to control everything yourself. It takes less effort and it brings with it amazing surprises. What you *can* do is prepare yourself to embrace your dream when it appears in the world of 3-dimensional time and space. I do believe that when the dreamer is ready, the dream comes true.

JOURNAL: AT THE WRITE TIME

Purpose:

To reflect on the events of your daily life from the new perspective of your Vision collage; to develop greater awareness of opportunities coming from your creative self; to stay attuned to your creative conscience

Materials:

- journal and pens

- Vision collage

Procedure:

1. Sit quietly and look at your Vision collage. Reflect on recent events in your life. Write about them using your dominant hand.

 - Do you see any signs leading toward the realization of your dream?

- Can you see any opportunities presenting themselves?

- What has occurred that is taking you closer to the fulfillment of your dream?

2. With your nondominant hand, write down your *feelings* about your heart's desire at this time.

 - How do you feel about opportunities or signs described in #1?

 - Are any fears or anxieties coming up?

 - Do you have doubts about the possibility of your dream coming true?

3. With your dominant hand, make a list of any obstacles or challenges you are facing, either within or without.

 - What can you do about these obstacles?

 - Is it a problem of negative self-talk? If so, the dialogues from chapter 6 can help.

 - Is it discouragement from others?

4. Try dialoguing with anyone or anything in your life that you perceive as an obstacle. Use your dominant hand to write your voice and your non-dominant hand to write for the other person or thing that poses a barrier.

5. If you are facing obstacles or challenges of any kind, write a prayer, invocation, or request for help to your creative self. Use your dominant hand.

Taking Care of Business

Embracing your dream means accepting all the challenges that come with it. Expecting it to be handed to you without some inner work is unrealistic. Committing to your dream is like becoming a parent; you're in it for the long haul, "for better or for worse." For instance, I can tell you

that wading through the interminable paperwork of the home-loan process, packing, crating, and shipping a lifetime's collection of furniture, artwork, collectibles, and office equipment was no fun. But it was part of the deal. First, you get your dream, then the real work begins. If you think that manifesting your dream means you're moving to Easy Street, forget it. Visioning is not a frivolous parlor game. The creative self tests you to find out if you're worthy. When you pass the test, it brings your dream to you in material form.

We can talk about the magnetic power of one's heart's desire, about the nonlinear nature of the pathways of the heart, yet we must be prepared to use the left-brain process of putting one foot in front of the other. There's a place for the slow, decidedly unmagical side of life: filling out forms, scheduling the calendar, and keeping track of things in a personal day planner or computer database. If you can't handle the mundane, the chances of your dealing with the magic of creativity are going to be pretty slim. You may get your dream, but if you aren't grounded in the procedural side of things, you may not have a vessel to contain it. Before the master musician can surrender and let the creative self play its divine music through her, she has studied and practiced for years and years.

I had years of experience in business before purchasing my house. If I'd been afraid of business dealings, I would have thrown up my hands in the middle of final negotiations. Each step of the way I was prepared to let the house go if it was going to be too much of a financial or emotional hardship. In other words, if it was going to take me hostage. Using my left brain to analyze the economic and emotional implications, I set limits. Many is the day I wanted to walk away from it all. While in escrow, I often thought: *Why am I doing this? I don't have time to tear my life apart and pack and move right now. I have a book deadline to meet. This is crazy!* But my creative conscience kept nudging me on. It would say things like: "There's always going to be an excuse for not having your heart's desire. This is what you asked for. Do you really want it or not?"

Of course, the answer was always a resounding "Yes." So I jumped off the cliff and learned (once again) that I could fly.

In making room for your dream, there will inevitably be gains and losses. You may have to let go of something: an attitude, a project, an attachment to something or someone. Perhaps it's time to mourn the passing of those elements that have become outmoded or lifeless. In deciding what you will and will not do, what extra baggage you are ready to drop, you can clear a space for your dream.

In order to embrace your dream, you need to use your head and your heart. Listening to your heart is not about frivolous or compulsive behavior. You'll want to avoid acting against your best interest, and that requires balance and levelheadedness. The next journal process will help you assess those things that are making it more difficult for your dream to take up residence in your life.

JOURNAL:
THINKING WITH BOTH SIDES OF YOUR BRAIN

Purpose:

To assess what you need to let go of in order to have your dream become reality, to say good-bye to the past, to acknowledge your limits and boundaries

Materials:

- journal and pens

- Vision collage

Procedure:

1. Sit quietly and look at your Vision collage. Using your dominant hand, complete the following sentence as many times as you like. *In order to realize my dream, I need to let go of ____.* These could be attitudes, feel-

ings, behaviors, self-definitions, relationships, a job, the place you live, etc. When you feel finished, go on to the next step.

2. With your dominant hand, on another page draw a simple picture or symbol for each of the things you need to let go of. Give each one a name.

3. With your nondominant hand, write down any feelings that came up during steps 1, 2, and 3.

 • Is there any sadness?

 • Can you say good-bye to these things that hold you back from embracing your dream? If so, write about it.

4. Write a dialogue with each element you pictured or write a farewell letter to it. If you do a dialogue, write your voice with your dominant hand and the voice of the element you are letting go of with your nondominant hand.

5. With your dominant hand, complete the following sentence as often as you like:

 What I'm willing to do to realize my dream is ____.

 Then complete the next sentence:

 What I am not willing to do to realize my dream is ____.

6. With your dominant hand, complete the next sentence:

 What I would like from realizing my dream is ____.

As Luck Would Have It

When lady luck, serendipity, kismet, or whatever you want to call it starts showing up, the heat can get pretty hot. Things often happen very quickly and it seems that there is just too much change to digest. Change isn't easy: lots of change in a short period of time can be quite stressful. At this point we may feel like we're being dragged kicking and

screaming into our destiny, not unlike Mickey Mouse as the Sorcerer's Apprentice in the movie *Fantasia*, with water-bearing broomstick characters run amok, flooding everything. We got what we wanted, but can we handle it? Part of us says "Yes" to our dream, another part says "Well, maybe" and another part might be saying "No, not yet," or "No, not under these circumstances."

I don't believe in accidents or coincidences. There appears to be a greater cosmic force that is working beneath the surface of things. As the scriptures say, "Ask and ye shall receive." The art of receiving from the creative self is to observe and embrace events and circumstances that look like coincidences. Sometimes a lot of these fortuitous occurrences crop up one right after the other. If that happens, just remember, *when the going gets tough, get out your journal.* Find out what your heart has to say, and find out what your head has to say, too. The head is great with practical matters and daily details. It has a contribution to make here. Just be careful that you don't put the cart before the horse. In this case the heart is the horse that takes you where you want to go. The cart is your head (full of valuable "stuff" to be used on the way and when you've reached your destination).

JOURNAL: IN THE WRITE PLACE

Purpose:

To identify the opportunities that are coming to you; to inventory your choices; to distinguish between the actions you need to take and those that belong to the creative self

Materials:

- journal and pens

- Vision collage

Procedure:

1. Sit quietly and look at your Vision collage. Using your dominant hand, write about the opportunities you have accepted that are moving you toward your dream.

 - What are they?

 - What have you done with them?

 - What choices have you made?

 - What changes have you made?

2. With your dominant hand, write about the things you can't control regarding your heart's desire.

 - What areas do you have to turn over to your creative self?

 - Who or what do you need to trust?

 - How do you do this?

Reach Out for Help

You are not alone in your quest for the Holy Grail of your heart's desire. As with all fairy tales and legends, the hero or heroine (that's you) always has helpers. In children's stories they may be animals, the fairy godmother, a wizard, or even seemingly ordinary folk. As a heroic tale, your journey of the heart has all the ingredients of the best stories. A vision that motivates you forward, some impediments to test you (both internal and external), and some helpers. Support for your dream will come in the form of faithful friends and loved ones, mentors, coaches, support groups, and other resources.

Orchestrating a support system is truly an art. It requires that you be the casting director and judiciously decide who plays what role. I

learned about this film and theater model for team building while working as a consultant at Walt Disney Imagineering. I kept hearing the term "casting" when design teams were being assembled. At first, it seemed odd to be applying theater lingo to design work. Yet, after a while it seemed perfectly appropriate. Each person's contribution to a team is also a role they play for that particular project. Like a repertory company in which the star of one production might be the stage manager of another, the parts are fluid and are driven by who brings the best blend of talents, skills, and interests to the particular tasks.

Your dream-in-the-making is a project. Those who can help you are actors in your play. Who can lend an open ear? Who has the information you need? Who can teach you some new skills? Who can cheer you on? It's up to you. Choose carefully, for you don't want anyone raining on your parade. Just because someone's a friend, relative, neighbor, or co-worker doesn't necessarily qualify him or her to play a part in your Visioning project. When I purchased my home, my support team consisted of my mother and three close friends (cheering team), my personal realtor (with guidance on how to get the loan, moral support in negotiating a good price, and valuable technical information), the mortgage company, the transfer and storage firm (who took care of the moving), and two friends (who helped me get unpacked and settled in). You can see how each person or group had a specific role to play.

As you build your support team, look for people who believe in you and your ability to realize your heart's desire. These are usually folks who have realized dreams at some point in their lives. They understand what it's like to have a dream and go for it. They understand what it means to take a risk, to jump off the cliff and fly. They will be your greatest helpers. Positive people love to help others. So don't hesitate to ask. I know because I have mentored hundreds of people myself, through counseling, teaching, and my books. It's very gratifying to hear about their results. There are people who want to help you live your dream. They're out there. Find them.

JOURNAL:

MY PERSONAL DREAM TEAM

Purpose:

To create a support system when you need help of any kind in embracing your dream

Materials:

- journal and pens

Procedure:

1. With your nondominant hand, draw a circle in the center of your journal page. From the circle draw some lines radiating out to the edge of the page. Think of the image of a sunburst.

 In the center of the circle, write your focus phrase. On the lines emanating from the circle write the names of people, groups, or resources that you can count on to help you embrace your dream.

 Beneath the line, under the name of each resource, write the function that person plays: cheering team, information resource, technical help, mentoring, etc.

2. Write a "job description" for each person on your support team. Outline what you want them to do and why you think they're the best person for the job. What "qualifications" do they have?

 - What qualities and personality traits do they bring to the job?

 - What talents and abilities do they possess?

 - What skills and experiences qualify them to help you?

 You can write this as a letter or memorandum, if you wish. For example:

Ted:

I need you to mentor me in this undertaking. I know you've accomplished something similar. You've probably encountered some of the challenges I'm currently facing. I'd like to know what you did in similar circumstances. I also need your inspiration. Besides being a practical dreamer, you're an enthusiastic person. Sometimes when I feel doubtful, I just need a little shot in the arm, someone to tell me I can do it. You know it can be done because you did it!

Now, let go. Have faith that your creative self will lead you every step on the pathways of the heart. Trust that your creative conscience will reveal to your mind that which your heart already knows. And so be it.

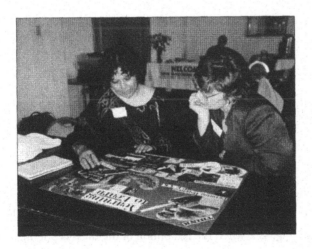

Sharing dreams.

Let's Have a Party

Tenth Design Principle:
Complete and Celebrate
the Final Product

In the design process, it's hard to say when the product is completed. Is it the first chair off the assembly line? Is it when the building is standing? Is it when the last button of the dress is put on? Each individual designer marks that step differently. With my first book, that moment came when the first box of books arrived from the publisher. As I stood there with the first copy in my hand, I knew the process was complete. Now I could celebrate. Some authors might feel complete when they send the final manuscript. This is an individual call. Only you will know deep in your heart when your dream has materialized.

VISIONING STEP 10: CELEBRATE
THE DREAM COME TRUE

Your heart's desire is now a living reality. Congratulations! This last phase of Visioning invites you to honor yourself, and also to express gratitude to your creative self and to those who helped you along the way.

There's no way to know when it's the right time to do this step. You'll have to decide. It depends upon how your dream unfolds and at what point you feel the need to start celebrating. It may take a few weeks, months, or more, depending upon the complexity of your heart's desire. The creative self has its own internal rhythm that gives us what we need when the time is right. Dream your dreams, do your work, but have patience and faith as well. Turn the results over to your creative self and trust the process. And remember that it is a *process*; there's no end point. Celebration occurs when you feel like acknowledging yourself, your creative self, and others who have helped you in your journey.

Let's start with you. Although self-acknowledgment may seem obvious, most people don't do it enough. It's so much easier to get caught up in what you *didn't* do, what you did *wrong*, or the things you still *have to do*. Those are all areas the inner critic loves to harp on. But where is the part of you that pays *compliments* to yourself, that says: "You did a great job! You put in the effort. You kept the faith! Good for you!"

Inside all of us there is a nurturing self, a voice in our head that can cheer us on, give us moral support and love, and reward us with treats when we accomplish a difficult task. Buying yourself a bouquet of flowers, getting a massage, taking a day off for rest and relaxation, going to your favorite restaurant for a special meal. You have your own list of special treats and thoughtful gestures that say, "I love you," to yourself. But actually doing them on a regular basis is not as easy as it may sound.

> We don't take pleasure serious enough.
> **CHARLES EAMES**

Lots of people were brought up to equate self-nurturing with selfish. They feel guilty for treating themselves with TLC, although they hope

for it, expect it, or demand it from others. When they want to treat themselves, their critic jumps in and says things like: "You can't buy that; you don't deserve it. You can't afford this. How frivolous! How extravagant! Take a day off to do nothing? Who do you think you are indulging yourself like this? You're supposed to be generous toward others. Don't be so self-centered. Get to work."

We all have the ability to nurture, but some people's nurturing self is focused *only* on others. They take care of kids, animals, family members, customers, the boss, and anyone in need. Being generous is certainly a wonderful virtue, but without generosity toward ourselves, we easily get out of balance. When the nurturing self is only turned outward toward others, there's nothing left for us. We end up feeling drained and resentful toward all those who take our energy, time, money, or attention. We're mad at the boss, co-workers, our kids, spouses, or anyone else we feel we've given to excessively. Eventually, the well runs dry and we have nothing more to give. The solution is to replenish our energy by directing the voice of the nurturing self inward and to turn up the volume.

Step 10 is about self-acknowledgment, gratitude, and celebration. It starts with you and spreads out to others. Hopefully, step 10 will be integrated into your life and spill out into everything you do. Honoring yourself on a daily basis benefits you and everyone around you. Get in the habit of rewarding yourself for taking risks, putting out the effort, achieving your goals, or even for failing (if you gave it your best shot). Fill your cup to overflowing.

What better reason to acknowledge yourself than the fact that you dared to dream and went for it. We all celebrate birthdays, anniversaries, graduations, weddings, promotions, and other turning points in our lives. Your dream coming true is an important event that deserves to be honored in the same way.

JOURNAL: GIVE YOURSELF A HAND

Purpose:

To get in touch with your nurturing self, to honor and acknowledge yourself for listening to your heart's desire and nurturing your dream

Materials:

- journal and pens

Procedure:

1. With your dominant hand, let your nurturing self write a letter to you. This is a love letter acknowledging you for going for your dream. It commends you for the risks you've taken, the time and attention you've given to Visioning your dream, and the faith you've shown.

2. Read the letter to yourself out loud.
 Optional:

 - Read the letter into a tape recorder and play it back.

 - Ask a good friend or loved one to read your letter out loud to you.

3. With your nondominant hand, write down any feelings that came up while you were reading your letter out loud or listening to it being read (by someone else or from your tape recorder).

4. Copy your letter and send it to yourself in the mail.

5. With your nondominant hand, make a list of treats and rewards you'd like. Write them in your calendar and be sure to follow through on them.

Lessons Learned, Qualities Earned

Visionaries report that their lives have changed internally as well as externally. They say things like:

- "I'm so much more creative now. I apply parts of this process all the time in my everyday life."

- "Keeping a journal for Visioning taught me a habit of self-reflection."

- "I've really learned to relax and trust my creative self to figure out how things will come about."

- "My self-confidence has skyrocketed since I manifested my dream. I've never felt so empowered."

- "I love collage-making and do it all the time now, just for fun. I think I discovered some artistic talent."

Acknowledging your inner transformations is a beautiful way to honor yourself.

JOURNAL: YOU'VE GOT WHAT IT TAKES

Purpose:

To acknowledge skills and qualities you have strengthened or acquired through Visioning; to review the challenges you faced and how you rose to the occasion

Materials:

- journal and pens

Procedure:

1. With your dominant hand, write about the changes you've observed in yourself as a result of your Visioning work.

 - How has your life changed?

 - How have *you* changed?

 - What new skills have you acquired?

- What talents or abilities have you developed?

- What new attitudes or perspectives have you cultivated?

- What have you learned about yourself?

2. With your dominant hand, write about your life today.

3. Review what you journaled in your time travel projection, "Telling My Story," in chapter 8.

- Are there any differences between what you imagined then and the reality of your life today?

- What are the similarities?

Saying Thanks

Acknowledging all the support you received throughout the Visioning process begins with thanking your creative self. As the source of your creativity and the sustaining force that helped you reach for your dream, your creative self deserves your gratitude and appreciation. This is an opportunity to express thankfulness from the bottom of your heart and to do it in as creative a way as possible. Starting with a thank-you letter, you can go on to conceive a unique and very personal ritual of gratitude to your creative self.

JOURNAL: THANKS TO THE CREATIVE SELF

Purpose:

To express gratitude to your creative self; to create a unique ritual of thanksgiving

Materials:

- journal and pens

Procedure:

1. With your dominant hand, write a thank-you letter to your creative self. Describe your feelings and experiences to your creative self.

 - What has it given you?

 - What has it taught you?

2. Design and carry out a gratitude ritual for expressing thanks to your creative self. Be creative and devise something that is unique, original, and heartfelt.

 - Is it a prayer you write or special card you make and display?

 - Do you dedicate a special corner in your home to your creative self?

 - Do you create a dance, ritual, or ceremony of thanks?

 - Is your ritual done alone or with others? If others are included, who are they and what role do they play?

3. With your nondominant hand, allow your creative self to write a message to you. If you have any questions to ask, write them with your dominant hand and allow the creative self to respond with your nondominant hand.

Credit Where Credit Is Due

Respect and appreciation bring people closer together. When you help to lighten someone's load or brighten their lives, it makes you feel good about them and about yourself. Hopefully your Visioning work opened you up enough to ask for help. If it did, you probably formed your personal "dream team" and experienced the blessing of asking and receiving. Now it's time to give back.

Those who extended themselves to you deserve your appreciation. No matter what role they played — mentor, cheering section, technical assistant — their part in your dream was important. Just as plays, movies,

and television shows always have credits at the end, your story has a list of credits, too.

LETTER WRITING: REACH OUT AND THANK SOMEONE

Purpose:

To identify those who helped you in any way to realize your dream; to show appreciation to those who supported you

Materials:

- journal and pens

Procedure:

1. With your dominant hand, make a list of all those who helped make your dream a reality. Next to their names, write down what their contribution was.

2. Express your gratitude to each one on your list. Do this in ways that feel appropriate for both you and the other person. Consider some of the following ideas:

 - Phone, fax, or E-mail a thank-you.

 - Send a note or letter to your supporters telling them what they did for you and how you feel about it.

 - Make a photocopy of a picture of your collage and a picture of the reality and send it to your "dream team" with a note of thanks.

 - Send a little token of appreciation, a charm or object that symbolizes your dream.

 - Create an "award" (certificate or ribbon) acknowledging the person's contribution.

Celebrating the Dream

Artists have a lot to teach us about how to celebrate one's dream. Having dedicated their lives to the creative self, to weaving dreams and making them come true, people in the arts seem to know how to say thank you through parties. After the run of a play or TV series, there's usually a cast party. Performers in the entertainment world are feted all the time, especially for opening nights. Art show receptions, new building dedications, book signings are other ways to celebrate the dream come true. Perhaps because society doesn't reward most artists with financial abundance, they've learned to reward themselves. Such festivities are a great reward for a job well done.

Celebrations are also a wonderful medium for expressing creativity in a playful and whimsical manner. They don't have to be expensive or burdensome, either. Honoring the dream, the dreamer, and the dream team can be a group effort. If you'd like a bash, but don't want all the responsibility, gather some willing members of your support system and brainstorm some ideas. When I moved into my dream house, I invited a handful of folks I knew in my new community to a housewarming. But I also asked them to bring one or more good friends who they felt I should meet and vice versa. We had a great turnout. I displayed my collage, told my "dream story," and gave credit to my "dream team" members who were present (friends, my realtor, my mom, etc.). The new friends I made that night helped me get established in my new life. Since then, a stream of visitors—old friends from Los Angeles and all over the country—have come to celebrate my dream house by enjoying it with me. Why not celebrate your life? After all, as you found through Visioning, you are designing it. You can have it any way you like. Use your imagination. Listen to your heart.

JOURNAL:

THROWING A CELEBRATE-THE-DREAM PARTY

Purpose:

To design a celebration in honor of your dream; to share the realization of your heart's desire with others; to show appreciation to your dream team, loved ones, and anyone else who helped your dream come true

Materials:

- Journal and pens

Procedure:

1. With your dominant hand, make a list of people you'd like to share your dream come true with.

2. Describe the kind of celebration you'd like to have.

 - Where is it?

 - Who helps you put it together?

 - What kind of celebration is it? Potluck? Costume party? Picnic? Playful awards banquet?

3. Throw the party!

Congratulations! This is the culmination of a wonderful journey you've taken, and you've arrived at one destination. But the trip isn't over. There are more dreams waiting in your heart and they are all connected to each other, like those brightly colored scarves magicians pull out of their hats. Yank one out and a whole bunch of dreams follow automatically. This is a point of arrival, for now, but it's just the beginning. Once you've acquired a taste for Visioning your dreams, you won't want to live any other way.

And you'll want to share it with others. In the next chapter there are

ideas for how to apply Visioning at home, work, and with any groups or associations you're a part of. If you thought Visioning your own personal dream was fun, try dreaming with others.

> We're just getting started, so if any of you starts to rest on your laurels, forget it.
>
> **WALT DISNEY**

Detail of 2000 Collage.

part

VISIONING IN ACTION

Photo Album

of Success Stories;

Ideas and Suggestions

In the next chapters you'll find some Visioning success stories from people just like yourself, who were facing typical life challenges:

- job stress

- career choices

- financial struggles

- physical illness and pain

- negative body image

- the desire to create loving relationships

- the search for a home

In liberating themselves from fear, the lives of these Visionaries took on the magic of a fairy tale. As you read about their challenges and desires, see their collages and what they manifested in the material world, you may very well find yourself saying: "Ah, yes. That's my story. I'm dealing with the same kind of challenges. That's my dream, too." In sharing these stories, I hope to inspire and encourage you to embrace your own Visioning adventures, to become the hero or heroine of your own fairy tale.

Each set of stories ends with some questions and suggestions pertaining to that chapter's theme. Whether it be work and career, relationships, health and well-being, abundance, or a place to live, there are specific guidelines for delving deeper into your personal issues and desires at any particular time. Since challenges and dreams are ever-changing, you can refer back to these chapters again and again, going to the theme that is most relevant for you.

Visioning in Work and Career

A large percentage of most people's lives is devoted to job or career. Paid employment, whether a random collection of jobs or a well-planned career path, consumes a great deal of time, energy, thought, and emotional investment. In my private practice, I observed that a high-quality work life was of the utmost importance for mental and physical health as well as spiritual well-being. As a corporate career and out-placement consultant, I have worked with hundreds of clients struggling with work-related stress or with job transitions. What I observed was that a chronically unfulfilling career or job situation can be very damaging and can have a domino effect on everything else. Self-confidence is shaken, family life suffers, relationships can be weakened, health frequently deteriorates, addictive behaviors often appear or may worsen, and a condition that could be called "soul disease" sets in.

I have applied Visioning with great success to help clients deal with job dissatisfaction and career burn-out. The fantasy-play that collage and journaling affords allowed them to begin to lighten up and gain a new sense of hope and self-confidence. The long term results have been even more remarkable and truly inspiring. These were folks with ordinary work challenges, such as:

- in the right job but with the wrong people

- in the right job with the wrong work conditions

- in the right career but the wrong job

- in the wrong career

- without any career direction

- out of work

If any of these situations sound familiar, you'll benefit from reading about Marissa, Steve, and Cathy and how they resolved their work crises using Visioning. The fact is that underneath such dilemmas, there is usually a dream hiding. Like a long-hidden treasure buried in your own backyard, the dream is just waiting to be uncovered. Once the vision of "how things could be" is in clear focus, the negative experience eventually loses its power. Why would you want to keep reinforcing an "Ain't it awful" script when you can play "Ain't it awesome"? That's exactly what these Visionaries did. And it paid off, as you will see.

PROBLEMS ON THE JOB: DEALING WITH DIFFICULT PEOPLE

Sooner or later, everyone encounters difficult people on the job. An overbearing or ineffectual boss, an incompetent or troubled co-worker, demanding customers, dishonest vendors, or any combination of the above. Usually such situations lead to the stress of emotional buildup. Feelings get stuffed, the body becomes tense, and energy seems to drain out.

Visioning is a highly effective method for dealing with such situations from the inside out. Why? Because it is possible to safely express emotional buildup through a picture of "what is" and then move on to

visioning "how it could be." The release of tension through collage and writing frees up tremendous amounts of creative and physical energy. Worries and anxiety can be dumped out onto the paper, clearing the way for the vision of a positive future. That's exactly what Marissa did.

Marissa, a therapist working in an intense hospital setting, had been referred to one of my weekend workshops by a friend. A hardworking professional who was used to putting in long hours on the job, Marissa was interested in having some fun through spontaneous expression in art. She looked tired when she arrived and in need of some real recreation. We did collages and paintings along with creative journaling. Marissa got completely absorbed in splashing paint and cutting and pasting images for her pictures. She looked like a little kindergartner daubing bright colors all over the place, tearing interestingly textured papers, and even constructing imaginative 3-D assemblages out of found objects. By the end of the second day there was a light in Marissa's eyes that hadn't been there before. She was smiling and laughing and said she felt rejuvenated. She had left her work-related tension behind. Her creative self had been liberated and wasn't going back in the closet.

Marissa was captivated by the whole experience, so captivated, in fact, that she began setting aside time on weekends to paint and make collages. Her living room was transformed into a studio on those days and, putting job stresses aside, she would fly into the realm of imagination, color, images, and dreams. She even invited a few women she had met at my workshop to share the space with her once a month for doing their own expressive arts explorations. There was no teacher, no structure. The women simply brought themselves and their materials and went to work making collages and journaling. Each session ended with

a "show and tell" circle, as the women shared their work and their insights. In this way, Marissa created a strong support group for herself, one that could offer her encouragement and positive regard, something she very much needed.

Meanwhile, Marissa's job was becoming more and more stressful. A woman who could be described as the manager from hell was turning Marissa's work environment into a horror. This manager was driving the staff crazy with her incompetence, devious behavior, and downright abuse of those under her supervision. Marissa really loved her counseling work at the hospital, but the atmosphere was becoming intolerable. In order to cope with this inner turmoil, Marissa decided to use art as a way to vent her feelings and search for a solution. Instead of quitting or indulging in explosive words or behavior on the job, she exploded on paper in the safety of her own home.

Marissa felt so much pent-up frustration and anger she decided to skip her regular-size art paper and go straight for a long roll of white butcher-type paper. With a paintbrush she scrawled out her pain and the rage she felt toward the manager. This took the form of huge graffitilike words. Unrolling yards and yards of paper, Marissa dumped her feelings out as freely as an angry child. What a relief!

Then using the focus phrase, "What can I do to heal this situation?" Marissa did some meditation and more writing on her butcher paper. This time what came out were positive messages for coping with this seemingly impossible situation. A wise voice from inside was giving her counsel, just as she counseled others in her role as a therapist. Marissa displayed this new "wisdom scroll" in her bedroom, wrapping it around the room from one wall to the next. When she woke up in the morning, got dressed, or went to bed at night, these words of guidance spoke to her, mirroring back her inner strength and a sense of hope.

Marissa also did three collage paintings: (1) "How the Situation Feels"; (2) "How We Might Survive"; and (3) "Peaceful Resolution." All

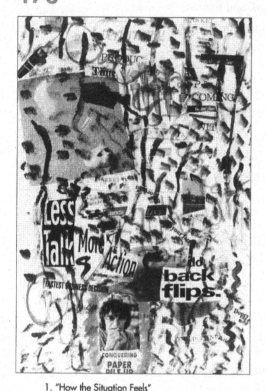

1. "How the Situation Feels"
This was Marissa's picture, showing the chaos and emotional upset she was in over the situation at work. Phrases like "Less talk, more action" and "Back flips" express her frustration with this seemingly no-win situation. And anyone can relate to the words, "Conquering the paper pile-up."

this writing and artwork gave her a way to focus on solutions instead of fixating on the problem. A much stronger and more self-confident Marissa emerged.

Back at work, the manager continued making everyone miserable. Soon, this normally passive group of employees started talking among themselves about the woman's abrasive treatment and counterproductive decisions. There was a revolt brewing. As tension escalated on the job, Marissa did more art catharsis in her off-work hours. She did not report directly to the offensive manager, but the atmosphere at work was definitely getting to her.

By expressing her feelings and getting them out of her body and off her mind, Marissa was able to achieve a kind of inner neutrality when co-workers came to her with their job problems. She could hear their feelings and their desires from a place of strength. In short, she could function the way she did as a counselor, as a sounding board and support who facilitates the growth process of others.

Eventually the staff got together and drafted a letter to the top administration, documenting the manager's unprofessional and abusive behavior. The letter was sent and it worked. Before long, Marissa and her co-workers' wishes became a reality. The manager was removed from the position and the entire department was liberated from a tyrannical leader. The staff all said they felt strengthened by the confrontation and they went on to create a very different atmosphere in the department, one of respect and cooperation. Marissa loves her job again and glows when she talks about this experience, which has transformed her, her co-workers, and the entire work environment. She attributes her ability to deal creatively and effectively with the situation to the Visioning work she was doing at home.

There are many aspects of Marissa's story that are worth noting. First of all, there is the innate spontaneity that arose from the act of art-making and writing. Remember that Marissa arrived at that first workshop in a state of burnout from work. She had so many feelings bubbling inside that they couldn't be contained. She threw herself wholeheartedly into the process, giving herself permission to break out of the bonds of traditional definitions of art. She explored far more elaborate media of expression than just pasting pictures on paper. Her pieces became 3-dimensional assemblages with branches and twigs from nature, twine, and other materials she collected on her own. Marissa's creative self was calling to her to break the old stereotypes about traditional or "acceptable" art materials. After living with the pressure of a tense and restrictive work situation, she grabbed the chance to "let it all hang out" through art expression. Marissa wasn't there to make pretty pictures, slavishly follow directions, or do it like everyone else. Instead she listened to her creative conscience, which was saying, "Go, girl. Here's your chance to let it out."

When Marissa started doing Visioning work at home on her own, she did the same thing she'd done at the workshop: listened closely to her creative conscience, which led her to the most suitable materials and media. Marshall McLuhan was right, *The medium is the message.* When she felt the urge to write her feelings out, Marissa could have used her journal. Instead she grabbed the butcher-type paper, brushes, and paint. This afforded her the size and format to really let loose. Graffitilike scrawls cannot be contained on polite little pieces of paper. Like the angry young "taggers" who deface the walls of our cities, Marissa needed space to shout out her frustration and rage.

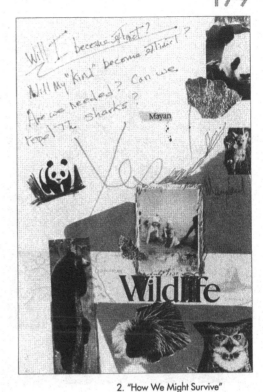

2. "How We Might Survive"
In her second picture, Marissa asked the question: How can we survive? She could only see images of extinction and portrayed this with pictures of endangered species with whom she could identify. She definitely feared for her job. The fact that a manager could be allowed to wreak such havoc in an institution dedicated to helping people was threatening, to say the least.

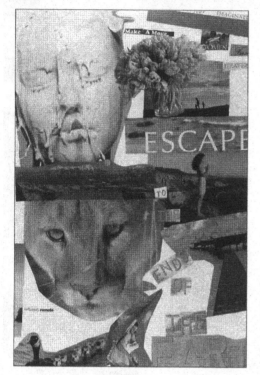

3. "Peaceful Resolution"
This detail from Marissa's final collage shows a positive image from her childhood: a mother duck with her babies. She used to have ducks as a kid. A lion representing strength and power for Marissa stares confidently from the page. An idyllic scene of an island home floating above serene waters appears with the caption, "Escape to the ends of the earth," symbolizing peace, beauty, expansiveness, and an escape from work stress.

As it almost always does, the venting of strong emotions led to that still point at the eye of the emotional hurricane: the inner wisdom and guidance of the creative self. With the very same materials she had used for giving her anger a voice, Marissa found an inner counselor who responded to her question: "What can I do to heal this situation?" From a place of deep knowing and compassion, Marissa's creative self gave her the solace she so badly needed and the courage and confidence to deal with the situation at work. She continued her inner listening when she later did her three-part picture series in which she first portrayed feelings of chaos and confusion, and then fear for her survival, followed by a new vision of how she wanted things to be.

By writing and picturing her feelings and portraying the state of being she wished to achieve, Marissa stayed clear on her vision and surrendered to her creative self. This brought about a newfound inner strength, security, and peace. When the opportunity to take action arose, she was ready.

Using logic, Marissa never could have predicted the course of events. And that's the key factor here, the magic ingredient. "The staff had always seemed so passive before," she told me. "I never expected that they'd be able to bring things to a head in such a direct confrontation. It was so out of character. But, of course, it was wonderful." This is not altogether surprising to me. When one individual in a group starts engaging in the Visioning process and listens to her creative conscience, a new level of awareness and effective action in the world just seems to happen automatically. I believe that Marissa's support of fellow staff members and her ability to facilitate their growth played a key role in the events that occurred.

Job Change and Career Transition

The downsizing of government and corporate America in recent years has brought with it massive changes in the workplace and the way we do business. Gone forever are the notions of job security, the ladder of success, and a pension and gold watch at the end of the employment rainbow. In fact, those very terms seem archaic now. Frequent job change has become the order of the day. In addition to this, we've entered the era of the virtual office, with more and more workers telecommuting or becoming self-employed "techno-preneurs." The TV commercial showing a woman in robe and slippers taking a business call in her home office sums up the dramatic overhauling of the concept of a workplace. As cyberspace becomes the new workplace-without-walls and we acclimate ourselves to the global market, we are pioneering a revolution when it comes to making a living. In this regard, Visioning is a powerful technique for imagining one's work in the world. Whether one is beginning a career, being downsized, or in need of a job change, Visioning has much to offer when it comes to reinventing work. Cathy and Steven are a perfect example.

CASE STUDY: HOLD FAST TO DREAMS

A line from the poet Langston Hughes, ". . . if dreams die/Life is a broken-winged bird that cannot fly," was the inspiration for one of my weekend retreats. This program attracts people who know they need some inspiration but aren't sure how to find it. After taking one of these weekends, Steven and Cathy, a married couple, really began flying. Here's their story.

Cathy, a university English teacher, wanted to become freer and more creative in her work and in her life. Her therapist suggested that she use some of my journal-writing and drawing techniques, both of which helped her a great deal. They also helped her husband, Steven,

who was in serious need of physical healing. He had been working in business administration for sixteen years and had been suffering from chronic headaches, indigestion, and other psychosomatic symptoms for most of that time. Steven had spent thousands of dollars on doctors, physical therapists, treatments, and medication to no avail. One day Cathy suggested that perhaps his physical problems had an emotional cause and recommended her therapist, with whom she had developed a very good rapport. He followed her advice.

Working with the therapist, Steven began journaling on a regular basis. It was through this work that he looked back over the years and became aware of a direct correlation between each illness and a specific job stress. He also uncovered deeply buried resentment toward his father, who did not support his son's early career goal of becoming an artist. Steven's first compromise had been to change his major in college from art to interior design. From there his career path was marked by one compromise after another. He became a furniture salesman, then a facilities manager, and, finally, manager of a design department for an office furniture dealership. He kept getting farther and farther away from his original dream.

As Steven described it, "It felt like floating out in the ocean. The tide kept me from getting back to shore. My father's attitude and expectations were 'the tide' that prevented me from finding my real self. I thought I had to be a responsible adult, a provider, someone who was acceptable to my father." Derailing his career dreams to seek his father's approval had given Steven a constant headache, made him sick to his stomach, and given him lower-back pain as well. It got so bad that he had to leave his job and go on disability.

At my workshop, one particular journal activity really catalyzed some major insights for Cathy. In this exercise the group was asked to do three separate drawings in a series from left to right, like a cartoon. Drawing 3 was to be labeled "The Life of My Dreams" and to be done

first. Drawing 1 was "My Life as It Is Today." Drawing 2 was "The Blocks," and was to depict everything that was preventing them from living the life of their dreams. In Cathy's ideal life picture, a little girl in a red dress runs through a field of sunflowers. Interpreting the picture, she said, "This represents my free and happy inner child. Free to try new things, to not *have* to be perfect."

In the first drawing, depicting her life as it was in the moment, Cathy drew scattered birds and flowers. "A few good things are happening in my life, but I'm scattered and not focused," she said. And in drawing 2, "The Blocks," a woman in a suit stands staring back from the page, frowning and saying, "You need to be perfect—always." A rain cloud hovers over the woman's head. The drawing is all in dark blues and grays, unlike the other two drawings, which are very colorful. Later, writing with her nondominant hand, Cathy's inner child told her she would get a new job, that it would be the right job, and it would be soon.

Upon returning home, Cathy did a career transition collage titled "California Educator," featuring photos of herself in the center with pictures of children and students making art and book projects. There were even photos of the particular school district where she was interested in teaching. Before doing the collage, she'd contemplated seeking such a job but had been dragging her feet about filling out the necessary application forms. Looking at the collage every day compelled her to complete the paperwork.

Cathy then broadcast her vision by sharing it with supportive family members and friends and enlisting their encouragement. She also turned to a support group that had grown out of my workshop, made up of other participants who wanted to continue the work together. Some people might have interpreted Cathy's goal of leaving the university in favor of teaching elementary school as a backward move, a career demotion. But her support system cheered her on, knowing that for Cathy this

was real progress in the direction of what was most important to her: a sense of freedom, spontaneity, and creativity. All of this gave Cathy the extra boost she needed to complete the process of applying for the job.

It worked. Everything pictured in her collage came true: the exact school she wanted, the safe, positive attitudes and atmosphere in the school, the progressive philosophy of education, the salary, the specific grade level she wanted, and even such details as good air-conditioning. (Cathy lives and works in a hot climate and had just come from a school with no air-conditioning.) A few months after my workshop, I called Cathy and Steven to find out if they had seen any results from their collage and journal work. Cathy told me about her collage and reported that she had just that day been hired by the "perfect school." She also told me she had bought herself a red dress. "Just like the one in the picture I drew," she laughed.

As for Steven, he had shown me his career collage at the workshop. He explained that he had created the picture at home (before coming to the weekend program) upon the recommendation of his therapist who was helping him explore new career options. His collage depicted a new life for Steven, the Artist, and Steven, the Woodworker who needs to work with his hands and to create things of beauty. He told me that just prior to making the collage he had applied for assistance in rehabilitation through a public agency. After completing the collage, he was accepted into the program. Then he took my workshop.

The night that I called the couple, Steven told me he'd registered for school that very day and was getting precisely the curriculum he wanted: cabinetmaking and woodworking. What was more, he would be using the exact same tools he had pictured in his collage. Needless to say, I congratulated both Steven and Cathy profusely. Their story is a textbook case of how Visioning works when you work at it.

What is most significant about both Cathy and Steven's story is that they were unhappy in their jobs and they knew it. It is not that they were incompetent, had been fired, or even laid off. They were still working

when they heard the "still small voice" inside telling them something was wrong. Cathy's inner voice spoke through frustration and the feeling of being hemmed in at her university teaching job. Her creative conscience was speaking through uncomfortable emotions that were churning around inside. Her job dissatisfaction turned out to be her ally, however, for it prompted her to seek help. If she had denied her unhappiness or kept it to herself, Cathy would have stayed stuck in an unfulfilling job. Many people do just that. But not Cathy. Fortunately, she admitted she was miserable to her very creative therapist, Paula, who was using tools designed expressly for contacting one's inner guide. The final result was that Cathy envisioned and manifested her "ideal job." By example she also influenced her husband to consider the path of the heart as a solution to his health problems, not realizing that he had the same problem she did: he was in the wrong job.

Steven is typical of the many, many clients I've worked with whose ailments were the disguised voice of their creative conscience. The creative self does not want us wasting our time, energy, or talents in jobs that we hate. It will do whatever it can to wake us up and get us back on the path of the heart. It was on this path that Steven found healing for his body and also work that allows him to live from his creative self. Once he understood that, the opportunities for training in the career of his dreams came to him.

Affirming What You Want

After attending my programs, Esther began affirming for a career as a writer and workshop leader. Photos of women on the go in business reflect the kind of experiences she wants, her new self-image as an entrepreneur, and her financial goals. She has already begun putting on workshops. Esther continues doing collage posters but has expanded her work into Visioning journals of what she wants to accomplish. The goals she pictures there include all areas of her life.

COLLAGE AND JOURNAL APPLICATIONS

Illness and Work

If you are facing career and work challenges and also struggling with illness or physical pain, there might be a direct correlation. We often harbor unacknowledged emotions and stress in the body. Revealing and releasing our true feelings can be a great relief.

Try writing dialogues with the body (which speaks through the nondominant hand). This is another application of the right/left-hand dialogues introduced earlier in the book. With your dominant hand, ask your body or painful body part the following questions:

- How do you feel?

- Why do you feel that way?

- What can I do to help you?

Let your body respond with your nondominant hand.

Also find out what your body needs in relation to your work, job, or career. From your body's perspective, *what does a health-promoting job situation or career look like?* In fact, that question would make a good focus phrase for a collage, especially if you are experiencing temporary or chronic pain and illness.

In dialoguing in your journal, it is really your creative conscience who speaks with the nondominant hand through your body, body part, or emotions. Here's a response from the body of someone who needs to change jobs.

> **Me:** (*dominant hand*) *Why are you sick all the time, especially on weekdays? You're always tired and I just can't get you to do what I'm supposed to do.*

Body: *I HATE that job you've got. I've been trying to get your attention. The only way I know how to keep you from going to work is to be sick. You know you're miserable there, too, but you just won't face it. So I have to do it for you.*

There will be more body dialogue examples in chapter 14, but I wanted to mention it here because poor health often signals the need for a job or career change. This was certainly true in Steven's case. Physical ailments were directly related to job stress. Of course, some pressure or challenges at work are normal, whether it's the dream job or not. But when you experience chronic illness or low energy, I suggest looking beneath the surface symptoms to the emotions that may be buried in the body. Your body doesn't lie. And it can give you some profound wisdom and guidance toward your heart's true desire.

You and Your Career

Another powerful dialogue motif is to have a written conversation with your career. Talk to it as if it were a person. Your voice is written with the dominant hand, your career speaks through your nondominant hand. Ask questions such as:

- What do you want from me?

- What are you here to give me?

- What are you here to teach me?

- What inner qualities or traits am I developing through you?

- What skills am I attaining through you?

The career, job, or work always answer with the nondominant hand.

You can do this journal dialogue with a particular project and you

can also do it with people in your work situation. It is especially valuable when you experience conflicts with others on the job. The same questions apply for people you are relating to. Again, your voice is written with the dominant hand and the part of the other person is written with the nondominant hand.

Exploring the dynamics of your inner world can provide you with insight as well as the strength to deal with difficult situations in the outer world, just as it did with Marissa. Shaping the vision of what you want through collage imagery can magnetize your dream to you, as it did with Cathy and Steven.

VISIONING IN A SUPPORT GROUP

Visionary working in a group.

Visioning may appear to be a highly individual process. After all, one's heart's desires are very personal. However, there is great power in group energy and support. The following are guidelines for Visioning in a group as a way for individuals to receive support and acknowledgment for honoring their own heart's desire. I've included it in this chapter because such support groups have proven to be especially effective for those who are dealing with career or job issues. However, these principles can be applied to any goals.

Organizing a Visioning Group

Many individuals who have attended my workshops became so enthusiastic about designing the life of their dreams that they formed ongoing groups. Other Visioning groups have formed under the leadership of

coaches I have trained. The work being done in these groups has been exceptional. Many have called or written to tell me how powerful the group energy has been for them. Reserving time on a weekly or monthly basis really tested their commitment and moved the Visioning process along. Being with others who are also traveling the pathways of the heart to realize their dreams is reassuring and highly stimulating. During times of discouragement, the group serves as a supportive and caring team. When individual successes are shared, it becomes a victory for everyone.

For those of you who thrive on group support, I'd suggest finding or forming a team for doing individual Visioning. This book can serve as your text, with the guidelines in this chapter assisting you in structuring your group. If you want a trained individual to lead your group or start it off with an introductory workshop, call our referral service at the number listed next to the title page. We'll be happy to recommend someone in your area.

TIME TO MEET—If you leave Visioning to chance, the chances are it won't happen. Make a commitment and stick to it. When considering a schedule for group meetings, it's best to be consistent: same day (or night), same time, and same place. For example:

> Weekly two- to three-hour sessions on Tuesday evenings for
> ten weeks (renewable after the first series)

> or

> Monthly sessions on the third Sunday of the month at 10 A.M.
> for a half or full day, in a series of four to six months or longer

Members are encouraged to do Visioning in their own time between group sessions. This definitely accelerates and deepens the process. Members can show their "homework" during opening sharing periods at the beginning of the session (described below in "Structuring group time").

SIZE AND SPACE —Find a space that works for the size of your group. It's a good idea to keep the group size small and manageable at first. Perhaps three to six, depending on the size of your space. After you've gotten established with one series, your group may grow in size. At that point you may need to move to a bigger space. Just keep in mind that sharing is part of the group process and if your group gets too big, there won't be enough time for each person to be included in group discussions. Sometimes it's better to break up into two groups rather than get too large.

Home spaces that have been used for group Visioning include:

Open living room, dining area, and kitchen space

Den or family room

Garage or workshop

Outdoor patio or veranda (in temperate climates or seasons)

Home studio

If your group is large and you can't find a large enough home, there are other options. Recreation rooms in apartment or condominium complexes are often available. Your local parks and recreation center or church may have a large room to rent out at a reasonable rate.

Each person needs plenty of table space, so if you're meeting in someone's home consider augmenting the furniture with collapsible card or utility tables and folding or garden chairs, if needed. Fold-out or expandable dining room tables make great work spaces. Some groups use hollow doors or sheets of lumber on sawhorses (stored in the garage when not in use) to make more work surfaces. One group turned a Ping-Pong table in the family room into an art space for two. *Be sure to cover all these surfaces with plastic drop cloths for protection.*

MATERIALS —Visioning materials for groups are the same as those rec-ommended for individuals. Each person needs scissors and glue, their own journal, and pens. Some groups prefer to leave the heavier supplies, like magazines, poster paints, and large art paper, at the location where meetings are held. Everyone contributes to this communal stash of sup-plies. Regarding large art paper, an inexpensive ream can be purchased communally (see Resource Guide) and shared. Since there are so many sheets, individuals can also take some home for work on their own. If storing supplies at the host's house is impractical, then each member will need to be responsible for bringing his or her own materials.

Structuring a Group Session

Everyone will need to read this book in advance of attending the group so that they understand the activities and the approach. If your group is not led by a trained facilitator, revolving leadership is advised in which individuals take turns moderating each session. Those familiar with twelve-step programs like Alcoholics Anonymous or Al-Anon will recog-nize this group leadership model.

The environment should be set up by all the members together, so a little time to prepare the space should be allowed before the session ac-tually begins. Once that is done, the activities can get underway.

LEADING A VISIONING GROUP —A typical Visioning session is struc-tured as follows:

Opening

1. **Group sharing.** The session starts with each member of the group taking a few minutes to share. The leader asks:

 What has happened between sessions?

 What are your goals for this session?

It's important to stay focused and be brief. If one member monopolizes the discussion, rambles on, or gets off the track, others in the group will not have time to share. If someone does exceed their allotted sharing time, it's the moderator's job to remind them of time and move things along.

The rule is *no cross-talk*. When one person is sharing, the floor belongs to him. If others start commenting or sidetracking, the discussion can drag on and take precious time away from the activity to be done. Also, analysis and advice from others are to be discouraged. Each Visionary is responsible for her own process and expression, setting her own goals and measuring her own progress.

2. **Assigning an activity.** After the group sharing, the leader reads an activity from the book. Starting with the first activity in session one, each activity is done in the sequence it appears in the book. In a full series of sessions, all of the ten steps of Visioning are covered. Some steps can be done for homework, but they should all be completed in the course of a full series.

3. **Activity.** A block of time is then set aside for each individual to do the activity that has been selected. For a weekly group this might be 1½ to 2 hours (depending on the length of the meeting time). For a monthly half-day or day-long session, the work period might extend to 3 or more hours. Additional work on a particular step of Visioning can also be completed as homework using activities from the book. Many Visionaries find themselves adding to their collage once they get home, or doing more journal work in their own time.

4. **Show and Tell.** Each session ends with a wrap-up sharing in which the members take turns showing their work (a few minutes per person). This is always voluntary. If, for any reason, a

member doesn't feel comfortable sharing a collage or journal entry, that is completely acceptable. No one should be pressured into pleasing the group, however if the atmosphere is safe, members will usually be eager to do so. Sharing oneself gives one a feeling of support and camaraderie with other group members.

Visionaries sharing their dreams.

Group Dynamics

Creating a nonjudgmental atmosphere is an essential ground rule for Visioning groups. It is crucial that a setting conducive to honesty and group support be established. *Safety* is the key word here. If anyone feels criticized, analyzed, or compared to anyone else, the results are likely to be disastrous. Heart-centered artwork and writing do not thrive in an atmosphere of criticism or judgment. We have enough of that going on in our own heads and out in the world without having to hear it from what should be a *support* group.

If anyone starts criticizing or analyzing the work of another group member, it's important that whoever catches it, calls it. For example: "Gerry, when you told Nancy how she could improve her collage esthetically, I felt really uncomfortable. I know you're a professional artist, but I don't feel safe if group members start criticizing the artistic merits of the artwork or writing. We're not making Art here. We're revealing our heart's desires."

The Power of Group Support

As with any effective team, Visionaries are there for each other, providing encouragement and acknowledgment. They often help out with

mundane issues like transportation to the group, baby-sitter referrals, etc. The information swapped in group sharing often turns into high-powered networking that leads individuals to the opportunities they need for realizing their dream. Penny's dream was to produce and market a papooselike infant carrier she had designed for use with her own baby. Another group member put her in touch with an old friend, Kathy, who had formerly owned a handbag design and manufacturing firm. The experienced designer took the fledgling entrepreneur under her wing and introduced her to women who did sewing for manufacturers in their own homes. Kathy also steered her to the right kind of distributors for her product. Before long, this distinctive baby carrier was being successfully marketed through baby furniture and maternity shops all over the city.

Since a feeling of teamwork usually grows over time with a Visioning group, it's a natural context within which to celebrate successes along the way. Such groups go on outings together, have potluck lunches (especially at monthly day-long sessions), and parties to honor the work of their members.

COLLABORATIVE VISIONING FOR TEAMS, COMPANIES, AND ORGANIZATIONS

Visioning at Work

As a corporate consultant and job out-placement counselor, I've had many opportunities to apply Visioning in business and industry. It's been amazing to see people at all levels of a company and from all walks of life respond enthusiastically. This approach brings an element of playfulness, creativity, and spontaneity into a world that tends to become quite serious and overly structured. Visioning releases stress and

brings heart into the workplace. For that reason, it is a perfect tool for doing corporate and organizational visioning from a higher place of creativity and wisdom.

Visioning brings some levity and humor to tasks like picturing the company's vision and crafting its mission statement. As opposed to more left-brain approaches to organizational goal setting, this approach is best exemplified in one of my favorite movies: *Big,* starring Tom Hanks as Josh, a little boy in a man's body. Hanks's character gets his wish to be big and ends up working as a toy designer and tester. Because he's really a kid, Josh's criteria for a good toy is to ask: Is it fun? Can you play with it? At a design-review meeting, his stuffy rival presents all kinds of left-brain market analysis, charts, and diagrams "proving" that a certain toy will sell. But when Josh tries to play with it, he comes up with a blank. Market research means nothing to the boy in the man's body. The toy is no fun! You can't play with it!

Having worked as a toy developer and tester at Mattel as well as a consultant to the world's premiere theme park design team, I can tell you that attempts at innovation that lack playfulness, intuition, and enthusiasm are likely to fall flat. Likewise, a mission statement or corporate image is useless if it can't inspire the employees and draw customers to your service or product. Left-brain logic simply cannot do the job. The visual, intuitive right brain can. And that's where Visioning techniques come in.

The visual nature of Visioning makes it perfect for pictorial "visioning," for creating "mission statements," and for sketching out the big picture for the future. It's extremely useful for visualizing a project's scope and essence, for fruitful team building and project focusing. Any organization—corporation, small company, community group, or institution—can benefit from using this method.

The freewheeling, nonlinear nature of Visioning coupled with the journal-writing that can be shared verbally in a group makes it a natural

for brainstorming new products and services. This is the phase in which innovations are hatched. In these sessions anything goes, all ideas are put out on the table (flip chart or mural) no matter how crazy or impractical they may seem. Judgment and criticism are parked outside the door and the playful, creative child within (like Josh in *Big*) gets to come out and have fun.

Creative problem-solving is another area in which Visioning techniques have been used in companies and organizations. "Before" collages can visually depict the problems and "after" collages show the desired solution (how things will look after the problem is solved). Marissa's story showed one woman's individual "before" and "after" collages, which contributed to solving major problems with management at her place of employment.

Visioning and Organizational Development

The principles mentioned in group Visioning are just as applicable in organizations of any size. The same materials, media, structure, and group dynamics are used. Whether a company is open to this approach depends on their level of commitment to innovation and creative problem-solving. Many companies and organizations pay lip service to ideas like "thinking outside the box," but when the chips are down they back away from it. That very term says a lot. If you are still thinking with just your left hemisphere (inside or outside the box), you're only using half of your brain, not to mention none of your heart, body wisdom, feelings, instincts, or intuition.

Innovation is no longer a luxury in industry and business. Companies that are not on the cutting edge face extinction. For those who are willing to embrace the power of the right brain, Visioning can breathe new life into any enterprise. That much said, I must add that organizational work is not without its hazards.

Group Dynamics in Organizational Visioning

Anyone who is interested in introducing Visioning into an organization needs to be realistic about whether the organization's culture is receptive to these kinds of methods. I have turned some potential clients down because it was clear to me that they could not create the safe, non-judgmental atmosphere it takes to conduct fruitful Visioning workshops. The companies and organizations I have worked with successfully, such as Disney, demonstrated a sense of openness, experimentation, and commitment to creativity that has been truly inspiring. And they have gotten the results.

If Visioning teams are established in an organization, it is extremely important that they have a voice in the company's direction and decisions. They don't have to be executives running the company. In fact, most of my work has been with the rank and file employees: middle managers, designers, administrative support personnel, engineers, production staff, etc. However, Visioning was seen as more than "busy work" or gratuitous training in "creative process" that doesn't translate into application on the job. Visioning is a practical tool for designing a desired future. If nothing ever comes of the Visioning work, if it isn't applied or implemented, the Visioning team is likely to feel disempowered and dispirited. They go away feeling that their ideas didn't matter. For that reason, great care needs to be taken in applying this method in organizational settings.

LEADERSHIP—The best person to introduce the idea of Visioning on the organizational level is someone who has done it and gotten results. That doesn't mean that such an individual will actually conduct the workshops, although it might work out that way. Marsha Gamel, one of my trained facilitators (who has a background in business and community work) happened to share her enthusiasm about Visioning with a

professor of business at her local university. He was so excited hearing about the method that he asked her to be a guest speaker in his classes. She led some hands-on collage experiences and was asked back due to student demand. The class applied it to their own lives right away and also saw its effectiveness and applicability to business.

Themes

Topics and focus phrases are somewhat different in organizational settings, especially when it comes to creative collaborative collages. They can include:

- vision and mission statements

- new products, innovative production methods, and services

- solutions to ongoing problems

- new management methods

- team-building

- project development

- environmental design (buildings and interiors)

- marketing and advertising

Activities for Organizational Visioning

An example of some basic activities for developing an organizational vision and mission statement might include the following, done in a series of collaborative collages:

Collage #1
Who are we?

Where have we been?

What are our shared experiences?

Collage #2

Where are we going? (current trends)

Where do we *want* to be? (our group heart's desire)

Collage #3

What's in our way?

What are the barriers?

Collage #4

Who will lead us to our goal?

How will we get to our goal?

How will we measure our progress?

FOR PROBLEM-SOLVING — For identifying and solving problems, a series of three collages is recommended as follows:

Collage #1

What does the problem look like?

Collage #2

What does the solution look like?

What will things look like when this problem is solved?

Collage #3

What is standing between the problem and the solution?

What are the barriers?

Team-Building and Project Development

The same approach works for team-building and project development. A series of collages can be made of the following:

> What does the team look like (include symbols and representations for each team member's contributions, talents, abilities)?

> What does the team need to accomplish? What is our mission?

> What talents, skills, etc. are missing? Where can we find them?

Creating and Working with the Collages

Judith, a financial consultant, shares a collage done at a Visioning workshop. Her dream is to start a retreat center in Mexico.

All of these collages are done in the same manner as those described in earlier chapters, with the difference being that the group or team is working together on the same art, poster, or mural paper. The collages need to be displayed where the creators of the work can see them regularly. Follow-up sessions would ideally be held in the space where the collages are displayed. Journal work can be done and shared on a voluntary basis, and the process can follow the ten steps outlined for individual Visioning. My own personal dream is to establish "creativity gyms" in corporations: places where employees can stretch their minds and imaginations and exercise their hearts individually and in Visioning teams.

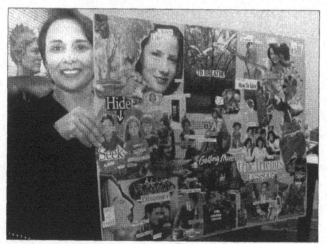

The Monitor, McAllen, Texas. Photo by Cindy Brown.

Visioning and Relationships

2

In the arenas of career, business, and finance, goals are set and implemented every day. However, when it comes to finding or creating satisfying relationships, we aren't accustomed to setting goals. Relationships just happen. Unless there's a crisis, that is, and then therapy or pastoral counseling are sought out. But as a rule, most people don't approach their relationships with family, friends, loved ones, or co-workers with anything close to the thoughtfulness and energy that is devoted to their careers or even to hobbies.

Visioning definitely has something unique to offer in the search for healthy, fulfilling, and mutually supportive relationships. It provides a new lens through which to look at relationships, one which allows the imagination to fly and the heart to soar. Collage-making and journaling allow a balance of visual and verbal communication. Once your creative self has revealed the kind of relationship your heart desires, you can relax in the knowledge that the best is yet to come. This holds true for every kind of relationship: romance and marriage, having a family, building work teams, and so on. The following true stories are examples of

> There's only one corner of the universe you can be certain of improving and that's your own self.
> **ALDOUS HUXLEY**

how Visioning has been used to create and celebrate relationships from the heart.

FINDING LOVE IN ALL THE RIGHT PLACES

CASE STUDY: LISA'S STORY AND COLLAGES

Lisa, an attractive and vivacious marketing consultant, had attended numerous workshops and week-long training programs of mine. She always brought great enthusiasm, talent, and creativity to the work. I hadn't seen her for a while when she suddenly appeared at a weekend retreat devoted to Visioning. The timing of the workshop couldn't have been more perfect considering recent developments in Lisa's life. She really needed to stop and listen to her heart.

I soon learned that Lisa's marriage had suddenly fallen apart. Her husband had left her for another woman and she was going through a tremendously painful upheaval. Rage, hurt, confusion, feelings of betrayal were bubbling up in her like a volcano. She told me that singing, writing songs, and playing the guitar had been her therapy during this difficult time. When she reminded me that she had a young daughter, I could feel the deep sadness in Lisa's voice. Having been down that path myself, my heart went out to her. I told her how glad I was that she chose this particular workshop and how confident I was that she'd get some much-needed support.

Lisa set busily to work creating a two-part collage, which she called "Reclaiming My Power." Later she explained the personal significance of the images and phrases.

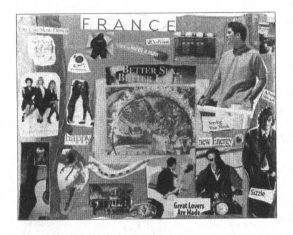

Reclaiming My Power

A tiger jumping through a ring of fire symbolized her innate strength being tested, a portrait of "grace under fire." Some photos of Egypt, where they met, represented the beginning of her relationship with her husband. In another picture, a couple is in a pool of water, with his back showing and her face looking out. To Lisa, this symbolized betrayal and her husband's leaving. There is another picture of a woman in pain holding a baby, expressing concern for her child. It can also be seen as an image of her nurturing self holding her vulnerable inner child. Some pictures from the movie *The First Wives' Club* represented her anger at being betrayed and her fantasies of revenge. Symbols for the death of the relationship included a skull with a snake crawling through it. There were also some positive images in Lisa's collage: an angel representing redemption and resurrection, pictures and words about men, better sex, and better love.

I next saw Lisa at a week-long training intensive in Canada three months later. It was obvious that she had traveled a long distance, both outwardly and inwardly, to come to this intensive session. She seemed much more centered than she had at the Visioning weekend. She was in the process of accepting that the marriage was indeed over and was

ready to move on with her life. The feelings were still there—anger, grief, vulnerability—and would be for a long time, but they were not as raw as they had been three months earlier. During the intensive, Lisa did some powerful artwork, journaling, movement, and dramatic role-playing. When it came time to make Visioning collages, Lisa lit up. Here are the two pieces she created.

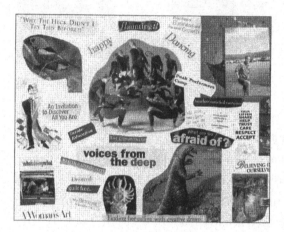
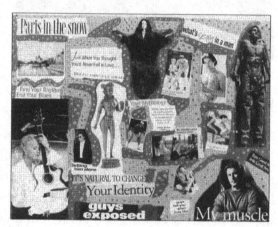

Discover All You Are

Some important words in Lisa's collage of the future were cut out of magazines:

> Peak Performers' Camp
>
> Finding her calling in creative drama
>
> An invitation to discover all you are

These words proved to be prophetic. Not long after this intensive, Lisa was offered the role of creative director in Play Back Theatre of Orange County, an improv group with whom she'd performed for two years. The invitation was a big surprise and an opportunity that Lisa embraced wholeheartedly.

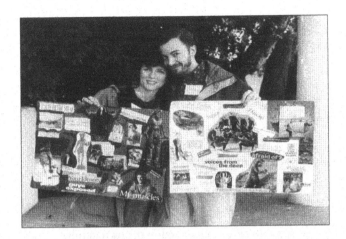

Lisa and Jim with her collages.

Lisa's second collage had to do with romance, men, and relationships. One photo shows a man and woman dancing. Others show handsome young men. Four months later, Lisa met and began dating a man who had an uncanny resemblance to a man in her collage. She is enjoying herself immensely and marvels at the speed with which her collage became a reality. When she shared her news with me on the phone, her voice bubbled with enthusiasm. The victim was gone, the creative, powerful woman I had always seen in Lisa was back. However, having been to the depths had softened and enriched her in ways that are just beginning to reveal themselves in her life. Lisa found something that can never be taken away. She found love in the right place, within her very own creative self. Now she is free to express it in everything she does and in all her relationships.

Nine months after doing her first collage in this series, Lisa returned to a workshop at the same location. This time Jim, her new boyfriend, accompanied her. Lisa looked like a different woman from the one who had attended less than a year before. She appeared relaxed, soft, and comfortable with herself in spite of the fact that she was in the middle of an ugly divorce. Her dream of a healthy, loving relationship had become a reality and she wanted to share it with me and the group.

As she told her story, one could feel the level of enthusiasm rise in the room. Lisa's light was definitely shining for all of us.

WEDDING BELLS AND HONEYMOONS

CASE STUDY: ALETA'S COLLAGES

In addition to creating new relationships of any kind, Visioning can be a wonderful tool for celebrating or enhancing the relationships you already have. A great example of this happened in my own family.

A few months before her wedding, my younger daughter, Aleta, came to stay with me for a few days. She needed a little time off. Sandwiched between her busy work and night-school schedule, she'd been busily planning her wedding. Armed with "to do" lists, she'd begun researching dates, costs, logistics, and so on. Although she is an experienced project manager, I could see that this "project" was beginning to take its toll. She was obviously stressed out.

Aleta also has a wonderfully creative and playful side to her personality, so I suggested she do some Visioning. I urged her to set aside her worries about money, assistance, and so forth, and just create a collage of the kind of wedding and honeymoon she wanted. In other words, to keep her eyes on the prize. During a quiet day-long session in my studio, she created two collages: "The Wedding" and "The Honeymoon." She took them home and displayed them in the bedroom where she could see them every day.

Wedding Collage

When she made her wedding collage, Aleta said she kept thinking about wanting an old-fashioned wedding, with lots of flowers and with loved ones all creating the event together. She thought of the strong family

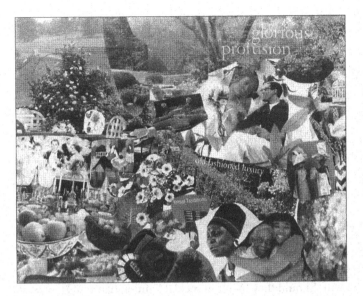

heritage of both of their cultures—Caribbean and Italian—and said she wanted that feeling at the wedding. She also hoped that their extended families would all be there even though many of them lived on different continents. At the time Aleta made the collage, the likelihood that they would travel such long distances to be at the wedding seemed very slim. Her biggest concerns had been to come up with a unique invitation design, to find a lighting solution for the outdoor area where they were planning to have the reception, and, of course, to find food that would reflect their multicultural heritage.

Regarding the wedding invitations, she knew she didn't want the traditional plain engraved one, but wasn't excited about the readymade alternatives. In gazing at her collage one day, it came to her: flowers. She searched and found a special textured paper with a pressed flower design. This definitely reflected her collage affirmation: *glorious profusion (of flowers)* and *old-fashioned luxury.* The invitations were custom printed and had the old-fashioned look she'd wanted. Another one of Aleta's worries had been her newly landscaped garden. Would it bloom

in time for the outdoor reception being held adjacent to the garden? Just as the collage said, it did blossom in *glorious profusion*.

Aleta is a great cook and has worked part-time as a caterer. Needless to say, food for the reception banquet was a very important aspect of her wedding plans. She did not want the typical wedding appetizers and main course of turkey and ham. When she expressed her desire for an ethnic feast to family members on both sides, they all got together and created a delicious array of Caribbean and Italian dishes. One cake was shipped in from the island of St. Lucia in the West Indies, the groom's birthplace. His uncle (who has extensive catering and bartending experience) took pleasure in managing the kitchen and bar.

Outdoor garden lighting for the evening reception had loomed as a big problem. Should they invest in special lighting fixtures? How could they create the right mood? One day she realized that the answer had been pictured in her honeymoon collage all along: candles. She and a bridesmaid came upon the idea of votive candles at each table. Because they were protected by glass cups, the lights stayed lit. Fortunately, it was a warm, balmy June night with not a trace of wind.

Let there be light.

As it turned out, Aleta and her husband, Marcellus, had the dream wedding portrayed in the collage. What is more, they received all kinds of help from supportive relatives and friends who generously contributed food, drinks, money, time, resources, and love to create a truly special family event. Aunts, cousins, and uncles surprised them by coming to southern California from all over the country and the globe: New Jersey, Texas, northern California, Canada, the Caribbean, and even London. The reception was a fabulous reunion for branches of the family that had not seen one another for some time. It was truly a wedding to remember.

Envisioning the ideal honeymoon, Aleta had pictured an island environment. She wasn't sure if it was Fiji or Hawaii. She'd also included a picture of a gold American Express card symbolizing the financial resources to take such a honeymoon. At the time she made the collage, wedding expenses were absorbing all their available funds. Right after doing the collage she applied for the AmEx card, fully expecting to be turned down. Shortly afterward, the card came in the mail, much to her surprise. Better yet, they received a wedding gift from a family friend: round-trip tickets to Maui. They had a honeymoon they'll never forget.

A honeymoon to remember.

BABY MAKES THREE

CASE STUDY: CHRISTINE'S STORY, COLLAGE, AND BABY ANNOUNCEMENT

Experiencing motherhood.

Just before moving from the Los Angeles area, I had some private consultations with a young woman named Christine. She seemed to have it all: good looks, health, a rewarding job, a handsome and loving husband. In fact, Christine did feel quite blessed. There was just one problem she wanted to deal with. Christine wanted very much to have a baby, but was unable to conceive. She and her husband had enrolled in an extremely expensive fertility program that provided for three in vitro fertilization procedures. They had undergone two attempts to no avail, and they had only one left. Under pressure to "succeed," she was anxious, scared, and depressed. "And on top of it," Christine told me, "I hate the procedure. It's cold and mechanical and feels so invasive."

I suggested we first explore any emotional blocks about having and raising a child. It soon became clear that unconsciously Christine was afraid that if she had a child there would be no time left for her own emotional and physical needs, for rest and recreation. She tended to work very hard as it was and the spontaneous, fun-loving part of her was afraid it would be crowded out if there was a child around to take care of.

My intuition told me that Christine needed to focus on the goal—the *experience* of mothering and raising a child—rather than on the means (conceiving and biological birth). I suggested she spend more

time using her creative imagination to envision herself as a parent. Her Visioning assignment was:

> Do a magazine photo collage about what mothering looks and feels like.

> Display it in a prominent place and keep reinforcing the idea by looking at it as often as possible.

She liked the idea, went home, and created a collage about motherhood.

Shortly after that, I moved out of the area without ever seeing Christine's finished collage. We lost touch with each other for almost four years. The next time I saw her was at the company where she works. I was conducting an in-service Visioning seminar there and she walked into the room. What a pleasant surprise! Christine greeted me warmly and handed me an envelope. "For some reason I didn't understand at the time, I saved this." Christine said, with a big grin. "Now I know why. I was supposed to present it to you in person." The envelope had been addressed to me but was marked "return to sender." Christine had mailed it three years before to my old address. Inside the envelope was an announcement for the birth of their adopted son.

Along with the announcement there was a personal note.

> Lucia,
>
> Thank you so much for your love and support. My private sessions with you really helped me discover that I wanted to stop putting my body through hell trying all these

newfangled methods to get pregnant, and just adopt. As you can tell the result was magnificent.

I wish you continued success, because it makes such a difference in our lives. And I'm sure our paths will cross again.

Love, Christine

Christine explained to me what had happened. "From doing the collage, I realized that biological motherhood was not my goal. What I really wanted was the *experience of raising and loving a child.* So I dropped out of the fertility program and we adopted our son." She was beaming. It was clear that Christine had realized her dream.

SUGGESTIONS AND APPLICATIONS

Creating a New Relationship

If you want to create a new relationship of any kind, the collage medium is a wonderful way to picture what you want. You can even put your own face or full body photo into the collage. This process can be applied to any type of relationship: friendship, romance, marriage, family, welcoming a new child (as in Christine's case), business partnership, and so on.

In creating a new relationship, portray the quality of the relationship and what you want to enjoy or experience with the other person. One woman whose birthday was soon approaching created a collage entitled "For that Special Birthday. Beyond All Expectations." Her picture featured candles glowing on a black background, loving couples embracing, and the quote, "He asked what I wanted for my birthday. A modest token of your love, I teased. Thank heavens, modesty has never been his strong suit." When she did the collage, this woman felt quite skeptical about romance as there was no love interest on the horizon. Or so she thought. Less than a week after her birthday, she went out to

dinner with an old friend. Things suddenly took a romantic turn as they sat amidst candlelight in the lounge of a local inn. She was as surprised as he was. In all the years they'd been friends, they had never expressed romantic or sexual feelings for one another. Neither one of them had suspected there was anything but friendship between them. Yet her collage had clearly spelled out her heart's desire in graphic terms. Cupid did the rest.

You can also have a journal dialogue with the person you want to have a relationship with. This works even if you haven't met the individual yet. The dialogue will help you define the kind of relationship you want. And it is your own inner clarity that will magnetize to you that which you desire.

In dialoguing with the real or hypothetical person you want a relationship with, write your own voice with your dominant hand and the voice of the other person with your nondominant hand. Ask the person to tell you about him or herself. Ask questions such as:

- What are your likes and dislikes?

- What do you look like?

- What is important to you? What do you value?

- What are your fears? What are your wishes?

Improving an Ongoing Relationship

If you want to expand or enrich an already existing relationship, the same principles hold true. Create your collage of how you'd like the relationship to be. Then dialogue with the person in your journal, as described above. Your voice is written with the dominant hand, and the other person's voice is written with the nondominant hand.

You can also invite the person you are in the relationship with to do a collaborative collage on the same piece of paper depicting how you'd

both like the relationship to be. There are more ideas for how to do this in the next section. It is also helpful for each person to create his or her own collage separately from the collaborative piece. In this way, you define what is important to you as an individual (personal collage) and what you share with the other person (collaborative collage).

One hears about the "match made in heaven," yet we can do our part as well by allowing our eyes to see what is hidden in our heart of hearts. Don't be afraid to shine your light onto your innermost dreams. There just may be someone out there with the same dream. Have fun with this. You have some fabulous surprises in store.

COLLABORATIVE VISIONING FOR FAMILIES

Visioning for Families

While counseling couples and families in my private practice, I discovered the value of collaborative collages in creating shared dreams and visions. When I use the term family, that includes people in a committed relationship, engaged and married couples, parents and children, extended family members, and anyone else who shares the family's dreams and goals. Through collage and journaling, some major healing has taken place. Going beyond therapy, which is rooted in a medical model of illness and pathology, these families have created healthy lives. They are working together toward what Abraham Maslow described as "self-actualization." Through Visioning, couples and families have not only realized their individual heart's desires but have co-created all sorts of things together, such as vacations, home environments, and leisure-time activities. Some families have even reshaped the way they interact with one another.

The power of group support cannot be overstated. Couples and families who do Visioning together report amazing results. Sometimes

they each work on their own collage but focus on the same topic, such as career. At other times a family may work together on the same collage, creating a shared vision. One couple's success story about their individual and shared Visioning appears at the end of this chapter.

The guidelines for doing family Visioning are basically identical with those described in chapter 11 regarding Visioning in a support group. The same nonjudgmental atmosphere needs to be maintained. The same safety and freedom to express oneself without fear of criticism must be honored. This may present a problem in families where criticism and judgment are pervasive and have become an automatic reflex. If a safe environment cannot be maintained, then it is best not to attempt Visioning as a family. Seek professional help instead.

LEADERSHIP OF FAMILY VISIONING — For obvious reasons, the family member who has already done some Visioning work on their own or in a group is the one who introduces the idea to their family. If the experienced Visionary has already gotten some results from the process, other family members are likely to be curious and become motivated to try it out. Of course, Visioning must always be voluntary. If any family members resist getting involved, don't coerce them. Visioning is for those who want it.

Once a family has gotten started doing this work, they can use a revolving leadership plan like the one described earlier. The principles of group dynamics are the same. Regularly scheduled sessions, no judgment, no criticism, no analysis. Each person has a voice in the common dream and gets to express how their own personal heart's desire fits into the big picture. And everyone gets to celebrate the dream when it comes true. Creativity in families is infectious. Be prepared for some wonderful times together.

The big difference in family Visioning (as opposed to the types of Visioning groups described earlier) is that, at some point, the members will probably work together to create one collage. They may start by do-

ing individual collages to express their own personal vision or perspective, but they can also collaborate on a collage that reflects the family's shared dreams or goals.

SOME THEMES FOR COLLABORATIVE FAMILY COLLAGES

- our living environment (a new home or redesigned one)

- our family goals (residence, education, etc.)

- things we want to do together

- quality of life

- vacation or other travel

- play and leisure-time activities

- our financial goals

- our lifelong goals

- retirement

DREAMING TOGETHER—It is possible to begin exploring these themes with individual collages. For instance, each family member can do an individual vacation collage expressing his or her heart's desire. After sharing their individual collages, the family members then create a collaborative collage. If a particular location or trip has already been decided upon, each member can put in what they would like to do or experience in the chosen destination.

The sharing time that follows the making of the collaborative collage enables each family member to observe the needs of others and how their heart's desire fits into the big picture. For instance, two family members may have lots of pictures of art museums while two others

have portrayed photographers out in a city taking pictures. A variety of combinations may arise, and if all of the desired activities are available at the destination, ad hoc excursion groups can be formed to respond to individual needs. Shared goals can also be ascertained. The idea is to create a win-win situation for everyone as often as possible. An atmosphere in which each family member can freely voice their heart's desire is likely to cultivate mutual caring, respect, and understanding. Some negotiating will be necessary regarding the goals set and means to achieve them. That's part of the creative process, too.

Media for Family Collages

The media suggested earlier in the book are just as relevant for families as they are for individuals. However there are some formats that work especially well for families.

MURALS—The mural format is made-to-order for collaborative collages. You can use large sheets of photographers' no-seam backdrop paper (usually available from a local portrait photographer or photo supply store) or rolls of brown wrapping paper or butcher paper. A really large mural can be created on the floor and later displayed on a wall. If there isn't adequate floor or wall space for such an endeavor, use panels of art paper or poster board (such as those used for individual Visioning collages) and tape them together from the back side. The advantage of this modular approach is that panels can be added on if need be.

The size of the collage will depend upon the size of the family. Everyone will be working on the collage at the same time, so the mural paper needs to be big enough to accommodate all family members.

JOURNALS—For family members who can write, the journal guidelines and activities suggested in earlier chapters can be used. Writing

about one's heart's desire can provide rich material for verbal sharing with other family members. Reflections can be recorded, dialogues can be written (especially if conflicts with the needs of others arise), and insights can be shared on a voluntary basis. This can lead the way to greater understanding of one's own as well as each other's needs.

Each family member who is involved in Visioning will have his or her own journal. Those who cannot read or write can do drawings and collages in their journals. For youngsters who are just learning literacy, a visual journal is wonderful practice in communicating ideas in a book. As they learn to write, they can include handwritten or cut-out captions for their photos and drawings. Later they can start writing in their journals. For preadolescent children, the nondominant handwriting is not necessary as they are usually in touch with right-brain functions of emotional expressiveness, intuition, and creativity. If you want more guidance in journaling with young people see my books *The Creative Journal for Children* and *The Creative Journal for Teens*. There are some exercises there for encouraging youngsters to follow their hearts and dream their dreams.

Of course, as with all journaling, the key word again is *safety*. Family Visioning won't work if members are worried about judgment, criticism, or invasion of their privacy. Sharing is always voluntary and the ground rule of privacy and confidentiality for journaling must be maintained at all times.

FAMILY VISIONING ALBUM — We usually think of family photo albums as a record of the past: weddings, birthdays, vacations, and the like. But why not create a forecast of the future with a Visioning album? The same materials can be used as those for memory albums except that most of the pictures will probably be from magazines. And, of course, you can also use snapshots of yourselves.

If you design your dream in a family Visioning album, save space in

the second half of the album. That is where you'll put pictures of the reality when it manifests. This is both an album of the future (vision) and the past (after the dream has manifested). It becomes a document of your dream taking form in the physical world. Now there's something to display on your coffee table! And what a special book to share with friends and extended family members.

POSTCARDS FROM THE CUTTING EDGE—Collage postcards are perfect for display on the refrigerator or any other place where the whole family is likely to see them. These can be done by individual members on the theme that the family is currently Visioning. It's a way to keep the idea alive and to add individual input to the family's collective creation. And remember, write your messages from a future time, as if the dream has already become a reality. Here's an example:

Dear Aunt Jane,

We're in Florence now, eating our way from one great restaurant to the next. Tomorrow we go to the ancient walled city of Siena. This whole country is one big photo op. I've already shot twelve rolls of film and we aren't even halfway through our trip.

Love, Jamie

Celebrating

What was said about celebrating earlier in the book holds just as true for families. It's important to celebrate the dream together. Acknowledge yourselves for daring to dream and for "going for it!" Designing a celebration that expresses your family's unique brand of creativity can be an incredible experience. I believe that "the family that *plays* together, stays together." I also believe in thanksgiving (not just on the official na-

tional holiday), so let your celebration include a big thanks to the source of your creativity and to those who supported your dream (in the family or outside of it).

A COUPLE VISIONS TOGETHER

CASE STUDY:
BEVERLY AND TOM VISION TOGETHER

Beverly, a therapist who is trained to teach my method, was highly enthusiastic about the Visioning process. She suggested to her husband, Tom, that they do some Visioning about what each of them wanted to experience together in their marriage. They made separate collages on this theme and also a collaborative collage without talking. In their joint collage they depicted all the things they like doing together and things they'd like to include in their relationship.

In seeing the finished collage, Beverly said she loved the joyful, wholesome pictures Tom chose for their future together, such as coffee and newspapers in bed, grandchildren playing with them, fitness, fun, possibility thinking, commitment, and travel. Through the collage, which they made mostly in silence, Tom expressed ideas and fantasies he hadn't ever put into words. He spoke to Beverly in a different way and she cried when she saw his selections. Usually a quiet man, Tom became quite eloquent when speaking in pictures and captions. Beverly was thrilled with the process.

Tom enjoyed the blend of where they were and where they wanted to be in their marriage. The collage was a statement of this in a different form than they usually communicate in. Collage-making helped him process those things he thought about but hadn't spoken about. The pictures sparked insights about what he values. They also helped him imagine or remember things that he really responds to but, if asked verbally, he might not have come up with.

As for their individual collages, both Beverly and Tom portrayed things they enjoy doing separately. For instance, Beverly loves going to personal growth workshops and her husband enjoys sailing. They don't share these particular interests, so they engage in these activities separately with friends who do.

A COLLAGE FOR THE WHOLE FAMILY

My friend Jim Ogden had attended some of my workshops and was inspired to extend Visioning into the realm of holiday cards. He created this lovely Valentine's Day card depicting all the members of his family: grown children, their spouses, and their children. He sent a color photocopy of it to all the family. What a lovely and heartfelt gift to loved ones.

Beverly and Tom's collage with details and words.

13

Visioning for Health and Well-Being

What makes you happy? What does health feel like? How do you define physical, emotional, mental, and spiritual well-being? What constitutes financial security for you? This chapter contains stories of how Visionaries have dealt with basic issues of self-worth, health and well-being, personal security, and abundance. This includes body image, physical health, weight control, and self-care in general. It also includes our relationship with money as the symbol for personal worth. How we relate to money and abundance says a lot about our sense of deserving and worthiness. Chronic anxiety about material security puts great stress on the body and colors the way we experience life.

REGAINING THE SELF

How we see ourselves (our self-image) is reflected in how we treat ourselves and how we allow others to treat us. Our self-image also shapes our bodies and impacts our sense of health and well-being. We'll begin

with a classic case of self-image and body image and how they permeate one's relationship to the world.

CASE STUDY:
GAYLE'S STORY OF INNER HEALING

A professional woman in her mid-forties, Gayle attended two of my public workshops nearly a year apart. The mother of two young adults, she had chronic relationship problems with men. Gayle had been married four times and was on the merry-go-round once again, this time with an active alcoholic and sex addict who was cheating on her. Several months after attending my workshop, she gathered the courage to ask this man to move out. Just prior to his leaving, Gayle suddenly started hemorrhaging and was hospitalized. She called her friend Judith, a nurse who was training in my method, and they did some role-playing to explore the emotional and psychological dimensions of Gayle's ailment. In the process of doing this work, she came to the realization that her parents had been disappointed that she was a girl. When she was born, they'd had their hearts set on a son. This revelation uncovered a deep emotional scar. A few days later, Judith suggested that Gayle make a photo collage.

Gayle's collage reflects her feelings of disconnectedness. The elements appear to be quite isolated from one another with no merging or blending. There are several sexy women's bodies (in full or partial view) but there are no faces. They have been covered up with words or other pictures. The only face showing *clearly* in this collage is that of a horse (Gayle did healing work with horses). The only woman's face is in a cartoonlike drawing of a golfer swinging her club, but the face is very sketchy and undefined. On the other hand, the body is in full view (as with the other portrayals of women in the collage). The phrase "AB-SOLUTE POWER" signifies Gayle's pattern of getting power through sex. There are other phrases like: "I'M BEAUTIFUL . . . FUN . . .

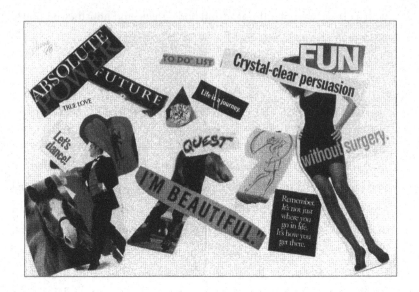

Gayle's collage of absolute power.

Crystal-clear persuasion . . ." and other images, such as a diamond solitaire ring (like an engagement ring), and fabricated butterfly wings worn by a man.

The word and image that are pivotal in this collage involve the very body part that Gayle was having problems with: the pelvis. In the original collage, only the word *surgery* appeared over the pelvic area of a sexy girl's body clothed in a tight, black, short-skirted dress, black hose, and high-heeled shoes. When Gayle shared the collage, Judith remarked on the word and its placement, pointing out that she seemed to be affirming for surgery. Since Gayle did not want to have surgery, she went back later and altered the collage, adding the word *without* right over the girl's pelvic region, making the new phrase "without surgery."

During this time period Gayle went through some medical tests, and although her boyfriend had moved out, she kept taking calls from him. She was having a hard time letting go, even though she knew it was the healthy thing to do. Her medical condition was diagnosed as cancer of the cervix, and six weeks after doing her first collage Gayle had a hys-

terectomy. In preparation for the surgery, she worked with Judith again and did another collage.

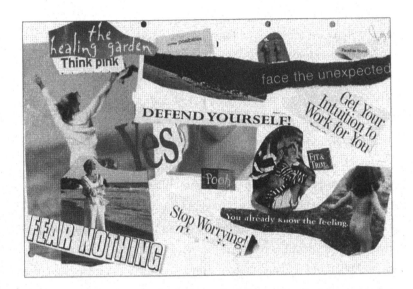

Gayle's collage of the healing garden.

Gayle's second collage is quite different from the first. In this one, Gayle wove the elements together, allowing them to flow together across the page. There's a new feeling of movement, integration, and health. All the women now have faces and they are expressing joy and pleasure. These women are active, womanly, and sensual but not sexy in the superficial sense of appearance and performance (the ones in the first collage). Colors are soft and clear blues.

Phrases like "Yes!" "FEAR NOTHING," "Stop Worrying!" "DE-FEND YOURSELF," "Think pink," and "face the unexpected" send a very different message, too. Gayle is now talking to herself from a place of inner wisdom and counsel. She is learning to set healthy limits and boundaries. The phrase "Get Your Intuition to Work for You" speaks to an ability and willingness to listen to her inner self. In the lower right-hand corner a naked little girl runs freely in the grass accompanied by

the phrase: "You already know the feeling." Through collage and journaling, Gayle had come home to her natural, spontaneous, and healthy inner child.

A phrase in the upper left-hand corner, "the healing garden," can be seen as the title of this joyful collage about healthy relationship with self and with others. Couples are portrayed in partnerships, expressing affection and sharing activities. A little phrase in the upper right-hand corner, "Paradise found," points to a healthy future for Gayle. In fact, all of the people in the picture are looking toward or moving exuberantly in the direction of that phrase.

After surgery, radiation treatments followed. During this time, Gayle learned to do a lot of self-touch to stay connected to her body in a loving, self-nurturing way. She did dialogues with her physical and emotional self, sending reassuring messages to her body and her inner child. When old feelings of desperately needing a man came up, she saw it as a wake-up call. It became clear that she really had a support system of her own and that she was very loved. Within a couple of months after the surgery, Gayle was able to end all calls from her abusive ex-boyfriend.

At the same time, a transformation occurred in Gayle's relationship with her parents. They were really there for her during and after her hospitalization in a way she had not experienced before. Her mother came to be with her and help her through this difficult time, and her father also expressed great concern. And Judith was there for Gayle throughout this time, providing emotional support and sharing tools for growth as well as medical knowledge and experience.

Gayle's illness is a classic example of a crisis that turned into a personal rebirth. What she let go of was an old way of treating herself and of being treated, especially by men. What she gained was a connection with her inner self and a healthy connection to her body. Gayle found a new sense of health and well-being with the guidance of her own creative self.

THE CREATIVE SELF DIET

In our society, body image is very much connected to size, especially for women. The supermodel image of the anorexic waif permeates the media, high fashion, the beauty and health care industry, and everyone's psyche. The damage this does to our self-image as women cannot be overestimated. Eating disorders seem to have reached an almost epidemic level, especially among young girls. And of course, billions of dollars are spent each year on weight reduction products, programs, and equipment in this, the most overfed nation in the world. The next woman's story is not only about self-image and weight loss, but about transformation in every area of her life. Susan used imagery and journaling to reshape far more than her body, as we will see.

CASE STUDY: SUSAN'S STORY OF HEALING, CHANGE, AND WEIGHT LOSS

Susan attended two of my weekend conferences in Texas that were held several months apart. Targeted at physicians, nurses, psychiatrists, and counselors at local hospitals and clinics, both workshops covered stress reduction and self-nurturance for professional caretakers. A warm, soft-spoken woman, Susan introduced herself by saying that she was there to support her friend who was hosting the workshop. However, it turned out that Susan had been struggling unsuccessfully with a health problem: a chronic and painful case of shingles. She was also quite overweight, but it was the shingles that had her attention at that time.

"I've been plagued with shingles for several years and have tried everything," she told the group. "I've just gotten over a severe outbreak and have been trying some alternative nutritional methods because medication was so hard on my stomach." The alternative approach had led to less frequent but more intense outbreaks. She was also having repeated bouts of sleeplessness and debilitating pain. Later on, Susan told

me that when she began the workshop she hadn't wanted to get her hopes up, only to be disappointed again. However, she'd been pretty desperate and was willing to try anything.

In the workshop we did some relaxation and guided imagery with a tour through the body to find any areas of stress or pain. This activity, featured in my audiotape *The Picture of Health,* leads the individual through the creation of a visual map of the body, coloring in the areas of pain, tension, and stress. This is followed by written dialogues with the body (using both hands). In doing this process, Susan got some powerful messages. Through her nondominant hand, her shingles were really talking to her. I had also given the group an overnight assignment: *Be aware of your physical surroundings and of your sensory experience. Practice being aware of your self.* Driving home after that first day of the workshop, Susan became aware of her senses and of her self in a new way and felt exhilarated. At bedtime, she played *The Picture of Health* tape and later reported that she hadn't had such a good night's sleep in a very long time.

When she came back the next day, Susan looked dramatically different. She was wearing a beautifully crafted dress that was a work of art, had put on makeup, and styled her hair. I'd never seen such a quick transformation. And it was more than cosmetic. Susan was glowing from within and said that she felt different, too. What is more, her shingles had faded a little and were less painful. She also came to the realization that all the other methods she had used to cure her shingles were external and chemical. This method was *internal.*

In Day Two of the workshop, we did self-reparenting work through self-nurturing activities. Susan told me that she had previously done inner child work using other methods, but they hadn't gone far enough. Now she knew why. "They didn't teach me how to nurture myself," Susan said. She'd found that part of herself that truly cared about how she felt. And it showed.

Susan then confronted the critical parent that lives in her own

mind. She saw it for what it was: a controlling and negative voice. The healthy part of her knew then that she needed to stick with this process and that it would somehow liberate her. At the time she was still trapped in the belief that she had to stay in her terrible job situation, had to go it alone and not ask for help. Susan presented an outer image of strength and independence to the world, but she felt that she was falling apart inside. A chronic struggle with her weight had also been accompanied by a fifteen-year relationship that she knew was unhealthy but had been unable to end.

In the weeks after the workshop, Susan continued dialoguing with her shingles. They turned out to be her personal counselor. Of course, it was her creative conscience speaking through her shingles. She noticed that they erupted when she was under stress. When she followed the guidance she received in these dialogues, the shingles would fade. One time they said, "You have to deal with work. Get over being intimidated." Before long Susan became aware of how unhealthy her job was and how verbally abusive her boss was. Prior to the workshop, she'd had no boundaries in place and could not protect herself from the offensive behavior of others. A series of events occurred at work that woke her up and one day she submitted her resignation. Susan immediately received three other job offers and she accepted the directorship of a program for adolescents. She also went back to school to finish her master's in counseling and guidance.

Although these gains were far more than Susan ever bargained for when she began this work, it turned out that she had only just begun. Her relationship with her shingles has shifted. For the most part they have faded away. If they start to come out again, she dialogues with them and they disappear. Instead of going through the full seven- to nine-day cycle she was used to with previous outbreaks, they are gone in a day or two and they are not nearly as painful as they once were.

After the second workshop, Susan started exercising with a trainer and lost more than 100 pounds. Her weight loss was so rapid that her

doctor suggested she slow down and maintain her weight before losing any more. This experience gave Susan a new sense of power within herself. What is more, she finally got out of the unhealthy relationship and is now committed to taking better care of herself in all her relationships. Susan realizes now that the extra weight and the shingles had been a reflection of her own internal strife.

Regarding her body image, Susan now looks back and marvels at the changes. She told me, "I had gone on so many fasts and fad diets, lost weight and even lost hair, and gained all the weight back. That's over." She went on to tell me that learning to deal with negative self-talk was a major turning point. "When I think of the inner critic now, I say: 'This is me. Take it or leave it,'" she declared assertively. "I've had enough of the critic inside. She was dictating how I was going to feel about myself. No more."

Susan also reports that her relationship with her parents, both recovering alcoholics, has been healed. When she left home at seventeen, they told her they were withdrawing all assistance. It took her twenty-eight years to test their threat. "I discovered that it had been a lie," she

Left: A self-image and body image collage by Susan. Right: A detail of Susan's collage.

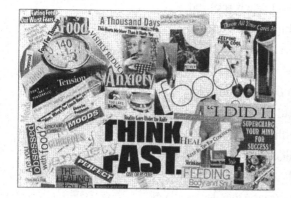
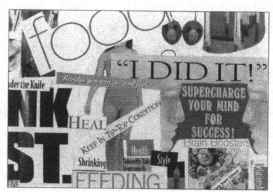

told me in an incredulous tone of voice. "When I decided recently to go back to school for my master's, I called them for some financial help. They said they were thrilled that I had asked and were very pleased to

help me." She paused, as if to savor this big turning point. Then she added, "No more secrets. The critic was the last secret. And now it's out." I thought of the words from Alcoholics Anonymous, "You're as sick as your secrets," and realized just how much healing Susan had done in only two and half years. She has taken her body and her soul back and continues to Vision the life she wants.

MONEY, SELF-WORTH, AND THE PURSUIT OF HAPPINESS

Just as women in our society and in the media are equated with a sexy body, men are considered successful and powerful only if they have money and possessions. We speak of someone being "worth five million," or we hear the question asked, "What's he worth?" (meaning a dollar value). Boys have this idea programmed into their brains early on. Just think of the bumper sticker: *The one who dies with the most toys wins.* Starting in adolescence, boys show off their power with cars. The more expensive the car, the prettier the girl they could attract, or so the belief went. Some men listen to the beat of another drummer and embrace another value system. Here are the stories of two men who discovered the true source of their happiness and contentment through listening to their hearts.

CASE STUDY: MARK'S STORY

Mark is a successful attorney whose career choice was influenced by his father and society. As a teenager, the assumption he made was: *If you're going to attract a nice woman, you need to make a good living.* At about the same time, Mark started playing the drums and later performed with groups throughout college. In high school he secretly thought about be-

coming a professional drummer. He told no one because he knew that such a notion would not fly with his parents.

Mark loved writing and considered a career in journalism, but chose law instead. His decision was based on the image of prestige, financial security, and career options that the legal profession offered. Incidentally, his father had wanted to become a lawyer, but didn't. Throughout his eighteen-year career as an attorney, Mark knew that his heart wasn't in it, but he didn't know of any other way to make such a good living. His real love was expression through the arts and when we began working together, Mark had just made a down payment on a set of drums, the first set since college days. Mark wanted to work with me in order to identify his true heart's desires and find avenues for realizing them. You could call it *heart* therapy as well as art therapy. He was exercising his inalienable right to the pursuit of happiness.

In working with Mark on a regular basis, I felt he needed to focus on what made him happy and integrate that into his life as much and as often as possible. He was eager to do so. Mark's assignments revolved around getting clear about what he loves and doing it. I suggested that Mark begin Visioning by creating a collage of the life he wanted.

I also recommended that he look back over family photos showing himself as a child. My intent was to get him in touch with his spontaneous inner child. In reviewing old snapshots, Mark was struck by the image of himself as a happy two-year-old. He recalled how much he had loved to dance and sing at that age and how he used to dream about becoming a dancer when he grew up. Mark began doing spontaneous dance with tapes of the five rhythms by Gabrielle Roth, author of *Sweat Your Prayers*. He found great enjoyment in this form of improvisational movement. He also told me he had recently rekindled his love of writing and that he had been creating short stories for about a year. I suggested some journal dialogues with any blocks that might be holding him back from fully realizing his heart's desires.

While dialoguing with his blocks, Mark discovered a very important

principle. "What came out vibrantly," Mark told me, "was that it was the rotation of negative thought forms in my mind that was creating an arena in which I could never win." He went on to say that he had learned his thought forms could be changed. He could create a different field of possibilities. He also realized that so much of what we do in our lives is dependent on the quality of *love*, which can only be experienced with an open heart.

"I now work with thought forms that build a positive, complimentary field of choices. And I've learned to pay attention to my heart," Mark told me. And of all the things he was doing—drumming, dancing, writing, journaling, and collage-making—it was the collage work that Mark was most excited about. I mentioned this in an earlier chapter. He just couldn't stop talking about what fun it was and how he'd spent "a small fortune" on special magazines that had pictures that really spoke to him.

Many people tolerate dissatisfaction in their work and their lives, postponing happiness until some distant day in the future. The problem with that line of reasoning is that the less you practice enjoying your life now by following your heart's desire, the less capable you will be of doing so in the future. If you don't know what you love to do and you don't do it, then you aren't prepared for a life of happiness and contentment. That's why so many people die right after they retire. They don't know what to do with their time. Visioning is a great way to practice happiness now. Just making your collage can open your mind and heart to a new way of seeing and being.

FINDING ABUNDANCE WITHIN

Money worries are one of the most common complaints from people on all economic levels. In my therapy practice I saw the same anxiety from wealthy people as I did from those living on a shoestring. It didn't seem

to matter how much they did or did not have in terms of money or material possessions. Their complaints all sounded the same. They felt a pervasive sense of lack. There was never enough. It became clear to me that one's attitude about security and abundance had little to do with the outer world. It stemmed from a deep-seated feeling of insecurity within. Greg is someone who found abundance by turning his gaze inward to his heart.

CASE STUDY:
GREG'S STORY OF DISCOVERING TRUE WEALTH

At an early age, Greg decided to study economics and enter the world of finance. When he was sixteen he also became committed to spiritual growth and a formal meditation practice that fostered his relationship with his inner self. I met Greg when we were both living in the same ashram practicing meditation, chanting, and yoga. We were also learning about how one's outlook on life directly affects inner experience. Greg was twenty-one at the time (a little younger than my own two children), and we became good friends. I used to refer to him as my adopted son and joked that the ashram was Greg's dormitory while he was at UCLA. I always marveled that Greg never had any conflict between his spiritual life and his career goals: to succeed in the field of business. I knew so many people who saw an opposition between money and spirituality and struggled to survive.

Greg graduated and became a stockbroker with a Fortune 500 firm. Over the years, we remained good friends, attending each other's birthday parties and talking on the phone from time to time. When I moved out of Los Angeles, Greg visited me in my dream house and marveled at the similarity between the collage and the reality. A few years went by, more phone calls, visits, and parties. Occasionally we'd talk shop, and I began getting the impression that, although Greg loved his work, he wasn't experiencing the degree of abundance that he wanted. He was

enjoying his work, his hobbies, and his life, but there was always a nagging sense of lack. I urged him to come to one of my workshops at a spiritual retreat center in Santa Barbara where we would be doing Visioning collages. He lit up and eagerly accepted my invitation.

With his typical sense of enthusiasm and joie de vivre, Greg threw himself into the workshop activities. The more photos he collected and cut and pasted, the wider his grin became.

By the end of the workshop, Greg was beaming. The big "Aha!" for him was that, although he'd had financial goals before, they were just so many numbers on paper. What had been missing was the vision from his heart of exactly what he wanted to do with money. How would dollars translate into experiences that he wanted to have in life? He's always known the answer deep inside, but his Visioning collage showed him — in living color and in concrete form — exactly how he wanted to use money and what he expected money to do for him. The spiritual knowledge he'd studied and acquired intellectually had now entered his heart.

Left: Greg's collage on travel, abundance, spirituality, family, home. **Right:** Detail from Greg's collage.

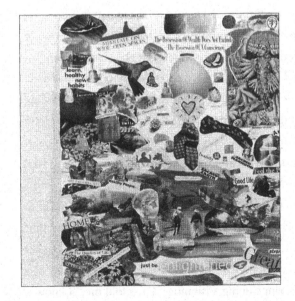

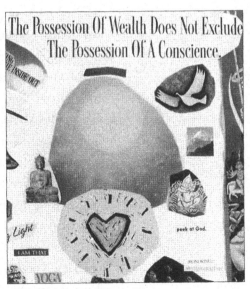

When Greg made his collage, he'd thought the focus would be money. Instead he pictured the things that he loved and valued: relationships, spirituality, creativity, and travel. These were the important things he wanted in his life. He also had a big insight: these elements already existed in his life. The results of doing the collage were subtle but powerful. Greg began to notice that, over time, a sense of gratitude and abundance was expanding more and more.

Not long after that workshop, Greg and his girlfriend, Laria, came to stay for a weekend. He took her for a walk on Moonstone Beach, one of our most romantic spots, and proposed marriage. Laria accepted and, at dinner that night, I was the first to hear the good news. What a wonderful occasion! Greg told me that when he was a little boy, he found a beautiful antique ring. He always knew he would give it to his fiancée and life partner some day and had shared that wish with his mother. Laria smiled and held up her hand. She was wearing the ring. "And it fit perfectly," she laughed. It was clear that Greg had been dreaming about this event for a long, long time.

In talking about his experience with Visioning later on, Greg emphasized his change in attitude. "I know it's the inner transformation that has made all the difference in my life," he told me. "I see the world in an entirely different way. Instead of focusing on what's missing or what I am dissatisfied with, I appreciate what I *do* have. For instance, driving home from work through rush-hour traffic, instead of obsessing about gridlock or about what I don't have, I notice things like the cloud formations at sunset and the beautiful colors and shapes in the sky. Such beauty is so uplifting and is an example of abundance in my life. What a gift. And it's free!"

Speaking of gifts, Greg recently received a free round-trip ticket to India from a friend. For seventeen years he'd wanted to go there but it had never worked out, for a number of reasons. The moment Greg believed it was possible, it happened. "My whole experience of money has changed dramatically since doing Visioning," Greg told me. "I know it

is my attitude of abundance that is drawing these things to me. For example, on a financial level, this has been the best year I've ever had in business and many seeds have been planted which can bear much fruit in the future."

Greg went on to talk about the real lesson for him. "How much money I made this year is really not the point. I realize that now. In my line of work I encounter very wealthy people, some of them multimillionaires. You'd be surprised how many of them have no experience of abundance in their lives at all. They worry and complain. They're extremely anxious about money and they 'cry poor' all the time. Their money is not making them happy or fulfilled. I see now that the feeling of abundance has nothing to do with your paycheck, your bank balance, or your possessions. It's all about seeing and perceiving reality in a totally new way."

Greg used to feel trapped in a belief that he was incomplete and that his life was lacking. Visioning reminded him how to focus on what he *did* want, instead of what he didn't want. He also began appreciating the blessings he already had. By kicking his intellectual knowledge into gear, Greg turned his spiritual beliefs into firsthand experience in his daily life. A student of ceramics for many years as well as an accomplished cook, Greg sees the connection between his hobbies and the rest of his life. "My life has become an art form," he told me. "This understanding has now become part of my spiritual practice. Now I see that God is not limited. Abundance is mine. It's not just words or a concept anymore. I'm *living* it. I can see my dreams manifesting before me in all areas of my life. My consciousness has shifted from one of lack to one of abundance, from dissatisfaction to deep appreciation."

What exists in the material world, what we apprehend with our senses is only a monument to the past. When we stop concentrating on our outer situation and pay attention to our inner vision, we create the world as we wish it to be. And we participate in divine creation. This is how the Creator works through us if we will allow it.

SUGGESTIONS AND APPLICATIONS

Body Image, Self-Image

Doing collages of our current self-image can help to heal the split between our head and our body. As long as our self-image is hidden from our own eyes, we have no choice. With greater awareness comes a wider range of options. In reflecting back to us the way in which we see ourselves, the collage acts as a mirror of our inner attitudes and beliefs. Once we see our self-image projected out onto the paper, we are free to move toward more conscious choices (as Gayle did with her second collage).

By paying attention to our physical self through collage and journaling, we allow the body to have a voice. As mentioned at the end of chapter 11, one can dialogue with the body using both hands: the self speaks with the dominant hand, the body speaks through the nondominant hand. The same questions can be asked:

- How do you feel?

- Why do you feel that way?

- What can I do to help you be healthier?

Other questions might come to mind. By all means ask them. And listen to the body's response with care and respect. It is very important that you follow your body's lead and give it what it needs. As mentioned earlier, the body never lies. It will tell you the truth, but you need to listen and respond accordingly.

Illness and Pain

Written dialogues serve us well in the case of acute or chronic illness or pain. One can dialogue with the entire body, with a body part, a system

of the body (such as digestion), or with a specific pain (headache). Again, the voice of the self writes with the dominant hand and the body, the body part, or the pain writes with the nondominant hand.

If you are dealing with illness or negative body image, dialogue with the body as it is now, then create a picture-of-health collage portraying what health looks like. You can depict self-nurturing activities, people, places, and so forth, or whatever else you associate with health and well-being. This before-and-after depiction is similar to Marissa's before-and-after collages in chapter 11.

Allowing the healthy body image that was pictured in your health and well-being collage to speak through a monologue in your journal can also be extremely helpful. Write it in the present tense to reinforce the reality of your desired state. If you write it in the future tense, it just might stay in the future tense and never happen in the here and now. For more ideas and journal exercises focusing on health, see my earlier books *The Picture of Health* and *The Well-Being Journal*. If weight is an issue, see *Lighten Up Your Body, Lighten Up Your Life*.

Abundance

Everyone has their own personal definition of abundance. Picturing *what abundance looks like* can help clarify your needs and desires. Instead of complaining about not having enough, get clear about what "enough" is for you. I know of no better way than to portray abundance through a collage, just the way Greg did. Once it's out there in front of you, the world can respond to your intention.

You can also do journal dialogues with aspects or symbols of abundance that are personally relevant for you:

- bank account

- money

- wealth

- security

- peace of mind

Always remember that *your* voice is coming through your dominant hand, the thing you are dialoguing with writes with your nondominant hand.

In dialoguing with issues pertaining to health, remember that inner peace and wellness are states of being that are your birthright. Use the examples of Susan, Gayle, Mark, and Greg. Open your heart to receive what is already yours.

Greg's abundance journal.

Visioning to Find Your Place

The place we live expresses who we are. Our home is like a second skin. It is a shelter but also a backdrop for playing out our personal lives. It may also house an office or studio for our work. Home may be an emotional mooring place to throw down anchor and relax or it may simply be a pit stop between activities in the outer world. Regardless of how you experience the place you call home, moving to a new residence or location is often a big transition. It can be fraught with anxiety, procrastination, resistance, and the sheer challenge of finding a suitable space at the right price and the right time. Many people who have been in a house-hunting mode have told me it's one of the most difficult tasks they've ever had to do.

For many psychological reasons alone, moving is often a big project. It may bring up feelings and memories associated with past relocations. Or the move may be connected with a current challenge that is charged with its own emotions, like an eviction, divorce, or separation. Also there is the job of packing all of one's belongings, getting them out of one residence into another. Your life can pass before your eyes as you go through what you've collected, deciding what to toss and what is worth keeping.

Live all you can; it's a mistake not to. It doesn't so much matter what you do in particular, so long as you have had your life. . . . The right time is any time that one is still so lucky as to have. . . . Live!

HENRY JAMES

Visioning has been immensely helpful for people facing the challenge of finding a home, a nest that feels like where they belong. Collages are the perfect medium for visualizing the right place and journaling can help sort out the psychological issues that make the process of moving more difficult. The stories that follow demonstrate the value of Visioning yourself into the right place at the right time. I'll begin with my own story.

Left: One panel of my dream house collage. **Right:** A detail.

A HOME FOR THE HEART

The real thing.

CASE STUDY: LUCIA'S STORY OF HER DREAM HOUSE

For twenty years I had harbored the vision of a home and studio in some remote forest by the sea. I often visited this imaginary house in my mind. Suddenly, one day while creating a photo collage on the theme "Projection of the Year Ahead," images of my dream house started popping up everywhere. Immediately,

the inner critic in my mind started yammering, "This is ridiculous. You don't have the money or time to buy your dream house right now. That's for later, when you retire someday . . . maybe. Anyway, your father has cancer. What kind of a daughter leaves town when her family needs her? And besides, your weekly consulting clients are here. You can't move away from the city. This is where the money is. Get serious."

Detail of another section showing the setting.

After years of journaling, I've learned to assert myself with this critic that resides in my mind by telling it: "Go take a coffee break, will you?" I completed the dream house collage and displayed it in my walk-in closet, where I could see it frequently every day. A few months later, my father died and left me some money. At precisely the same time, my sources of income began shifting away from Los Angeles with invitations to conduct workshops throughout the United States, Canada, Mexico, Europe, and Australia. This meant I could live anywhere I pleased as long as it was near an airport. Less than two months after my father's death, while visiting a town on California's pine-forested coast near Big Sur, the dream house in my collage materialized.

The actual coastline near my home.

Everything had conspired to make my dream come true with no conscious planning, struggle, or effort. My life circumstances had changed completely to accommodate my innermost heart's desire. What is more, once I saw the house there was no doubt in my mind. The collage matched the physical reality so precisely that it gave me goose bumps. I would have had to be blind to miss it. The decision happened on the spot. My heart said "Buy it!" and I listened. The greatest challenge was to believe it was truly happening, to get out of my own way and accept the *realization* of my dream. Yes, I had some resistance, mostly fear of financial responsibility and change of lifestyle. But I did a lot of creative journaling and also reached out to my personal support system: friends, family, and my realtor. I live in that house today, where I sit writing this book in my sun-filled studio overlooking a pine forest and the sea. My dream came true and I know yours can, too.

Visioning is a wonderful way to create your dream house, whether you design and build it yourself or find exactly what you want already built. Technically speaking, I was not the architect or builder of my dream house, but I might as well have been. The house met my specifications so perfectly that I feel as if, at some magical level, my heart's desire got communicated to the woman who designed it for herself and the contractor who built it. In fact, since buying the house, they have both become friends. When I had the first vision of my home in the fall of 1973, the house hadn't been built yet. The original owner didn't build it until 1984. When we met, I thanked her for sparing me the trouble of having to build the house myself.

So join me in the adventure that I call Visioning.

DREAMS FOR RENT

Jane had been Visioning various aspects of her life faithfully for almost two years as part of a group that formed after one of my workshops. Jane

had changed careers later in life and became a body worker. She also moved from Colorado to a small California coastal town and traveled a lot, taking classes, workshops, and training seminars all over the country.

Thoughts about moving to a smaller place had crossed Jane's mind, but she had taken no action. One Saturday she heard the words in her mind and heart: *Time to downsize.* The next day happened to be her Visioning group's scheduled Sunday. She immediately zeroed in on a focus phrase: "What does the end of this year look like?" Her collage featured pictures of the kind of house she wanted. Three words appeared that would prove to be most helpful in the weeks to come. They were: *Patience, Skill, Trust.* Jane had no idea what they meant in terms of her move, but she'd learned to trust the process of gathering and sorting and listening to her creative conscience. She believed that the meaning would be revealed, and it was.

I can't show you a picture of Jane's collage because she got rid of it after her vision manifested. Part of her downsizing process included getting rid of things she didn't need anymore. It's enough to say that Jane wanted a one-bedroom place that had enough room for her to work at home. Usually, finding a small house or apartment to rent in the tiny town where she lives is *extremely* difficult. The market is full of homes for sale, but Jane wanted to rent. In this town, many people report that they've searched for months before finding something suitable. By contrast, Jane found what she wanted literally *overnight.*

The morning after the Visioning session, Jane went to see the property manager from whom she was currently renting. There were two listings for small homes. One was clearly not what she wanted, the other one sounded like just the thing and it had an ocean view! However, Jane had to wait ten days to actually see the house inside. It was then that she realized why the word *patience* had appeared in her collage. Once she actually moved in, she needed patience again because of some problems in getting the phone installed. They'd told her she'd have service within two hours, but it dragged on for many days. As a self-employed

person with private clients this was a real challenge. Also the washer and dryer didn't work, another inconvenience that tested her patience for a while.

Jane also needed *skill*, another word from her collage. There were certain details in the house that needed altering. She came up with ingenious impromptu solutions, like turning a bed sheet into a curtain because the window covering that had been there did not come with the house. She also decided to move her things by herself, as none of her friends were in town or available to help at the time. She managed it on her own and was quite proud of how skilled a job she did. The word *trust*, which she'd put in her collage, also appeared to be prophetic. The original carpet in the house was a dark, terrible color that Jane disliked intensely. The manager said she'd ask the owners to replace it and Jane rented the house trusting that this would come to pass. It did.

In spite of the little glitches here and there, Jane was in awe of how easy and how rapidly things had gone compared to previous moves. She had to take a trip right after relocating. When she came home to her new place, she was still surprised and had to ask herself: "How did this happen?"

MARA MOVES TO SANTA FE

CASE STUDY: RELOCATING TO A NEW AREA

Another woman whose relocation was amazingly quick and painless was Mara. As in Jane's case, Visioning proved valuable in clearly portraying her heart's desire and moving her forward into the reality.

When I first met Mara, she was a schoolteacher looking toward retirement. A warm and caring person, she couldn't stop thanking me for the powerful transformation she'd experienced using my journal method. Nondominant-hand writing and dialoguing had put her in

touch with her inner child and this brought about profound healing from a horribly abusive childhood. "This work saved my life," she shared with me. "I really mean that quite literally." After that, Mara began attending my workshops and trainings and upon retirement got her Ph.D. in psychology. An extremely gifted and creative individual with a background in music and dance, Mara was a natural at integrating expressive arts therapies with body work. She built a successful private practice overnight.

I asked Mara to assist me at a week-long intensive session at Ghost Ranch, New Mexico. A native Angeleno, Mara had never lived in any other city. I couldn't recall her ever talking about moving out of Southern California, but that changed in an instant once we arrived in Santa Fe. It was a cool November day. Mara had never been there and, as soon as we started strolling around the charming plaza that marks the center of this utterly picturesque town, she exclaimed, "Oh, this is wonderful! I'm going to live here." Now, for anyone who hasn't visited Santa Fe, let me say that many, many people become infatuated with it. It is surrounded by breathtaking high desert scenes à la Georgia O'Keeffe (who memorialized the area with her art). The architecture and art of this region are unforgettable. So, of course, like millions of other tourists, Mara fell head over heels in love with the place.

She wasted no time. Within twenty minutes of arriving at the plaza, Mara had bought a paper, settled down over coffee in a cafe, and was searching the classified ads. The second rental listing described a reasonably priced two-bedroom casita (an adobe house typical of the area) and she intuitively felt that this one was it. Swept along by the momentum of her heart's desire, she sought out the management company and went to see the place, which did turn out to be *it*. Mara adored the design of the home, which even had a cozy extra room for doing massage therapy. Better yet, it was conveniently located near restaurants, shops, and a great bookstore. She told the broker she was seriously interested.

Then it was time to move on to our final destination, Ghost Ranch,

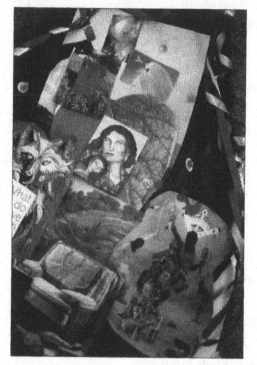

Mara's Santa Fe collage.

and the workshop on the inner family. One activity that was very popular with the staff and participants alike was the Visioning collage and journal work. Mara did a collage on the theme "Life in Santa Fe." Since we had lots of local magazines in our resource pile, it was easy for her to find very specific images of her burgeoning dream. She even went beyond the flat surface and created a free-standing 3-dimensional format.

It soon became clear that Mara was wasting no time in realizing her dream. By midweek she drove back to Santa Fe, paid a deposit on the house, signed a lease, and returned to the workshop. As a group we celebrated her vision and her courage. When she got back to Los Angeles, Mara closed her counseling practice, packed up all her belongings, and threw a gala sixtieth-birthday party for herself. It was as much a celebration of her dream as of her biological birth. The next day she set out for Santa Fe and a new life.

Now this may look too easy to be true, but there is more to the story than meets the eye. In retrospect Mara says, "If I hadn't been doing this kind of personal process work with art and writing and collage-making for some time, I never would have trusted the inner voice that led me to make this move so suddenly. It is through using these tools that this voice has gotten so strong over the years. I no longer question the guidance. When I don't pay attention to my intuition and my heart, things become difficult. When I do listen, my life works. All the support I need simply shows up as if by magic. It all falls into place. And even so, it still astonishes me that my move to Santa Fe happened so quickly and so easily. There was no effort."

ANNA'S RANCH

CASE STUDY:
ANNA FINDS HER DREAM RANCH

I used to think that a positive attitude was a prerequisite for successful Visioning. That is, until I met Anna. She taught me that dreams have a life of their own. Like babies, when it's time for them to be born they will be, sometimes in spite of our strongest resistance. I also learned—once again—the power of reinforcing one's dream image by displaying the collage and looking at it repeatedly.

Anna was actually "sent to me" by her mother, Mary Catherine, who had heard me speak about "putting talent to work" at a big conference in Silicon Valley. In a phone conversation later, Mary Catherine told me, "I was on fire after that talk. When I found out you live near my daughter, I insisted that she attend one of your workshops. I'm even paying for her to come. She seems really stuck in her work and in her life and I think you can help her."

Anna, a tall, outgoing young woman, showed up at my next one-day workshop. We were focusing on Visioning, making collages, and doing journaling. The group seemed highly motivated and confident about the process. Everyone except Anna. After telling us that she was a music teacher, she announced to the group that her mother had sent her and had even made the check out to me so that Anna couldn't spend the money on anything else. Anna admitted openly that she was skeptical about realizing any dreams through collage and writing. I knew that to be "sent by Mom" was probably the worst reason anyone could have for being there. I quietly adopted a "you can't win 'em all" attitude. In spite of herself, Anna did seem to enjoy the collage process and even the writing. She created a large photo and word picture of a ranch out in the country.

When it came time for the group to share, Anna showed her collage

Detail of Anna's ranch collage.

of a ranch. She told us about her long-held wish to have such a piece of property of her own someday and how well-meaning but nonsupportive relatives had trashed the idea as impractical and unfeasible. When Anna said she had forsaken her dream a deep sadness hung in the room like a heavy weight. Then she said, "Okay, so I did the exercise, but how can this dream become a reality? Even if I found such a ranch, I probably couldn't get a loan to buy it."

In spite of her pessimism, Anna did point to a visual solution to the money issue: a photo of a Chase credit card from a magazine ad. She explained that this represented "credit" or the financing for purchasing her dream ranch. When the workshop was over, Anna's skepticism was still running high. I secretly wrote her off as not having the right attitude. How wrong I was!

A couple of months later, at one of my workshops about creativity at a nearby spiritual retreat center, I was pleasantly surprised to see both Anna and her mother beaming at me from the audience. At the break Anna told me her amazing story. With great gusto and humor, she later told her story to the group. She called it "the dream that came true in spite of myself."

Anna described carrying her collage and her skepticism home from

the earlier workshop and tossing her artwork into the corner of her room. It sat crumpled and neglected there for some time. One day, she gazed over at it and heard a voice inside saying, "What are you doing? Those are your dreams all crumpled up over there! Pick them up and put them on the wall, the way Lucia said to do." Of course, it was her creative conscience speaking. Anna immediately rescued her collage from the corner, smoothed it out as best she could, and displayed it where she could see it every day.

At this point in telling her story, Anna started grinning. "I began casually looking through real estate ads. It couldn't hurt to at least look, I thought." She found a listing that intrigued her: a ranch on many acres of some of the most beautiful rolling hills on California's central coast. Anna got up the courage to drive out and visit the property. It was unmistakably the ranch in her collage. But, of course, there was still the little matter of securing a loan. She mentioned this to the realtor, who said he'd get back to her. The next day, Anna received a phone call from, guess who? Chase Bank. They heard she'd found a piece of property and were offering to finance it!

By this time the audience was gasping. "I'd never even *heard* of Chase Bank before," Anna chuckled. "Chase doesn't have banks in California. When this guy called, I remembered the Chase credit card photo I'd put in my collage and thought, 'Somebody's playing a practical joke here.' But it was no joke." As it turned out, Chase Bank really did want to help her make her dream come true (for a price, of course). In the long run, she didn't need the financing because Anna and her mother were able to sell some property and fund the dream ranch themselves.

I attended the "housewarming" a couple of months later. Anna's mother also attended and we felt like proud grandmothers at the birth of a "dream child." There was a huge gathering and a lot of partying that day at the ranch. Because the ranch had a large house and smaller cottage as well, Anna had rented the extra space out to friends, thereby creating a community. Anna's dream had prevailed. In spite of her initial

pessimism, her heart's desire had crept out of the corner, like Cinderella, to emerge triumphant.

Anna, her mother, and the collage in front of the barn.

IN CLOSING

The Visioning process is clearly a passport into the future. As you move back and forth from the world of *imagination* to the world of *material manifestation* you practice the creative process. It is through this hands-on experience that you'll understand the immense creative power that is your birthright.

To live more abundantly—to *feel* abundant—requires that you apply the creative process in your everyday life. Mere knowledge of the creative process is nothing. *Understanding* is the highest attainment. With understanding we gain insight and wisdom. All of these—understanding, insight, and wisdom—come from *experience*. What I am talking about is direct knowing, the intelligence of the heart. The Visioning process is a map to that kind of intelligence.

Seeing with your heart, knowing with your heart transforms you and your world. If you want to change external conditions and circumstances, start by changing yourself. First, give yourself permission to be

all that you can be. It is who and what you are inside that determines the environment outside. As you change your inner perspective, the outer world transforms before your very eyes. Looking for happiness by trying to change others or alter external circumstances is futile. We can rearrange the outer world forever, but if we haven't rearranged the furniture in our hearts and minds the experience of fulfillment will elude us. As we replace outworn beliefs and limiting perceptions with new pictures and a new scenario, we literally recreate ourselves.

As you join forces with your creative self and learn to trust that "still small voice within," a new life can unfold, just as it did for Gayle and Susan, for Greg and Mark, for Anna and Lisa, and for me. In closing, I can send you off with no better wish than this:

> May you find your creative self.
> Dare to dream.
> Listen to your creative conscience.
> Follow the pathways of the heart.
> Create a life that was once a dream,
> but is now a living reality.

Many of us have done it. I know you can do it, too. And I'm on your cheering team. So if you falter or lose heart, picture me behind you saying: "Go for it! You deserve the life of your dreams!"

Resource Guide

BOOKS

Lucia Capacchione

The Creative Journal: The Art of Finding Yourself. Athens: Ohio University/Swallow Press, 1979.

The Power of Your Other Hand: A Course in Channeling the Wisdom of the Right Brain. Van Nuys, CA: Newcastle, 1988.

Recovery of Your Inner Child. New York: Fireside/Simon & Schuster, 1991.

The Picture of Health: Healing Your Life with Art. Van Nuys, CA: Newcastle, 1996.

Lucia Capacchione and Peggy Van Pelt

Putting Your Talent to Work: Identifying, Cultivating and Marketing Your Natural Talents. Deerfield Beach, FL: Health Communications, 1996.

The Imagineers

Walt Disney Imagineering: A Behind the Dreams Look at Making the Magic Real. New York: Hyperion, 1996.

Corita Kent and Jan Steward

Learning by Heart: Teachings to Free the Creative Spirit. New York: Bantam, 1992.

John Neuhart, Marilyn Neuhart, and Ray Eames

Eames Design: The Work of the Office of Charles and Ray Eames. New York: Harry N. Abrams, 1989.

Gabrielle Roth

Sweat Your Prayers. New York: Jeremy P. Tarcher/Putnam, 1997.

Bob Snyder (editor)

Buckminster Fuller: An Autobiographical Monologue/Scenario. New York: St. Martin's Press, 1980.

AUDIOTAPES

Lucia Capacchione

The Wisdom of Your Other Hand (set of five tapes). Sounds True

Bobby McFerrin

Medicine Music. EMI
Simple Pleasures. EMI

Carlos Nakai

Canyon Trilogy: Native American Flute Music. Digital Chrome

Gabrielle Roth

Endless Wave, Volume One. Red Bank, NJ: Raven Recording
Initiation. Red Bank, NJ: Raven Recording

Tony Scott, Shinichi Yuze, and Hozan Yamamoto

Music for Zen Meditation. Music of the World, PolyGram Records

ART AND JOURNAL SUPPLIES

Art Supplies

art supply stores
hobby shops
phone/E-mail order art supplies
office supply and stationers
variety and five-and-dime stores

Blank Books for Journaling

bookstores
stationers
art supply stores (hardback sketcher's diary or spiral-bound sketchpads)